Snowdon

Public Appearances

1987–1991

SNOWDON

PUBLIC APPEARANCES 1987-1991

INTRODUCTION BY JOCELYN STEVENS

THE VENDOME PRESS
NEW YORK CITY

Photographs and text © Snowdon 1991

Introduction © Jocelyn Stevens 1991

First published in 1991 by

George Weidenfeld & Nicolson Limited

91 Clapham High Street, London SW4 7TA

Published in the United States by

The Vendome Press, 515 Madison Avenue, New York, NY 10022

Designed by Paul Bowden Design

Library of Congress Cataloging-in-Publication Data

Snowdon, Anthony Armstrong-Jones, Earl of, 1930–
Public appearances, 1987–1991 / Snowdon.
p. cm.
Includes index.
ISBN 0–86565–130–2.
1. Celebrities—Portraits. I. Title.
TR681.F3S62 1992
779′.2′092—dc20 91–29756
CIP

Colour separations by Newsele Litho Ltd
Phototypeset by Keyspools Ltd, Golborne, Lancs
Printed and bound in Italy

To my Mother
and Father

ACKNOWLEDGEMENTS

I want to convey my very special thanks to everyone who so kindly gave up their valuable time to be photographed in the last four years. All the pictures in this book were commissioned so I would like additionally to take this opportunity to express enormous gratitude to my patrons and also to everyone I have worked with either in the studio or on location. For me every sitting was the greatest pleasure and experience but the photographs themselves were only made possible by a team of people to whom I would like also to express my warmest thanks and admiration.

Robin Bell
Elisabeth Biondi
Paul Bowden
Terry Boxall
Peter Brightman
Gunn Brinson
Tina Brown
Victoria Charlton
Ros Chatto
Felicity Clark
John Cumming
Lillie Davies
Maureen Doherty
Michael Dover
Roger Eldridge
Geraldine Flax
Paul Gatt
Jane Gillbe
Angela Hale
Anna Harvey
John Hind
Nigel Horne
Iain Horner
Georgina Howell
Evelyn Humphries

John Humphries
Patrick Kinmonth
Richard Krzyzak
Terry Lack
Sung Lee
Peter Lyster-Todd
Alan McLintock
Lucy Manningham-Buller
Robin Matthews
Beatrix Miller
Sophie Miller
Issey Miyake
Nancy Novogrod
Michael Rand
Kathy Saker
Jocelyn Stevens
Andre Leon Talley
Makiko Tamura
Liz Tilberis
Ray Watkins
Jill Westray
Susan White
Jenny Wilson
Anna Wintour

INTRODUCTION

It is typical of Snowdon to have announced two or three years ago that he was only taking black and white pictures and then to have produced a book that is awash with vivid colour.

But then he has always been contrary. I have a terrible feeling that he was delighted when Yves Saint Laurent failed to turn up to have his picture taken and instead sent Moujick, his dog, in a chauffeur-driven limousine. At least Moujick made the cover of this book. But should we be surprised? On the cover of *Stills 1984–1987*, his previous book, which, together with *Sittings 1979–1983*, forms a trilogy of what he calls his scrap books made public by publication, there appeared a gloriously fat toad caught in a balletic pose as it scrambled out of a glass tumbler. 'I prefer non-people covers—there was a whale on the cover of *A Personal View*', he says, ' I hate the word portrait—a portrait on the cover would give entirely the wrong impression of the book'. So does he prefer photographing animals to people? 'No. I don't like animals much—besides I'm not very good with them. They seldom do as they're told, and never keep still.'

Public Appearances opens with a stunning spread showing a silver pheasant in flight. 'I didn't mind the silver pheasant being paid more for the picture than me,' he says, 'but I refused to photograph a silver fox which was to be paid even more money.' Later in the book, after a spread which couples the Pet Shop Boys and Griff Rhys Jones as Toad of Toad Hall, there follow six surprising pages of sheep, pigs, cows and a perfectly beautiful cockatoo in close company with Lana Ogilvy.

What does this book tell us about the photographer? First there is his life-long love of ballet—fourteen pages of moving shapes photographed with all the skill and style for which he is rightly renowned. My favourite picture in this section and, incidentally, a classic example of his resourceful approach is the one of Darcey Bussell, Nicola Tranah and Viviana Durante. Before the sitting, having been told that the dancers' costumes would not be ready, he asked only for some silk net to be made available and that Anthony Dowell be present for the whole of what turned out to be a five-hour session. 'It's perfectly all right to paint or draw the nude in a life class,' he explains, 'but it's very tricky to photograph the naked body with elegance. There is always the danger of vulgarity.' In this photograph there is no eye contact between the dancers, or with the camera, and their arms are entwined to conceal their nudity. The photograph has an almost sterile lack of sensuality and yet the effect, three butterflies caught in a net, is extraordinarily sensual. Only after he had taken the photographs did he discover that in *Winter Dreams*, the ballet for which the dancers were preparing, a gauze net separates the principal dancers from the activities upstage. 'Serendipity', he calls it.

In the photograph of Darcey Bussell on the next page, we see his cleverness in the building of

sets which shows up throughout the book—a flair which he undoubtedly owes to the influence of his uncle Oliver Messel, and to his early training as an architect. In fact Darcey Bussell did not dance in *Manon* and so we have to be content to see how she would have appeared.

Snowdon had two assistants in attendance in order to achieve the dramatic photograph of Petrushka, so that after every time he had pressed the button, one could describe to him the exact position of his hands and the other the exact position of his feet. 'In the event, only the Polaroid I took was really right,' he says. Faroukh began by telling him exactly at what moment his photograph should be taken. Infuriated, Snowdon handed Faroukh his camera and suggested that he try to photograph his ballet teacher in mid-air. Faroukh snapped away but in every photograph both feet appeared firmly on the ground. Faroukh was soundly defeated.

The Kirov dancers were all photographed in a rehearsal room in Leningrad. Having discovered on an earlier trip to Russia that it was almost impossible to find suitable background material, he took with him a twelve-foot-wide roll of painted canvas. In Helsinki, the man from Aeroflot said that it could not be loaded onto the plane as it was two feet too long. Snowdon enquired whether the Russian had heard of the Kirov Ballet. The Russian said that of course he had. 'Right,' said Snowdon, 'if you insist on cutting two feet off the width of the backcloth, you and you alone will be responsible for all the dancers, in the programme and publicity for their World Tour, appearing with only one arm and one leg.' Horrified, the official leapt onto the wing and removed a window so that the canvas could be squeezed onto the plane. The resulting photograph shows how important is the quality and texture of the background, however subtle, to the perfection of this photograph. His choice of lighting, which is always very simple and comes from one direction, is in this case a single light from high above.

Snowdon's photography is full of games, fairy tales, flights of fancy and pantomime. Rules can be broken—even gravity can be defied (by the use of a trampoline to catch Errol Pickford in an impossible leap). Frances, Snowdon's daughter, appears, improbably clad in a Marmite pot. And there is Carl Toms in Snowdon's coat and bright blue scarf, which incidentally features again in the photographs of President Havel and Tom Stoppard. 'I hate photographing people in a collar and tie', he says.

He claims that he never knows how a sitting is going. My experience is that although he appears nervous and is intensely active, he mostly succeeds in preventing the sitter from becoming involved. Always, before the sitter is photographed, he will have engaged in excessive research into every aspect of his victim's personality and background, reading about and talking to as many people as he can usefully find. I only became aware of the penetrating intensity of this process when he came one day to interrogate me for an interview in *Vogue*. Hours later, the experience not only left me shattered but a room full of typists whose job it was to unravel and transcribe the tapes, in tears. Whether he is campaigning for disabled people, designing a wheel-

chair, attacking British Rail, debunking the Royal Horticultural Society or berating the Design Council, Snowdon's life is distinguished by a burning inquisitiveness, an obsessive attention to detail and an impatience which sometimes turns to aggression. And so it comes about that when photographing, having made his plan, he is uncannily successful in getting what he wants.

Arriving to photograph Barbara Cartland, his instinct took him to the cloakroom in her house where he found and used the plastic umbrella under which she appears in her photograph. The session with Joan Collins in the Oliver Messel Suite in the Dorchester Hotel was lifeless until Joan Collins at lunch picked up a banana and began to eat it. When Barry Humphries arrived at the studio, Snowdon already had a lavatory for him to climb into. For Jean Simmons as Miss Haversham he found a machine that made cobwebs; for Cameron Mackintosh a window frame which just happened to be in the studio; for Karel Reisz a wooden dog with a similar expression; for V S Pritchett a wooden horse from the garden next door.

Sometimes the tricks are more convoluted. John le Carré is David Cornwell in the looking glass; John Osborne is a Spy cartoon, with a rolled up umbrella; Nigel Mansell leans on a tractor wheel. Antony Price's scarlet hat boxes appear in the reflection of his model but he does not; Michael Kors and Donna Karan are accompanied by plastic models and real models; Michael Roberts, famous for his photographs of nude white boys, is himself photographed in front of a live dark tapestry of just such posing figures; John Bellany, who has painted many fish, has a halibut slung across his shoulder. Snowdon's photography allows for jokes both mischievous and outrageous. Lady Harlech with 'The Men of Harlech' in the background, opposite Michael Clark in high heels; James Earl-Jones and John Goodman as Kings.

He has his favourites. John Gielgud has appeared in all three books. I can never imagine him taking an unkind picture of Sir John. 'Besides everything else, he has such very nice manners.' Old fashioned manners matter to Snowdon very much. This is the very first lesson that he teaches his assistants. He likes to imagine himself as a chameleon blending into the background of his studio; there must be no false familiarity to break the spell.

Photographing Audrey Hepburn at Hidcote Manor he told her, 'I have loved and admired you so much that I'm too nervous to take a picture'. With infinite care he had arranged the cast-iron table and bench which he had brought all the way from London for Miss Hepburn to sit upon, had gathered a basketful of roses to be beside her and was about to begin the session when he heard the journalist, who had been sent with him, remark, 'It'll be better from over there'. He was even more irritated when the journalist was credited with styling the picture.

After the actors, mostly men and mostly classical, there come the writers. Among the writers there is Mrs Major, the biographer of Joan Sutherland, with her husband, and Mr Havel, the playwright, against a background that could be the set for an opera if you did not know that Snowdon had placed the soldiers where they were to disguise an open manhole. And there are the

dress designers. Geoffrey Beene, seated on bean bags, borrowed a white coat to protect his clothes while he painted the backdrop for his photograph. When he finished, Snowdon suggested that he paint the coat as well. Valentino, the sleekest of all couturiers, is in the shower.

For the interior decorators, he adopts one approach—only glimpses of their work are allowed to appear; the rest is covered in dust sheets. For the sportsmen, the painters, the sculptors and the musicians, he shifts his focus from the all-important eyes to the hands and the feet. 'Few people see what they are most famous for', he says. Lineker's legs show the scars of his trade; the late Sir Thomas Sopwith, the grand old man of aviation, the wrinkles of a hundred years; Paolozzi's hand the contours of a thousand sculptures and Zubin Mehta's hands unfold like a snake from a basket.

But Snowdon's eye is a versatile eye, and sometimes a little irreverent. Paloma Picasso is photographed in the Lord Mayor of Nottingham's robes. De Savary—a change of gear between Barbara Cartland and Les Dawson—black-helmeted and astride a crested motorbike, posing with his screaming daughter, is a Hell's Angel; Ute Lemper a pin-up from the Thirties; Gerhard Richter a face from a horror movie. On rare occasions there are protestations. Mrs Mosimann thought that Snowdon had made her hirsute husband look too animal. Her appeal was disallowed. The portrait now hangs in Mosimann's club above his desk. Lady Menuhin did not like her husband being photographed in his vest, as it had a hole in it. Snowdon agreed that the hole could be touched out.

The book, for which Snowdon has chosen every picture, and dictated the order and pace, ends with a four-page tribute to Margot Fonteyn of everlasting beauty. She is sitting in her rocking chair surrounded by chickens, all wooden except for one. It is just the kind of picture anyone would have dreamed of taking of her. But for us, mere mortals, it doesn't work out like that. 'It's all luck', says Snowdon, which of course is hardly the truth. Photography, as Voltaire might have said, is a set of tricks played upon the living.

Jocelyn Stevens
June 1991

PICTURES

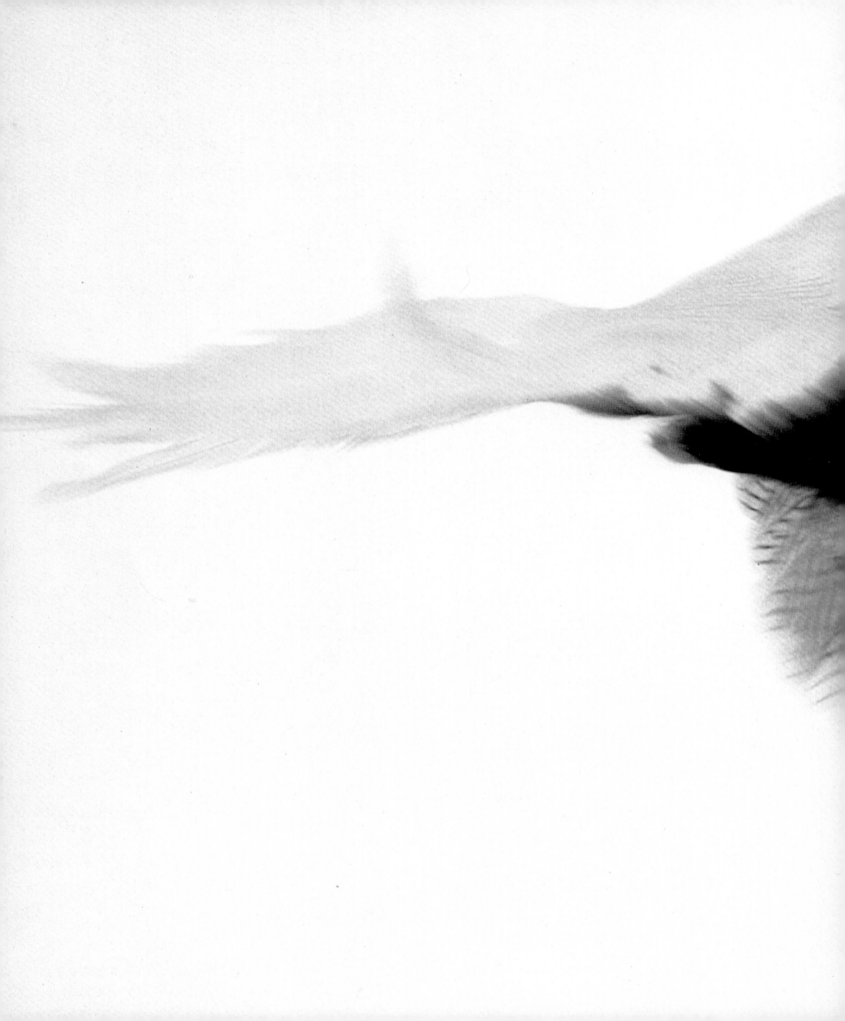

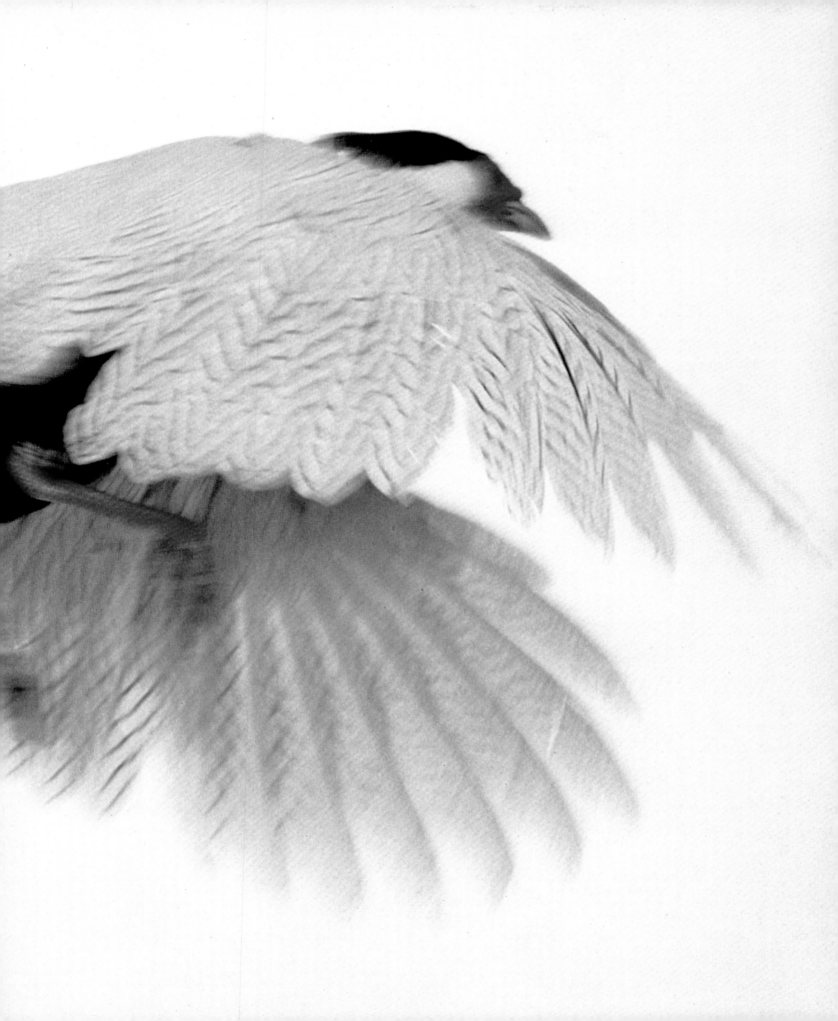

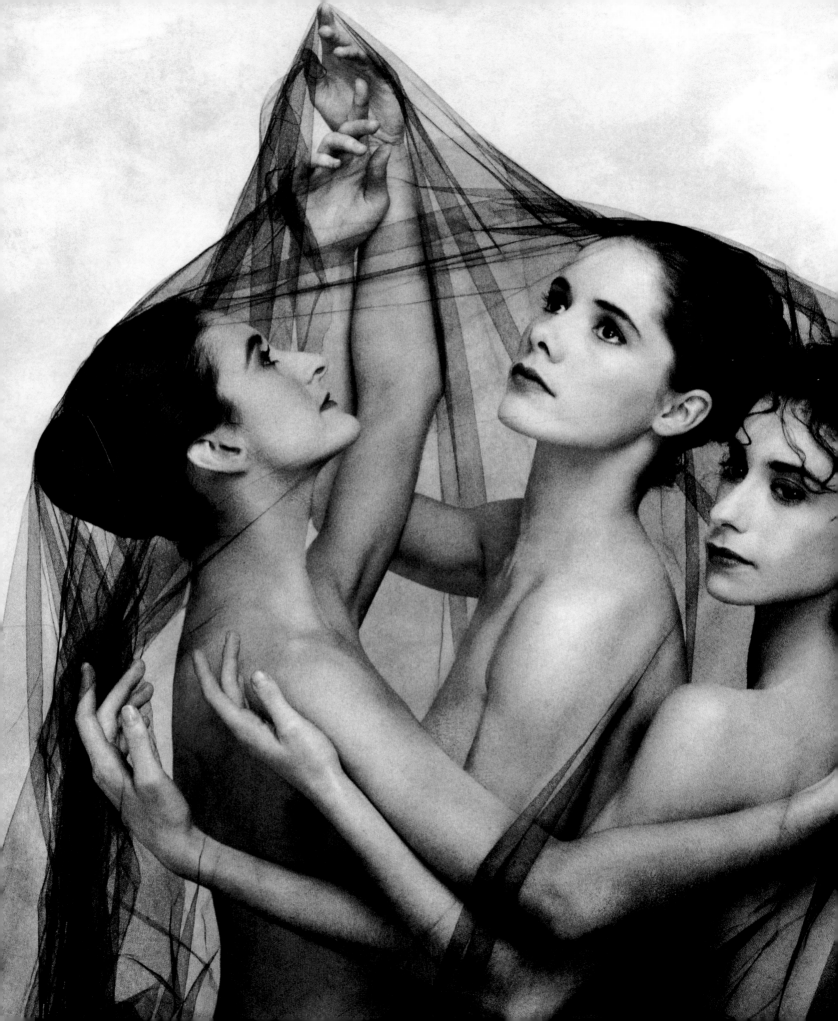

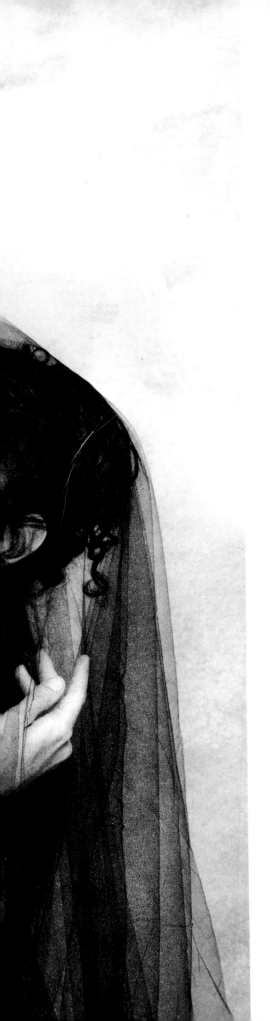

Preceding pages, **Silver Pheasant**, Christmas *Vogue*, 1989

Nicola Tranah, **Darcey Bussell** and **Viviana Durante** as
The Three Sisters in Sir Kenneth MacMillan's *Winter
Dreams*, The Royal Ballet, Covent Garden, 1991

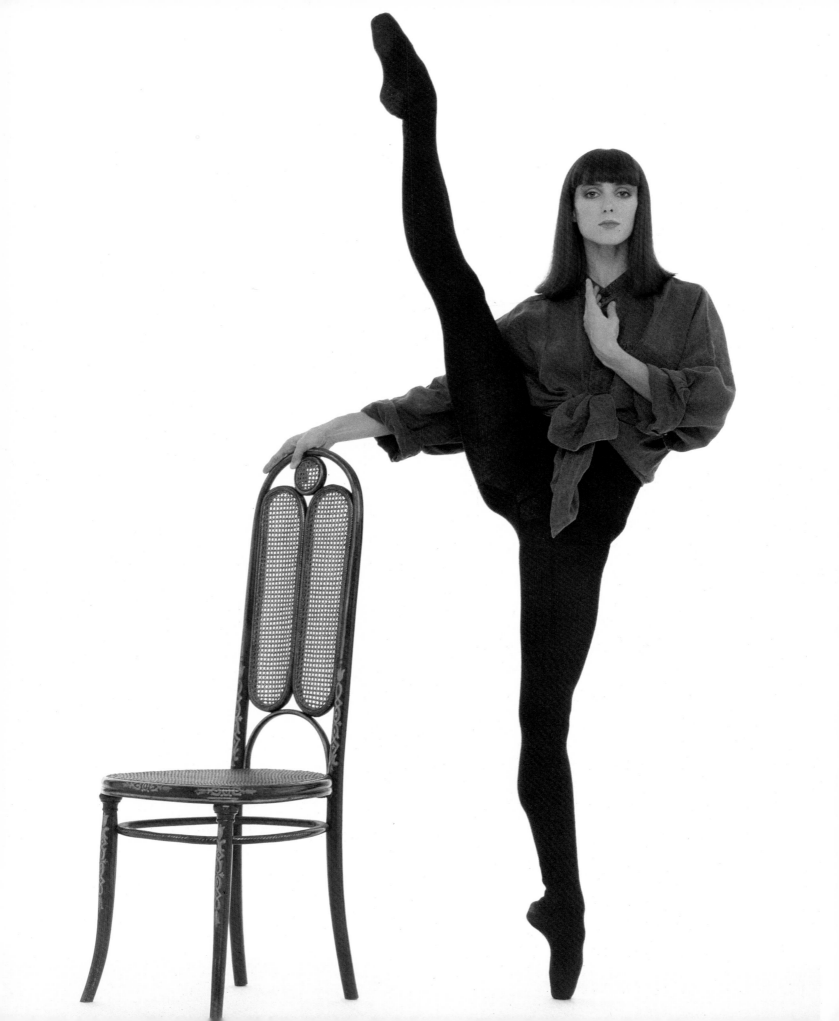

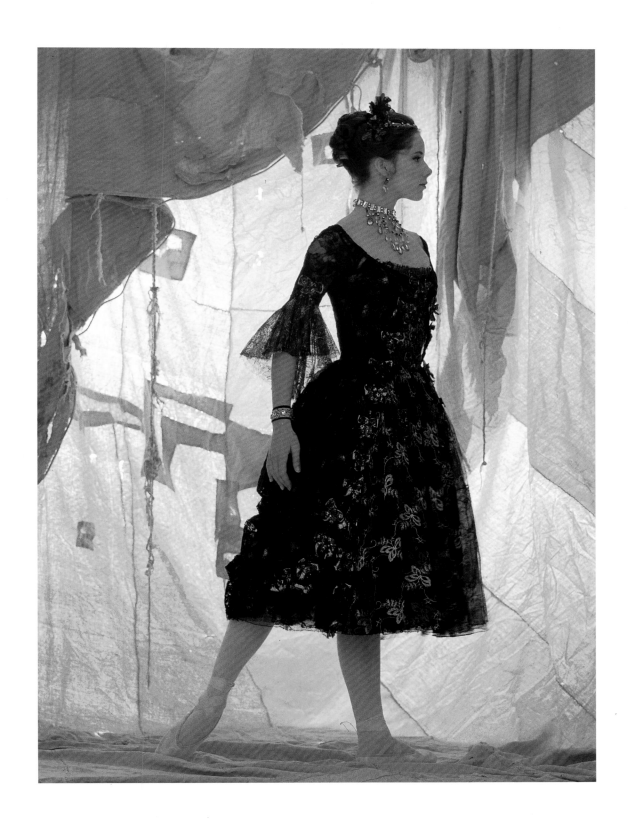

Darcey Bussell in the Costume of Manon
designed by Nicholas Georgiadis, The Royal Ballet, 1990

Sylvie Guillem, A Principal Guest Artist with
The Royal Ballet, Covent Garden, 1989

Andris Liepa
as Petrushka,
The Kirov Ballet,
1990

20

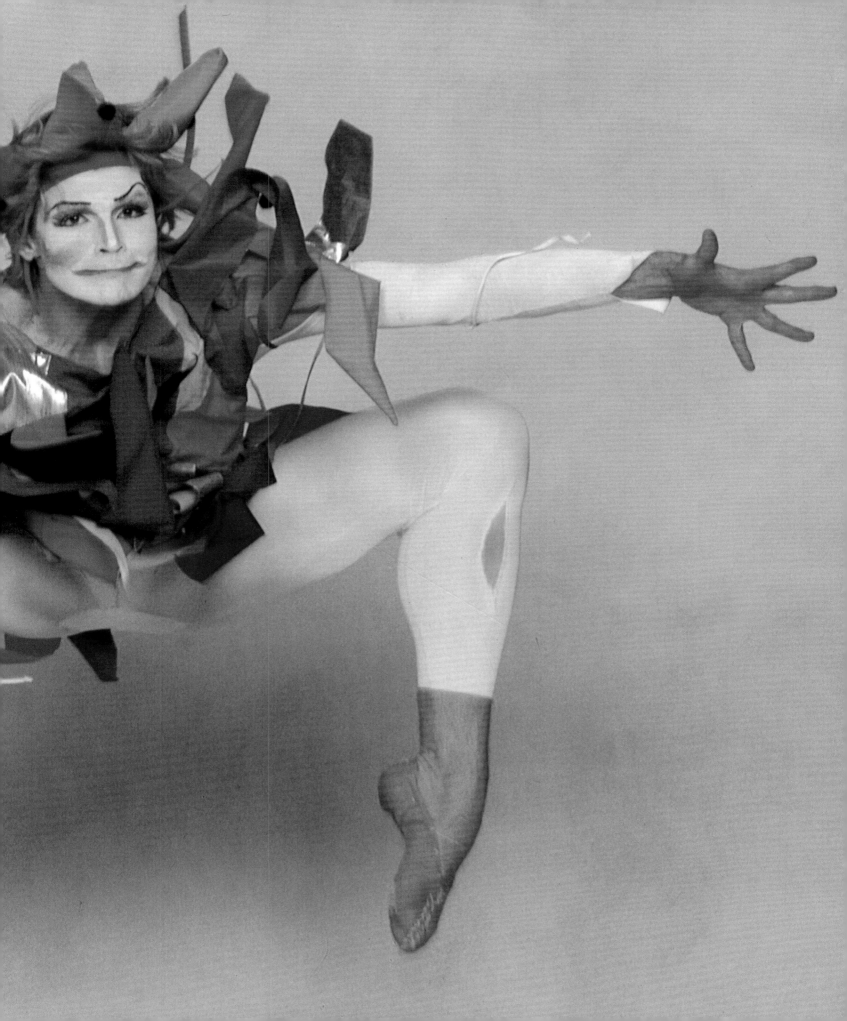

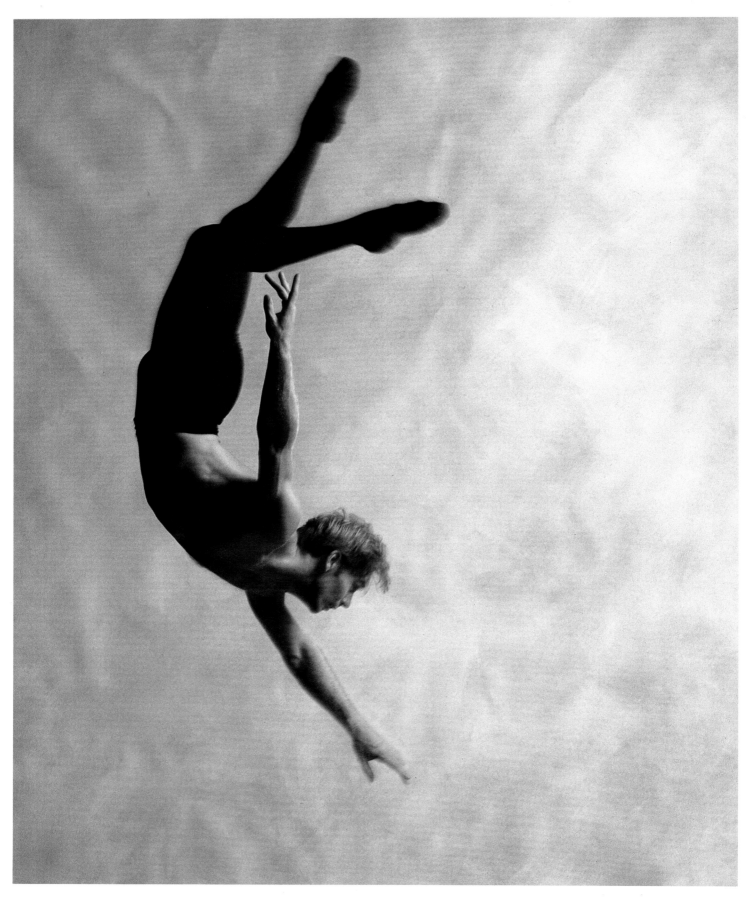

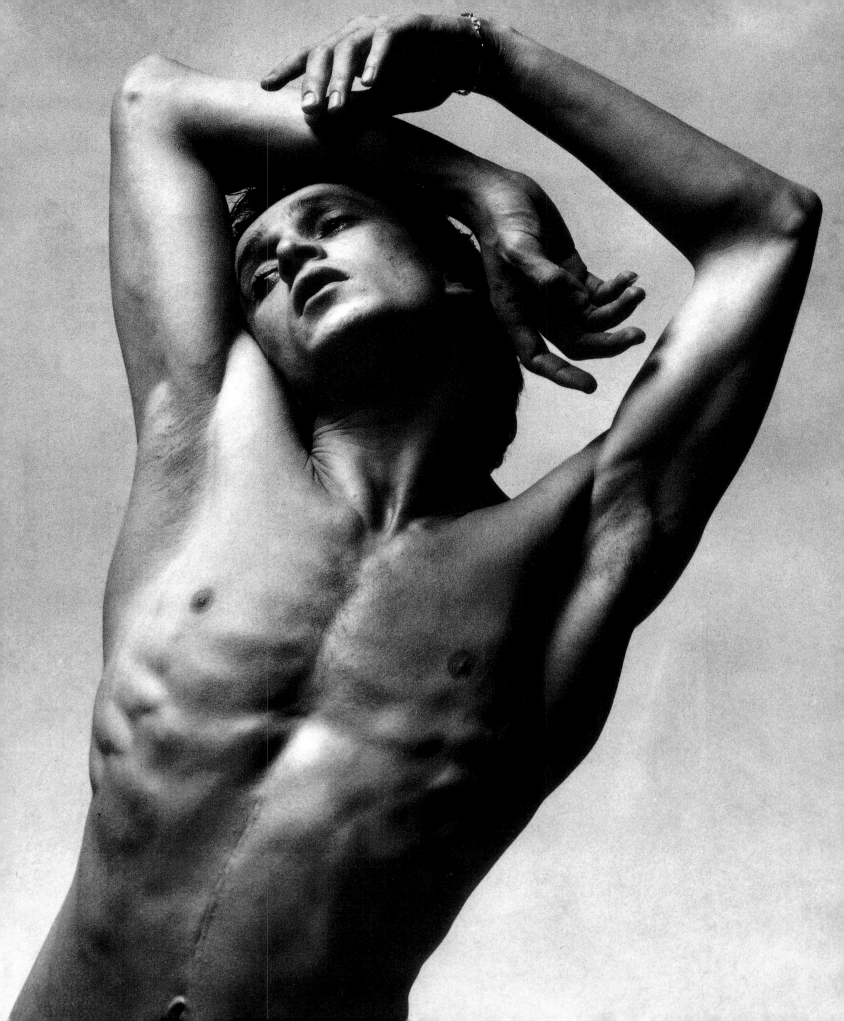

Errol Pickford, A First Soloist, The Royal Ballet, 1990

Faroukh Ruzimatov, A Principal, The Kirov Ballet, 1990

Inna Petrova, A Principal, The Bolshoi Ballet, 1990

Andris Liepa as Prince Siegfried and **Yulia Makhalina** as Odette, *Swan Lake*, The Kirov Ballet, 1990

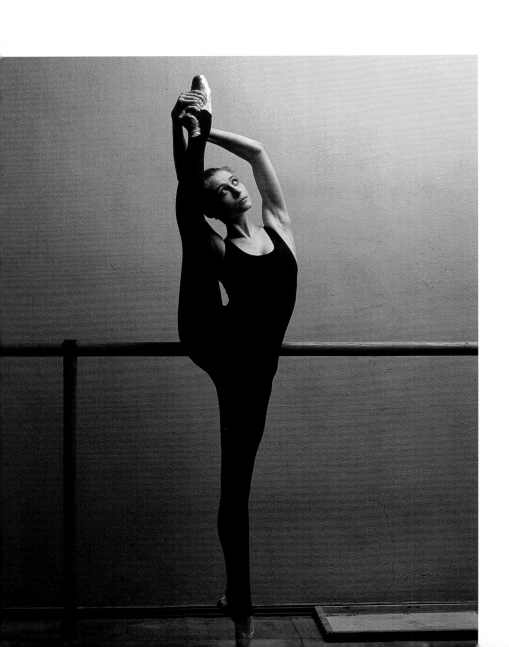

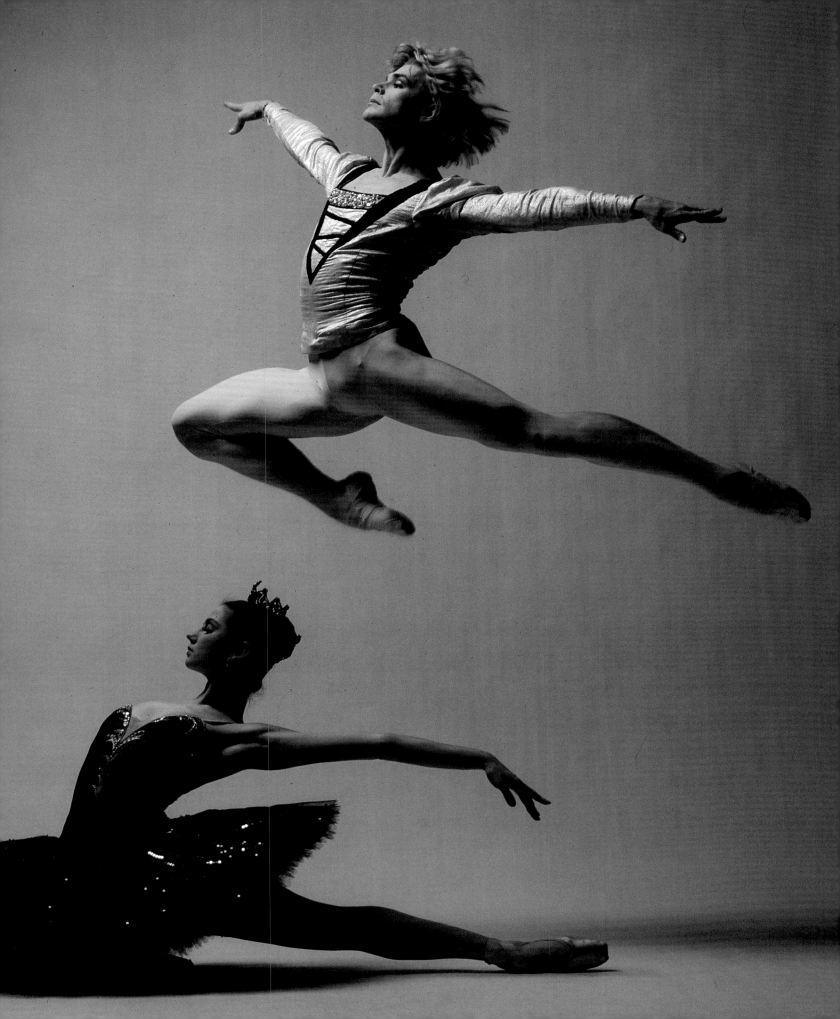

Zhanna Ayupova, A Principal, The Kirov Ballet, 1990

Konstantin Zaklinsky and **Altynai Asylmuratova**
in *Swan Lake*, The Kirov Ballet, 1990

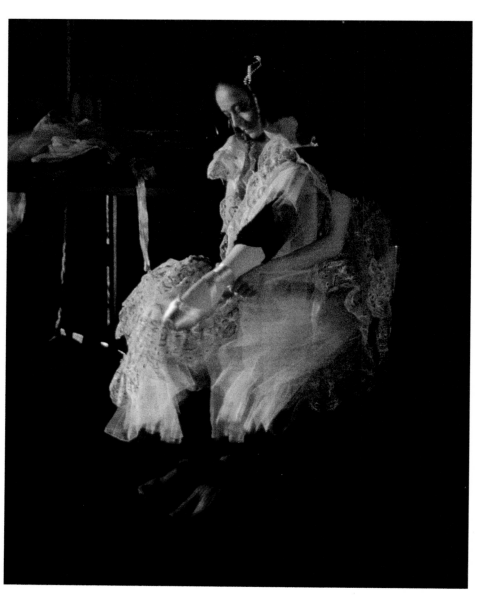

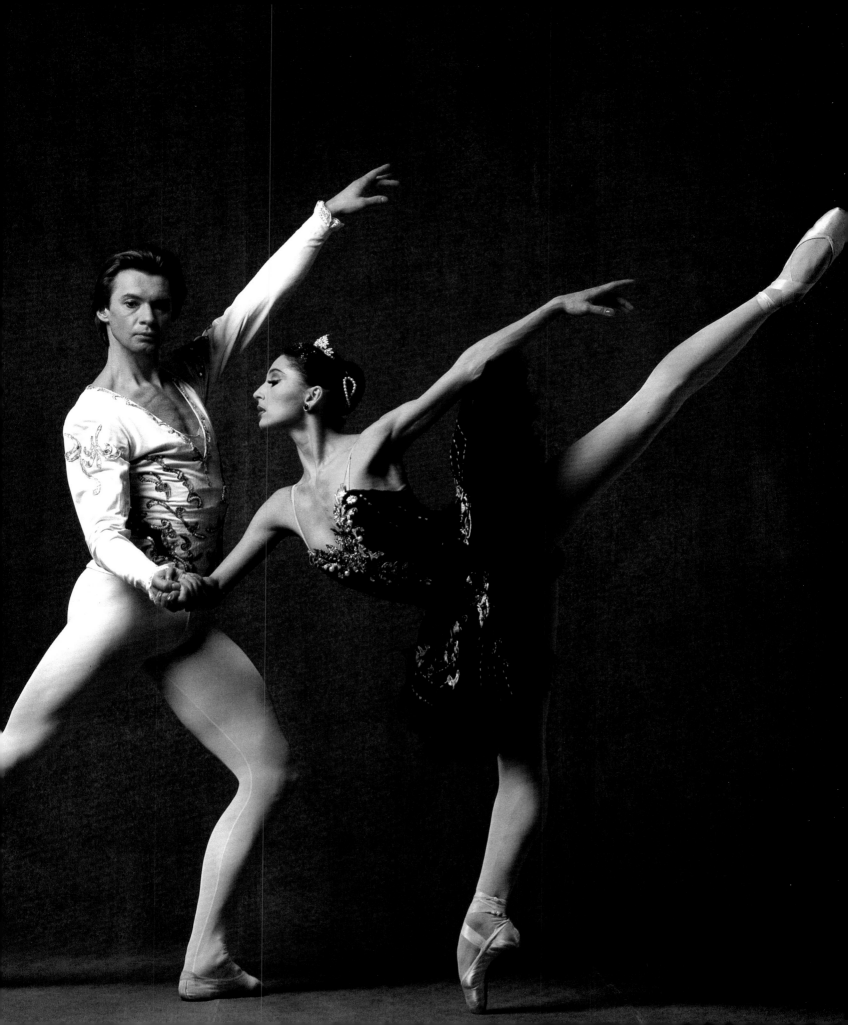

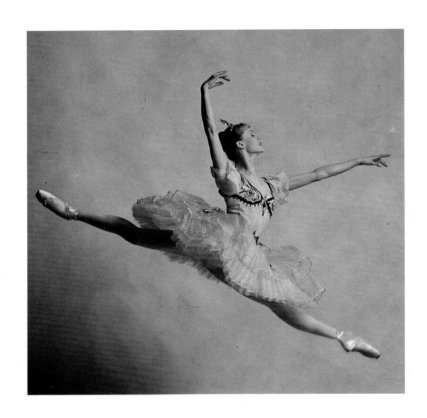

Yelena Pankova as Gulnara, *Le Corsaire*, The Kirov Ballet, 1990

Olga Likhovskaya, A Principal, *Les Sylphides*, The Kirov Ballet, 1990

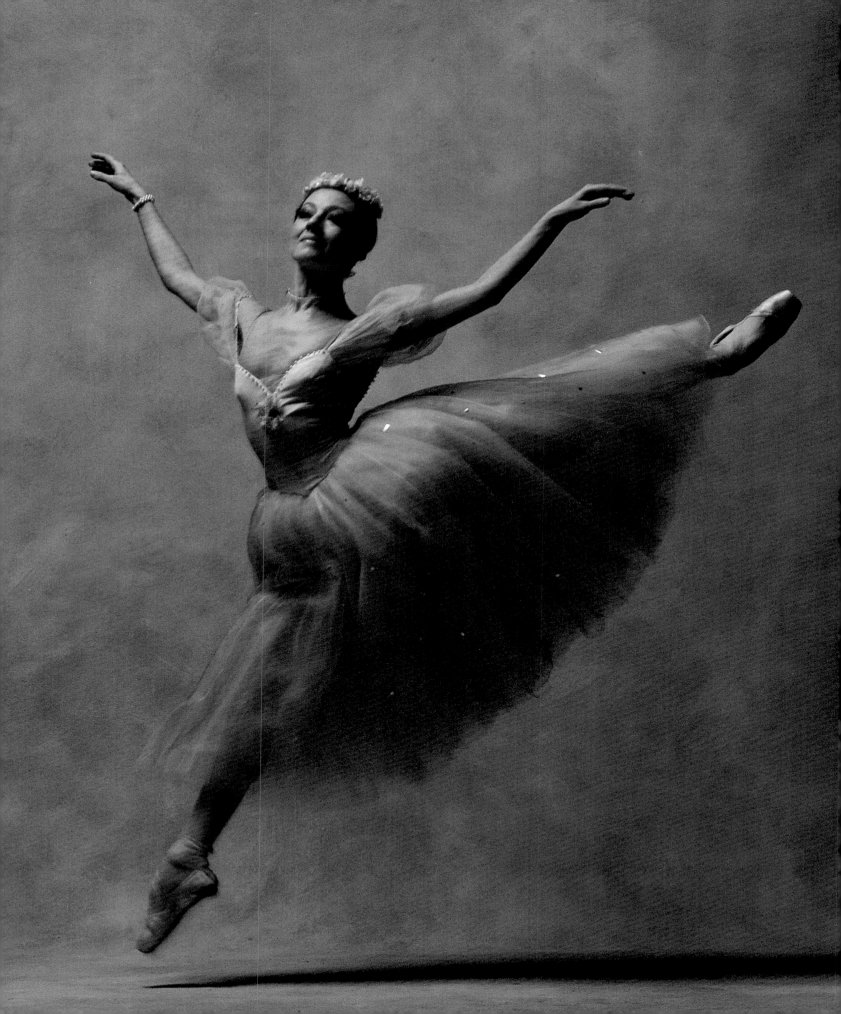

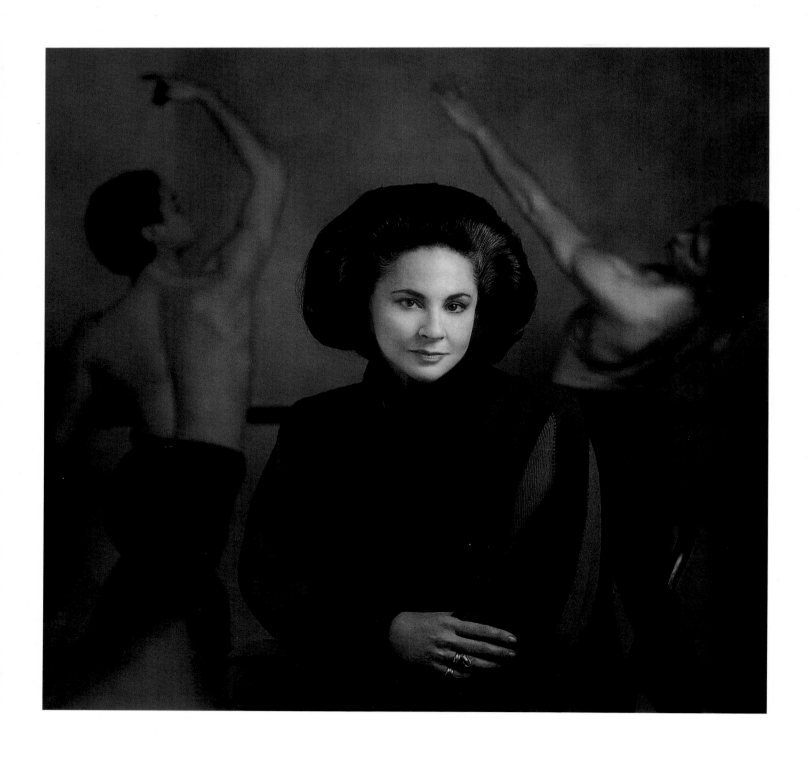

Pamela, Lady Harlech, Chairman of the English National Ballet, with Junior Soloists **Seth Gilbert** and **Paul Jenner**, 1990

Michael Clark, Dancer and Choreographer, with a Saluki, 1987

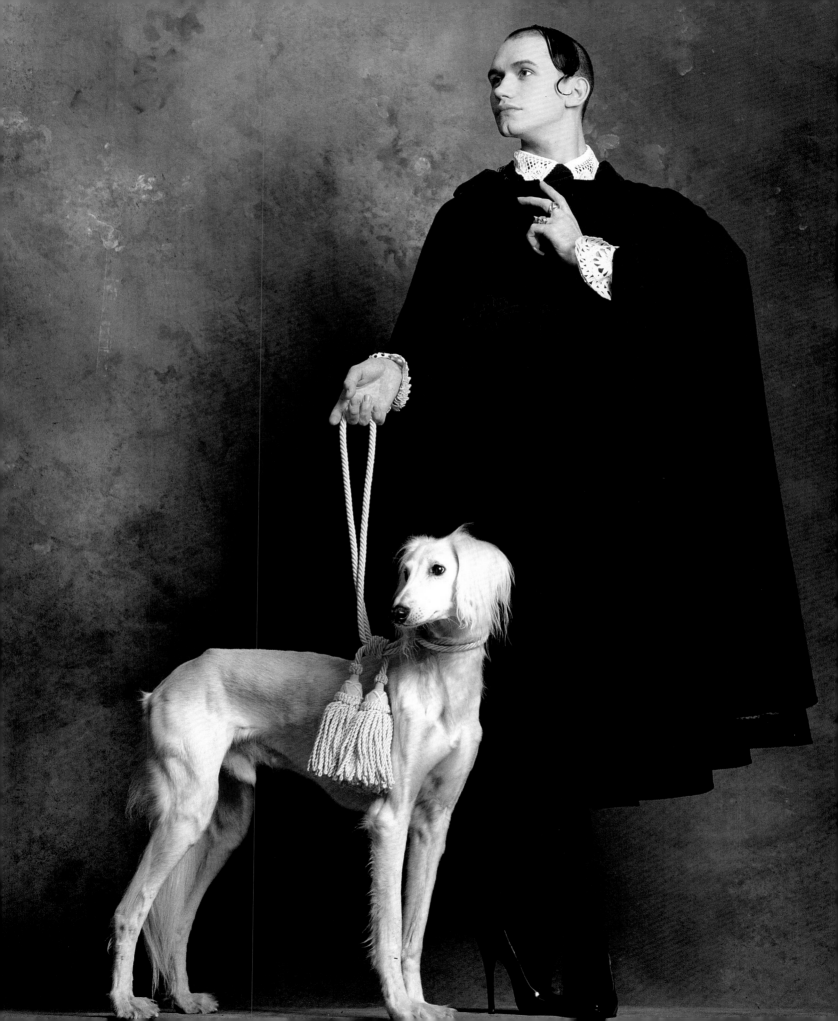

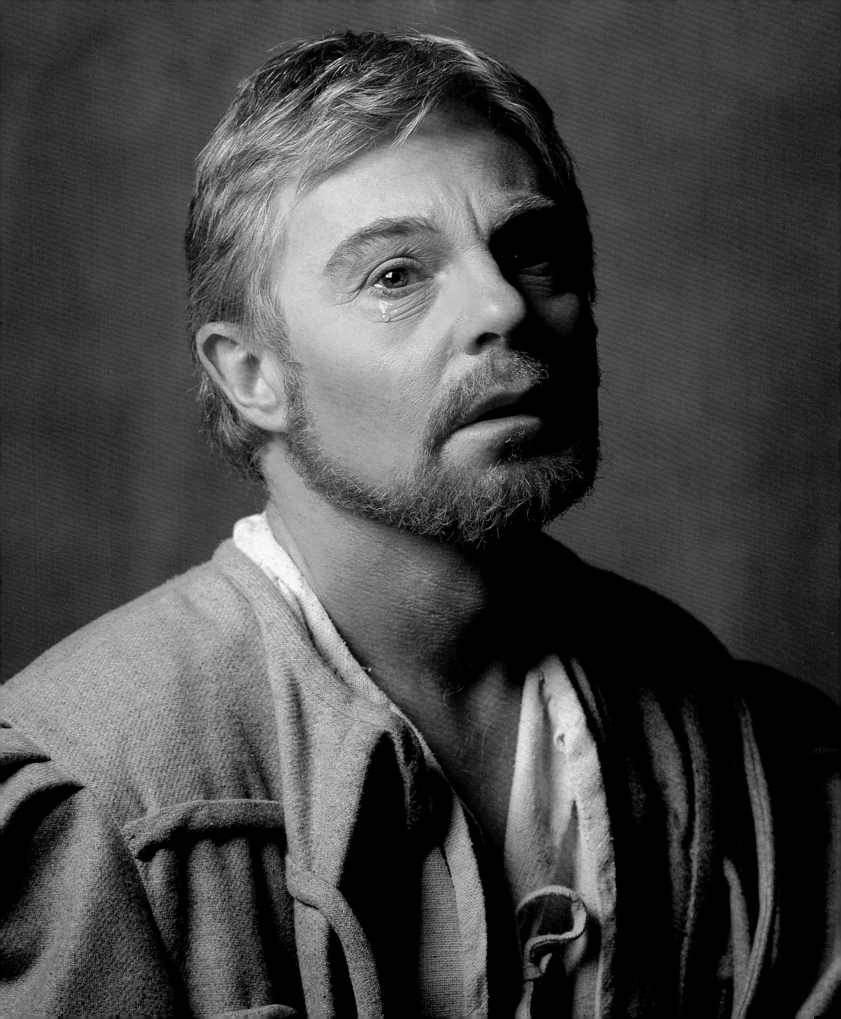

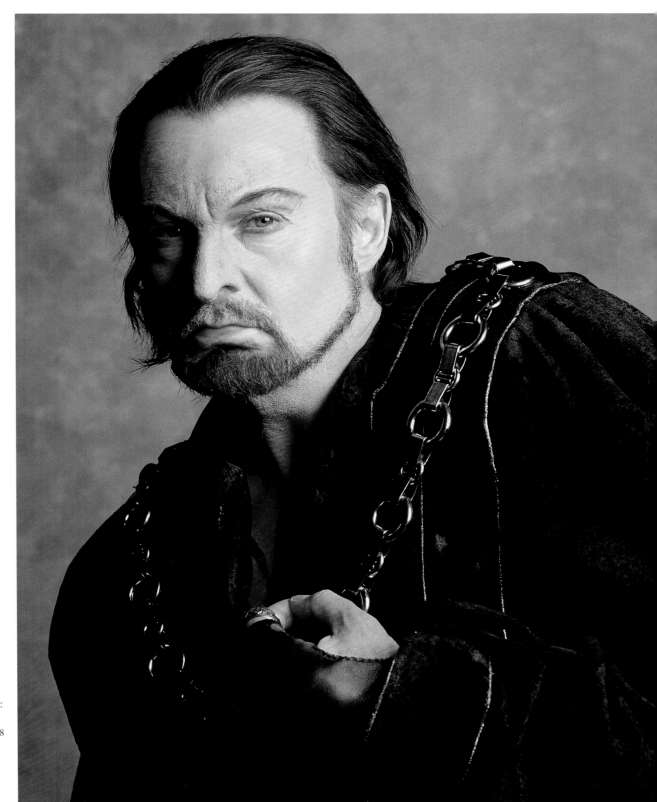

Richard II and Richard III:
Derek Jacobi, Directed
by Clifford Williams, 1988

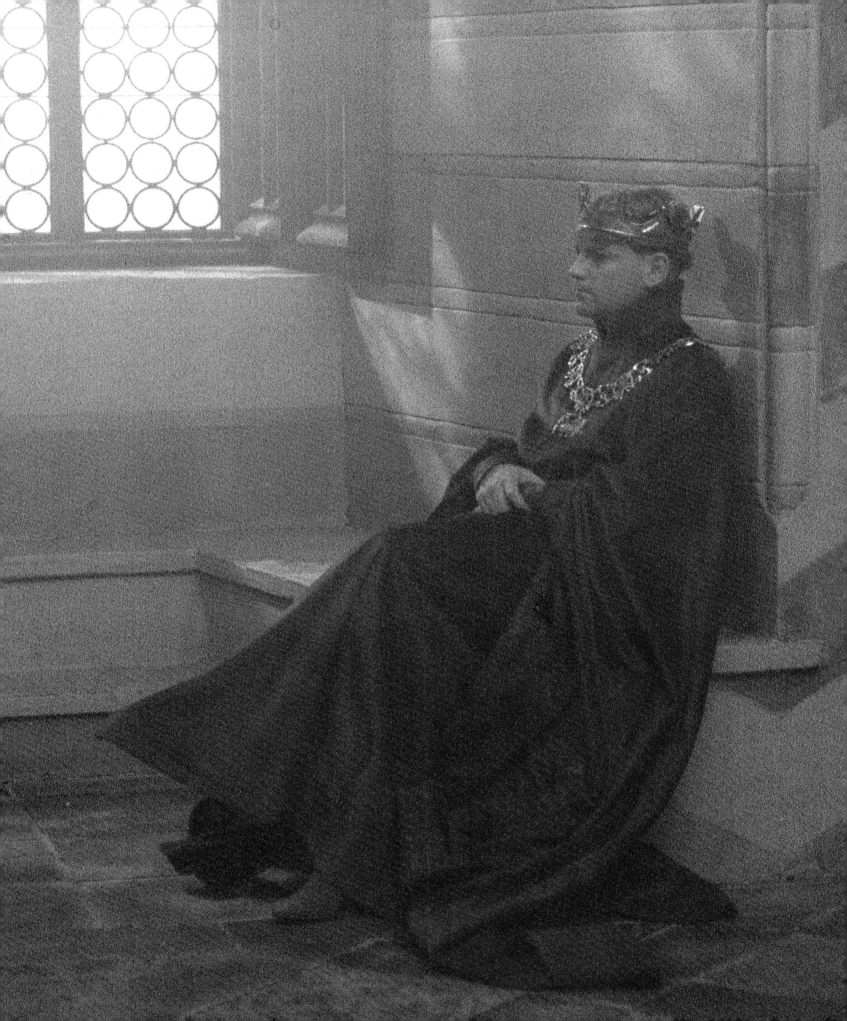

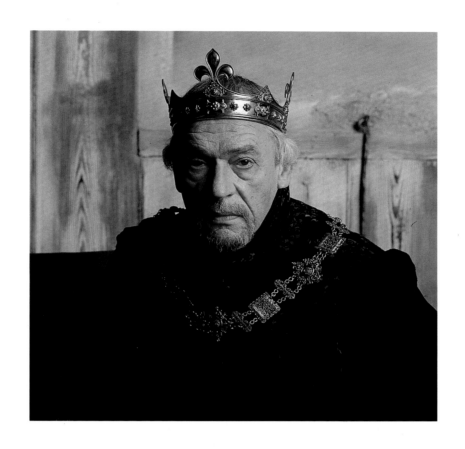

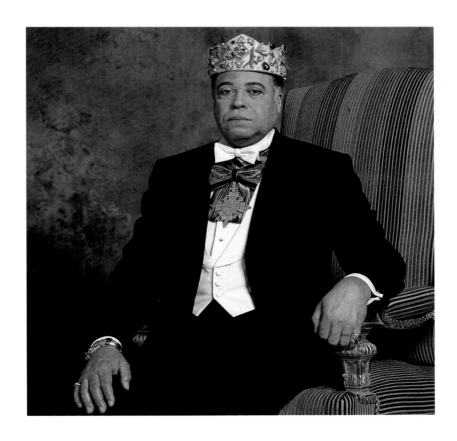

Henry V, Played
and Directed by
Kenneth Branagh,
Filmed at Shepperton
Studios, 1988

Charles VI of France:
Paul Scofield in the
same Production, 1988

King of Zamunda:
James Earl-Jones in
Coming to America,
a Paramount
Production, 1988

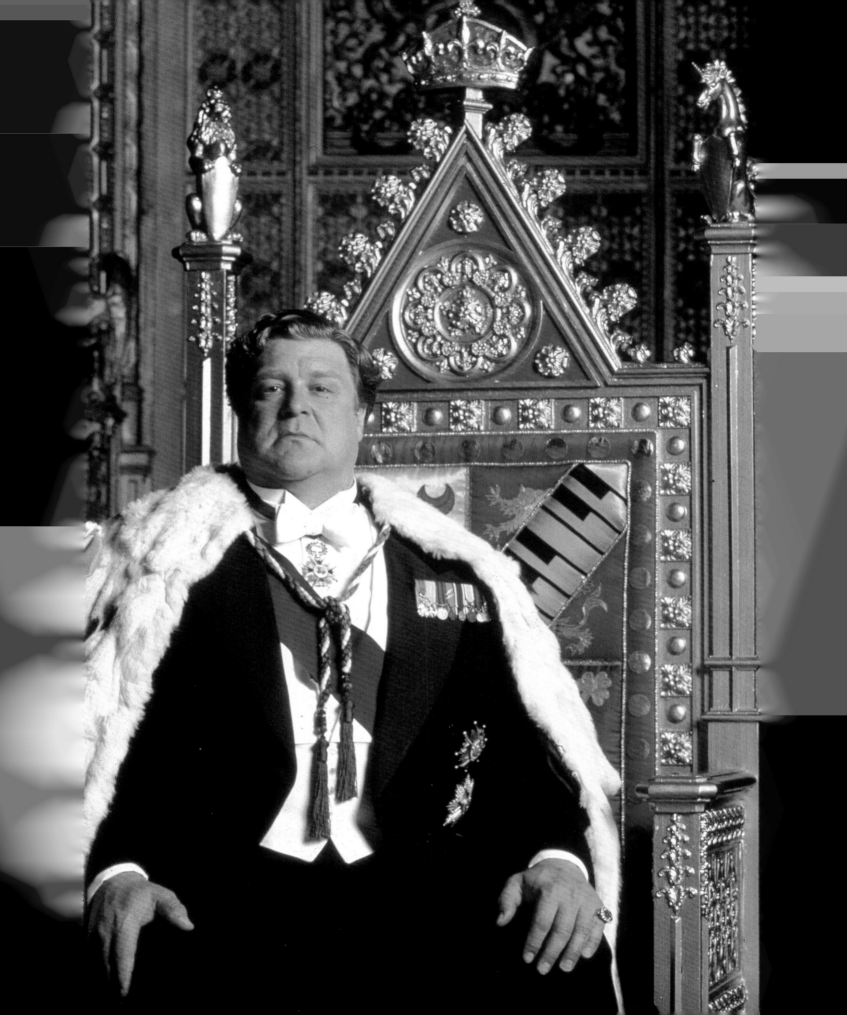

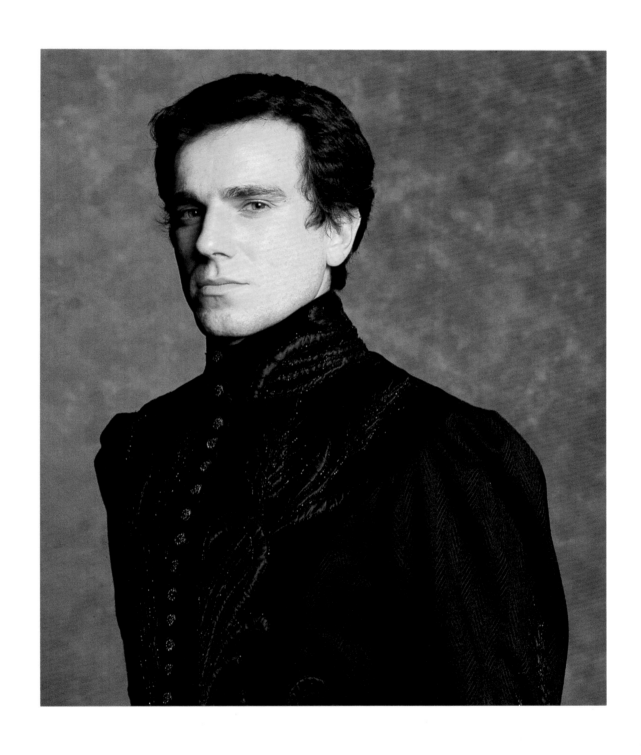

King Ralph: **John Goodman**, Pinewood Studios, 1990

Hamlet: **Daniel Day-Lewis**, Directed by Richard Eyre, The National Theatre, 1989

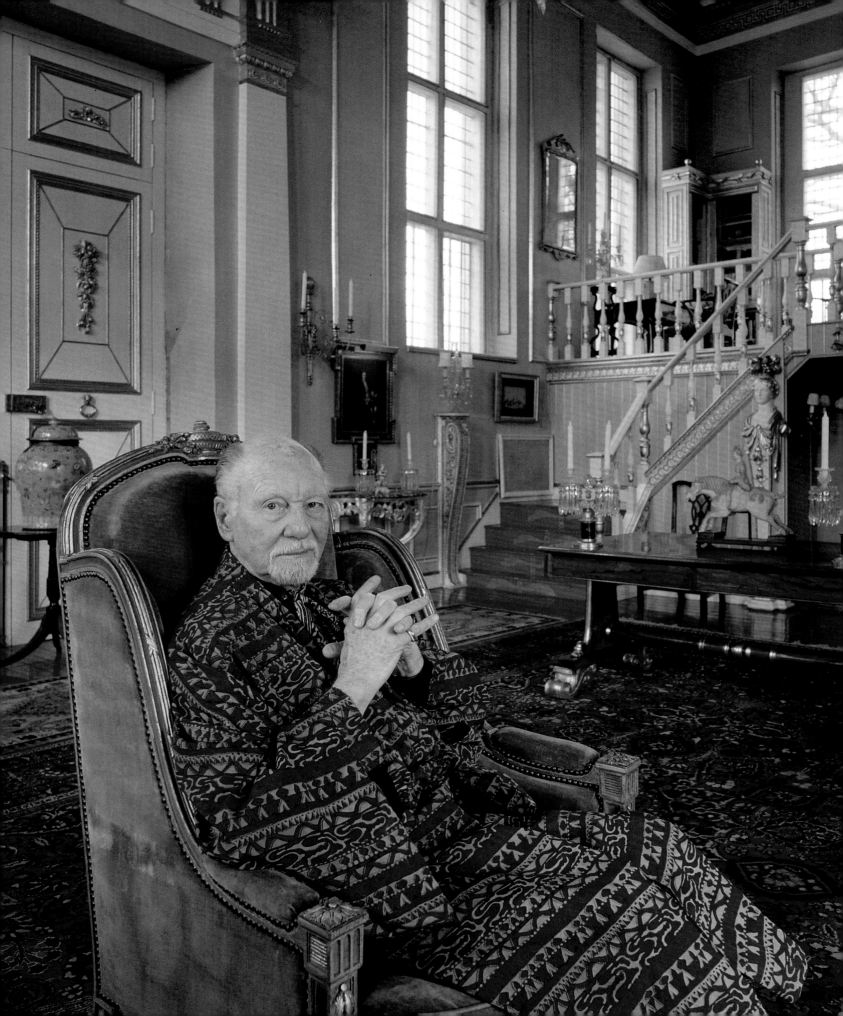

Sir John Gielgud at home, 1988

Dame Wendy Hiller and **Patrick McGoohan**
in *The Best of Friends* by Hugh Whitemore. Directed
by Alvin Rakoff, 1991

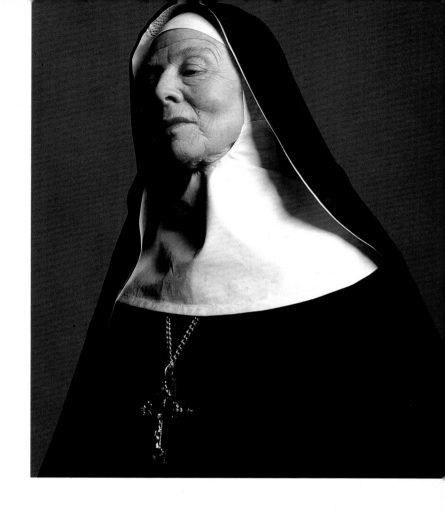

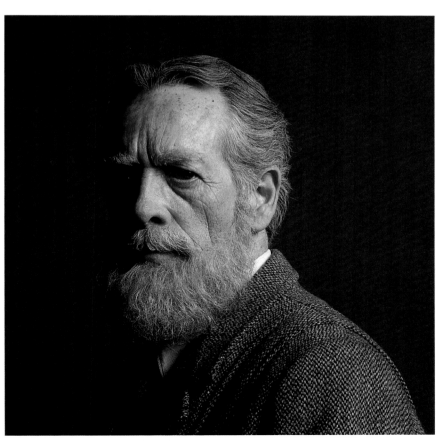

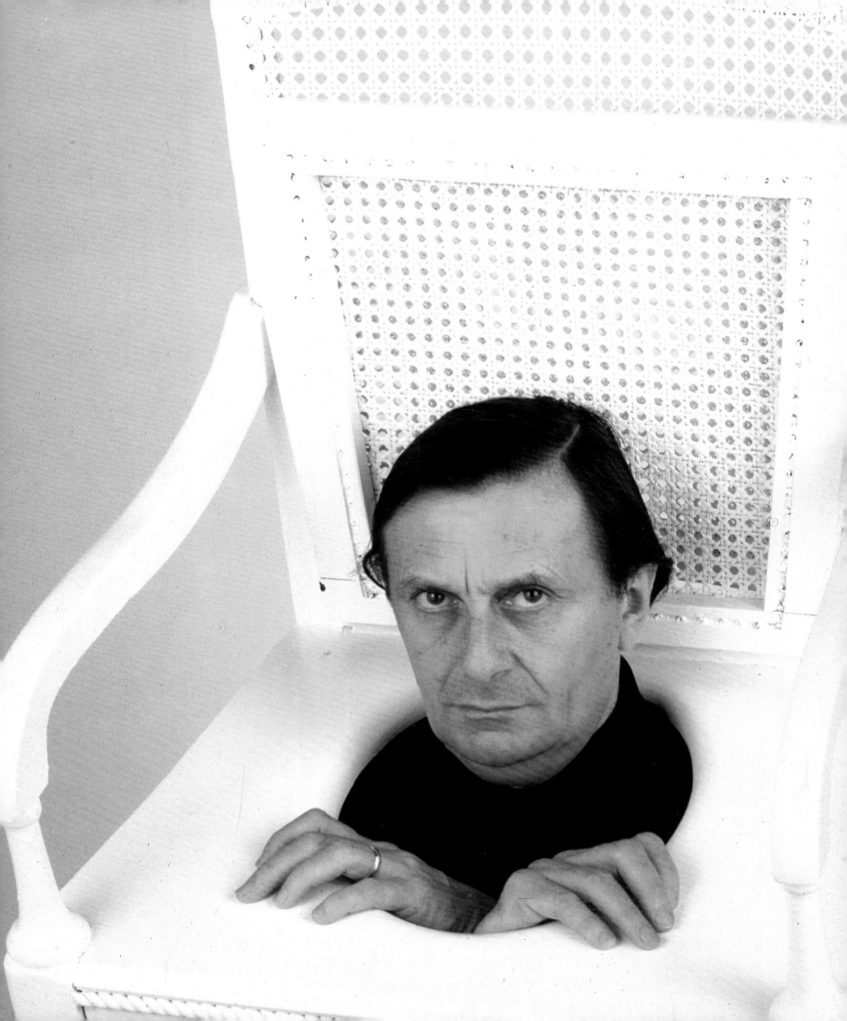

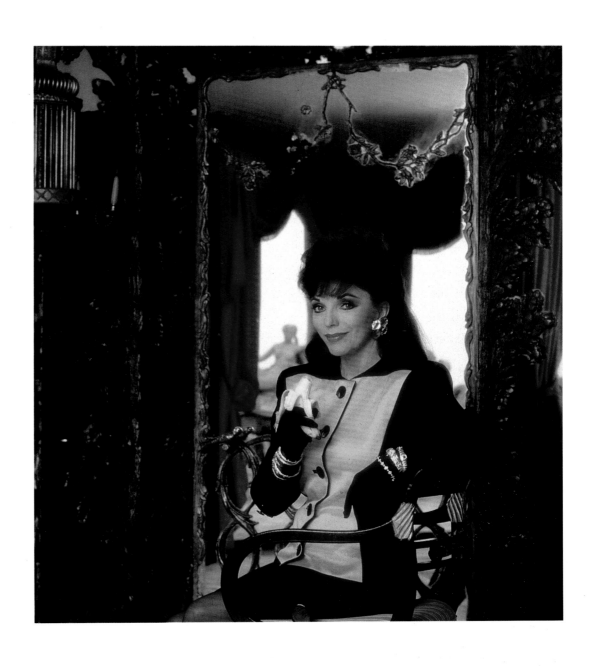

Barry Humphries, 1987

Joan Collins in the Oliver Messel Suite,
The Dorchester, 1988

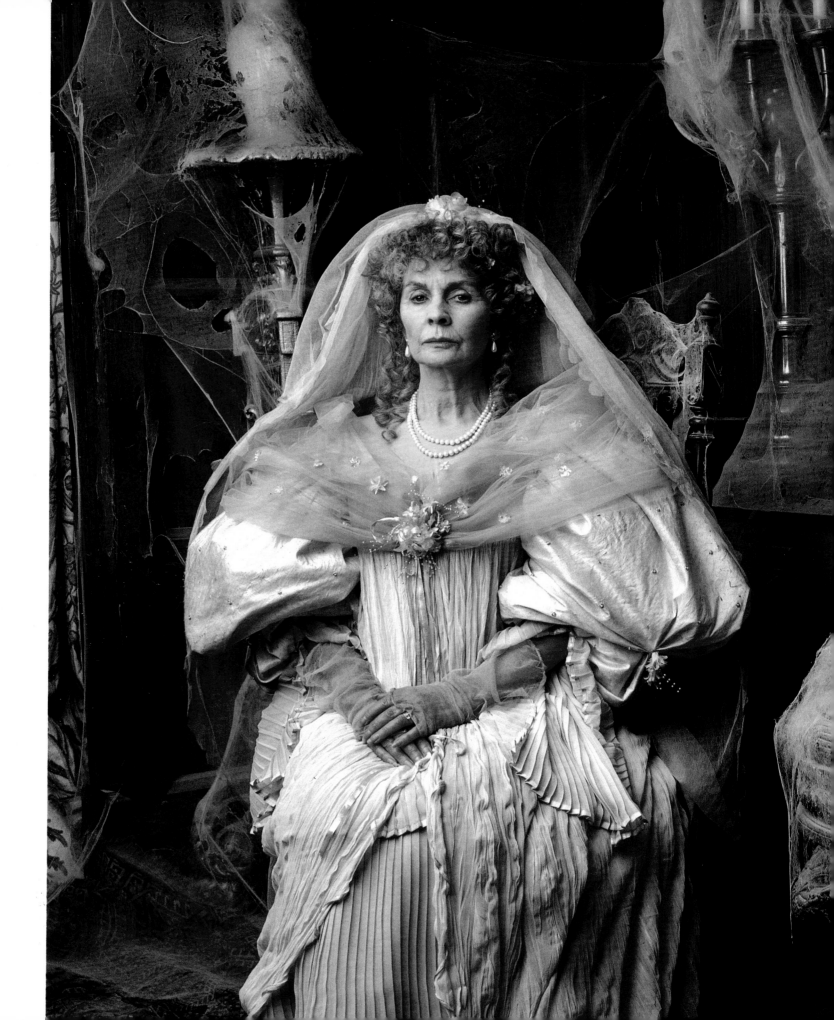

Jean Simmons as Miss Haversham in *Great Expectations*.
Directed by Kevin Connor, 1988

43

Audrey Hepburn in the Garden at Hidcote Manor, Gloucestershire, 1990

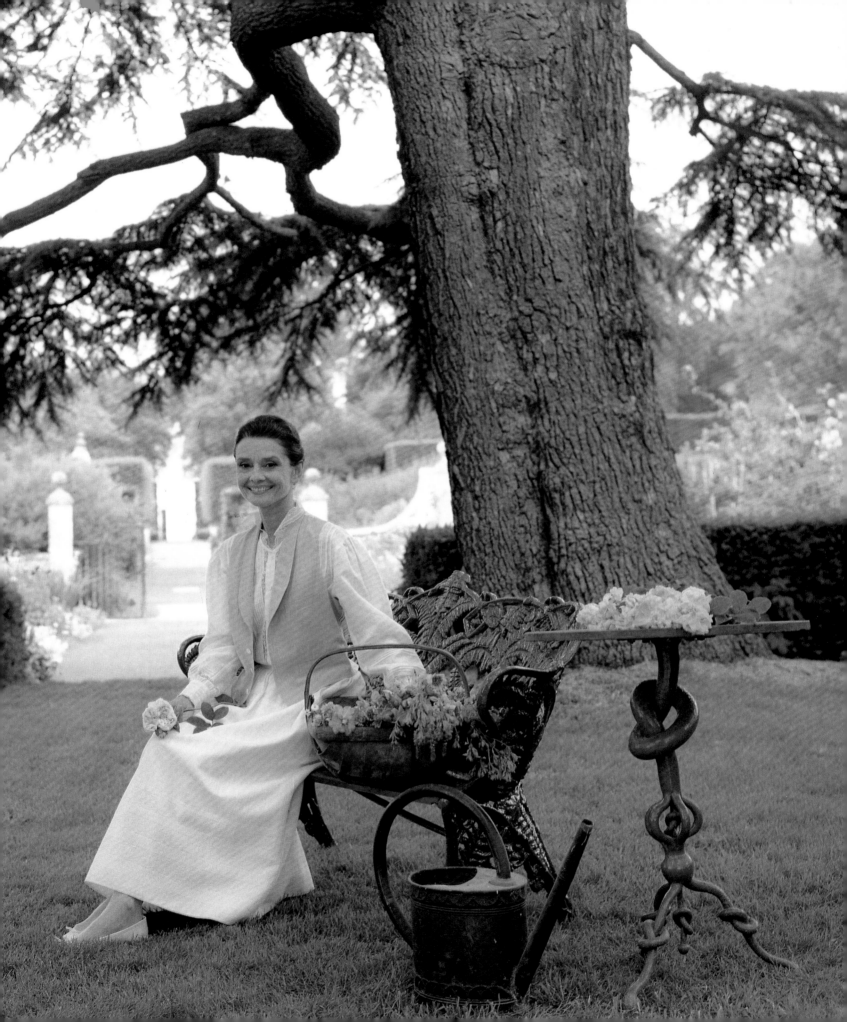

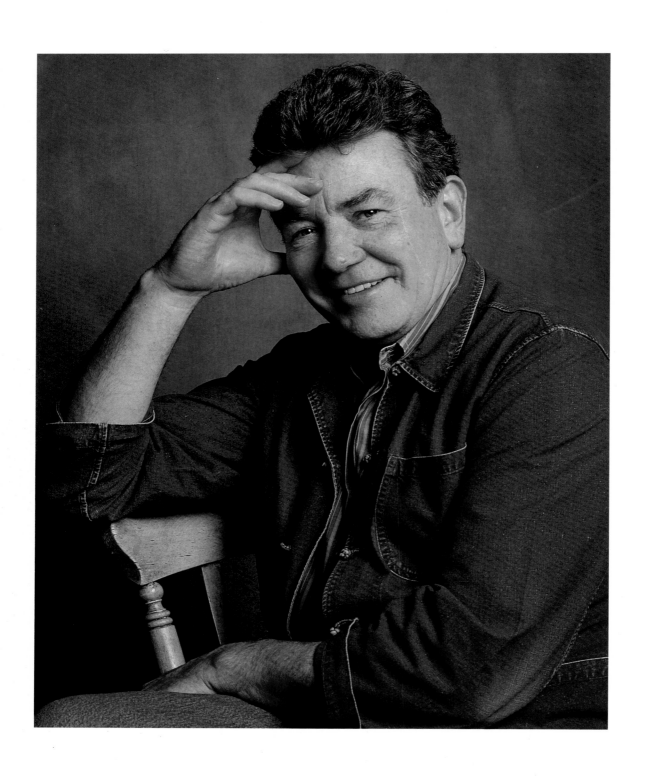

Albert Finney, 1990

Sir Ian McKellen, 1991

46

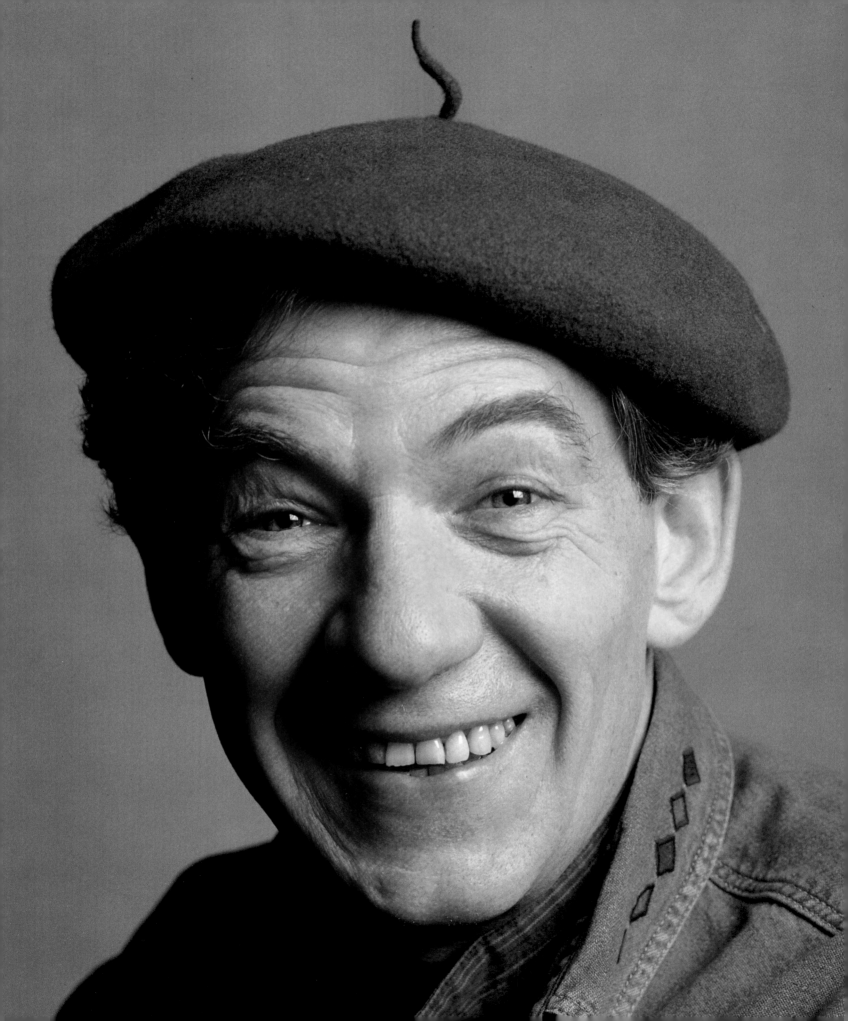

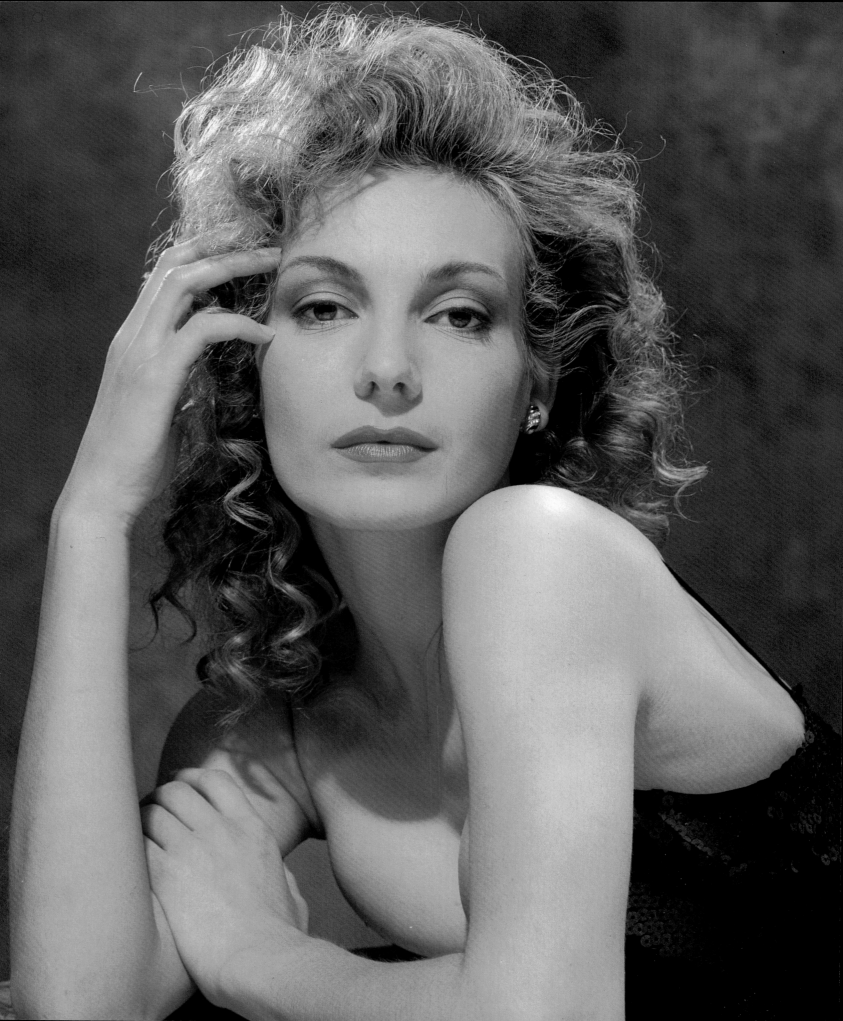

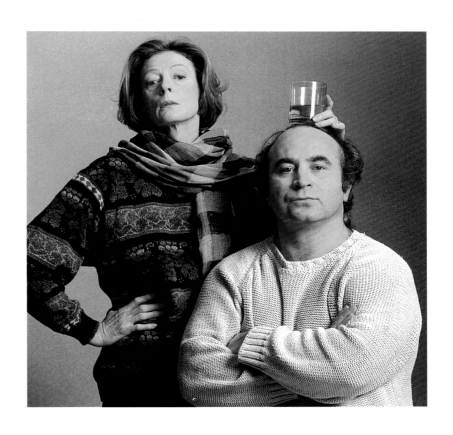

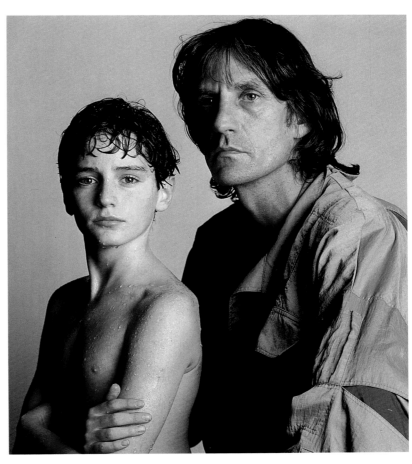

Ute Lemper, Singer, 1989

Dame Maggie Smith and Bob Hoskins
starred in *The Lonely Passion of Judith Hearne*, 1989

Andrew Birkin, Writer and Director
of *Burning Secrets* with David Edberts, 1988

Dirk Bogarde, Cover for *A Particular Friendship*, 1989

Sir Michael Hordern, rehearsing *Bookends*.
Directed by Ned Sherrin, 1990

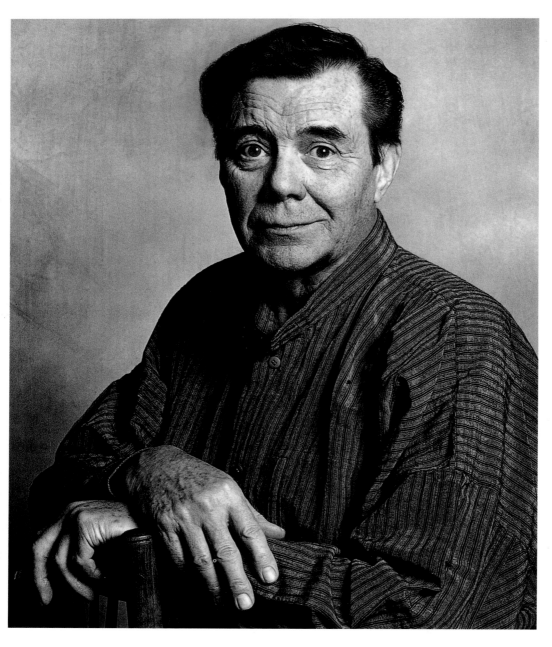

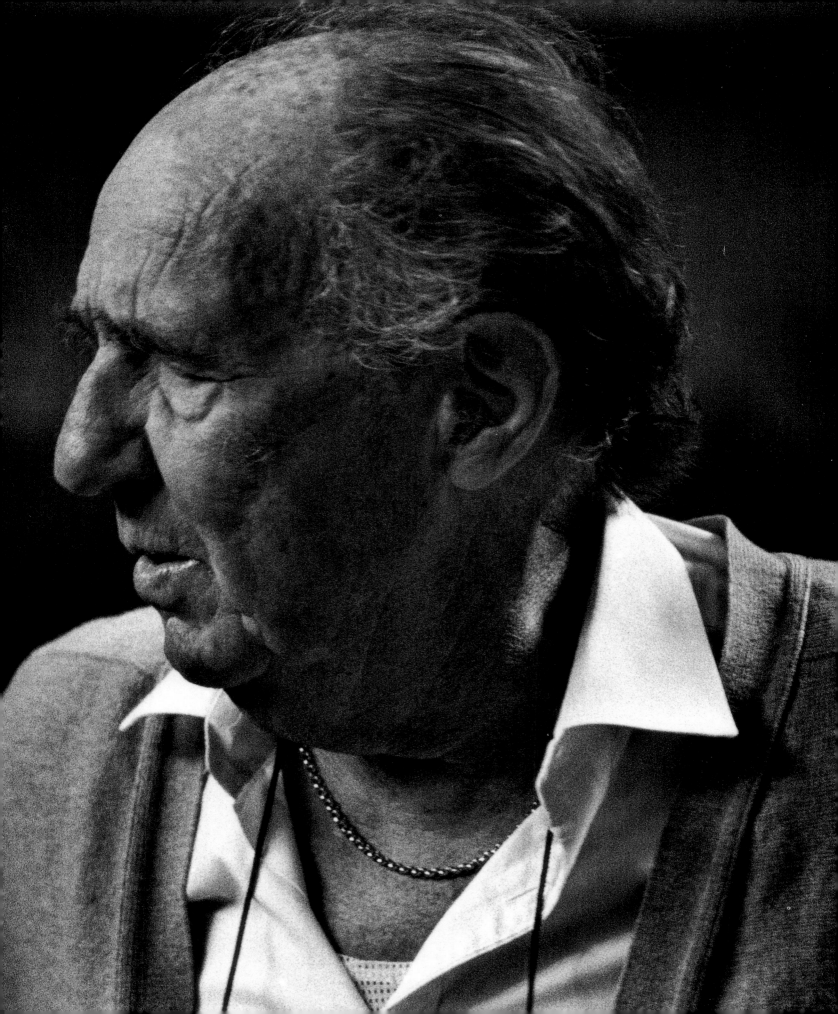

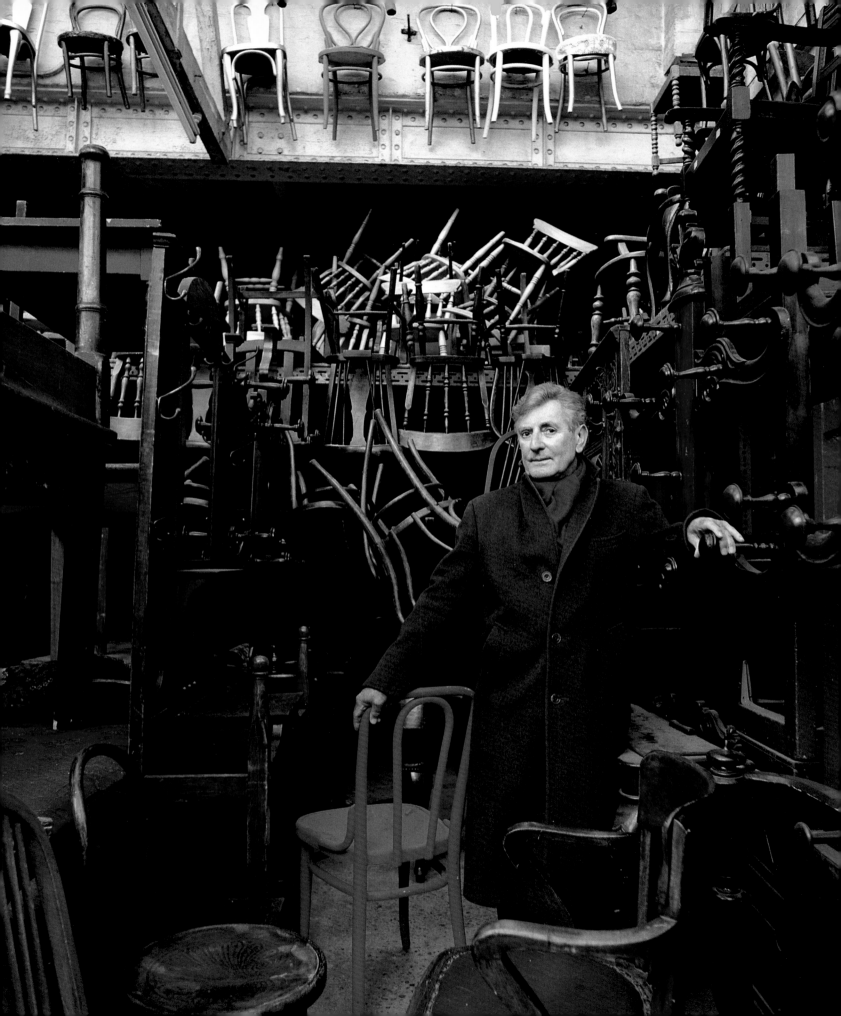

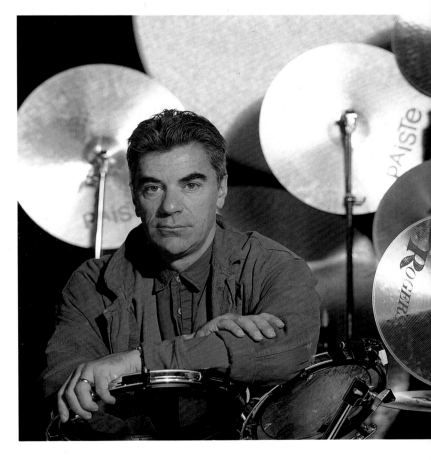

Theatre Designers, 1990

Carl Toms

William Dudley

John Napier

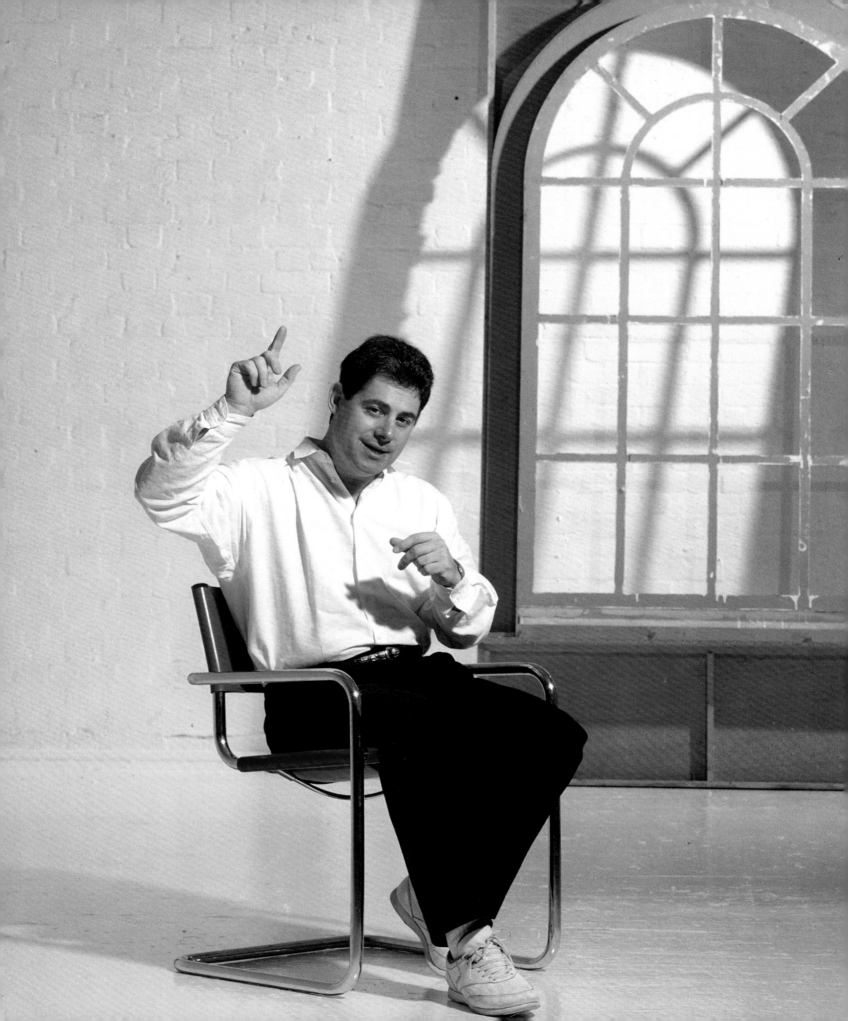

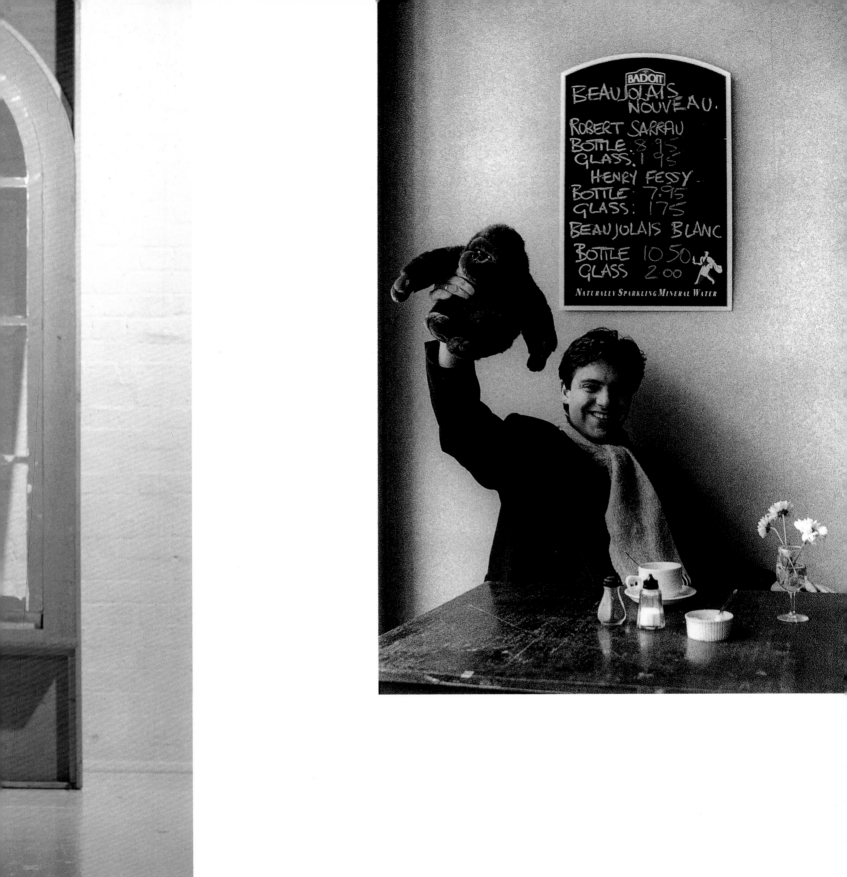

Cameron Mackintosh, Producer, 1990

Sam Mendes, Director, 1990

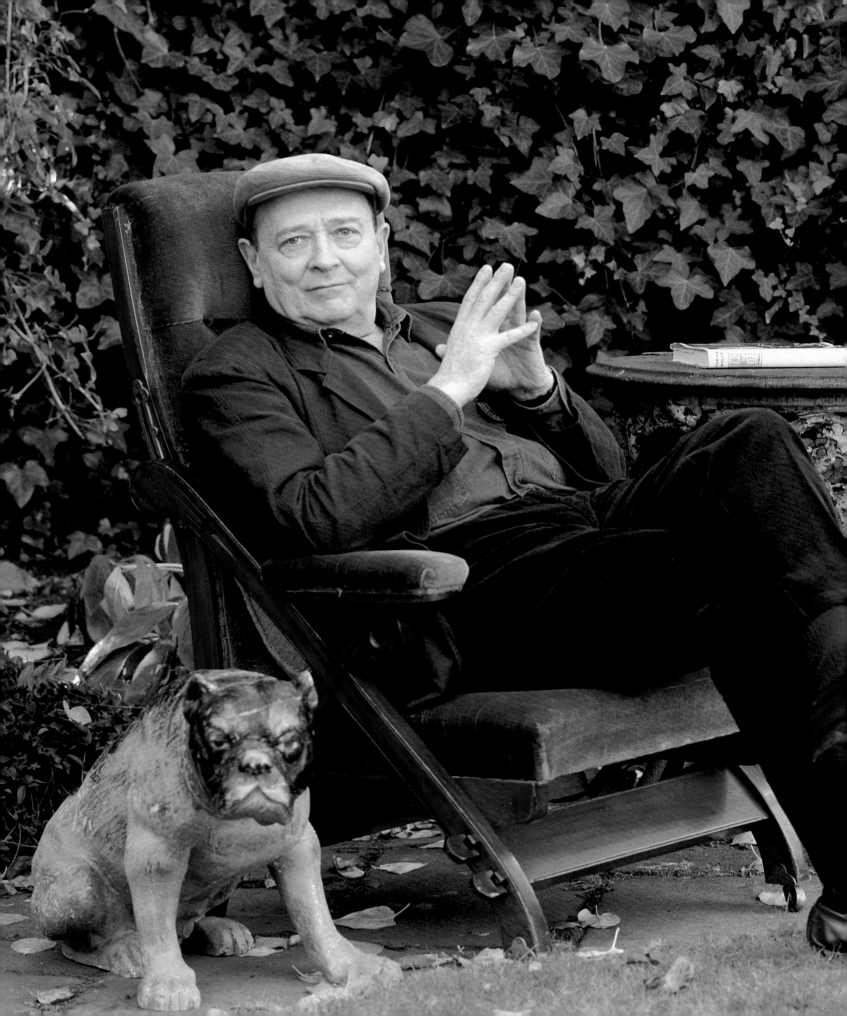

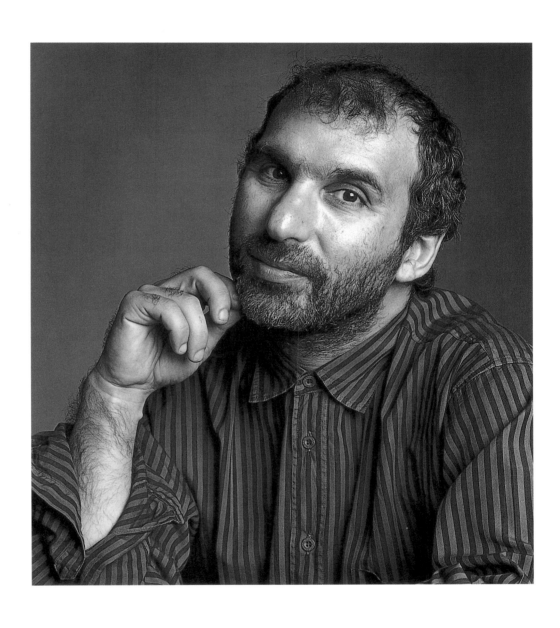

Karel Reisz, Film Director, 1990

Alan Yentob, Controller of BBC2, 1988

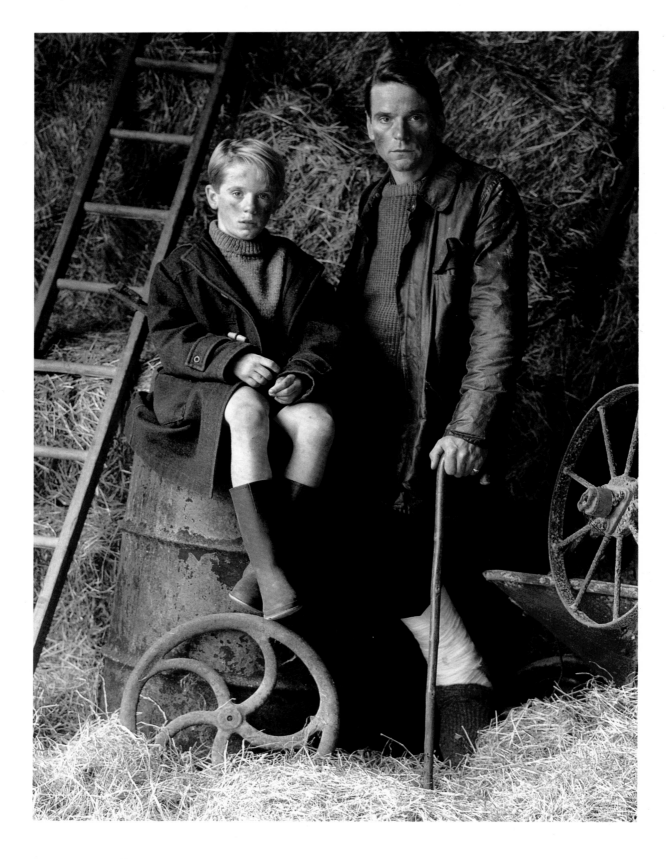

Jeremy Irons and his son **Sam**, in *Danny The Champion of The World* by Roald Dahl, 1988

Roald Dahl, 1988

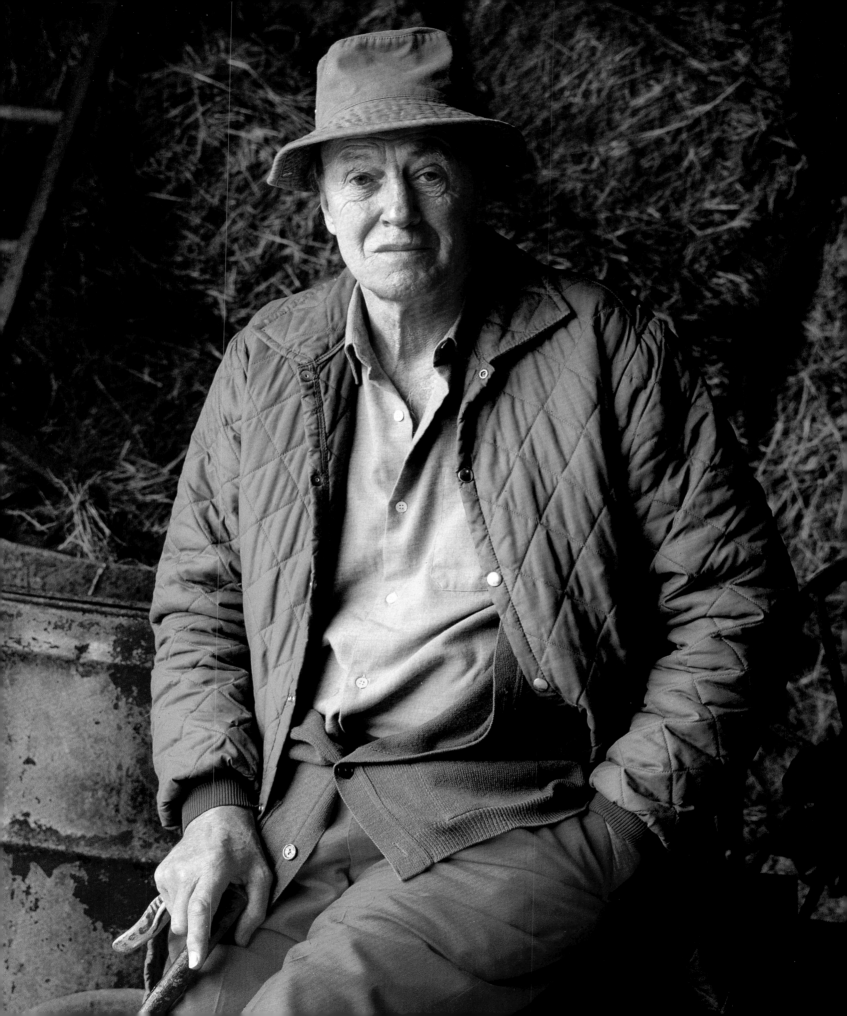

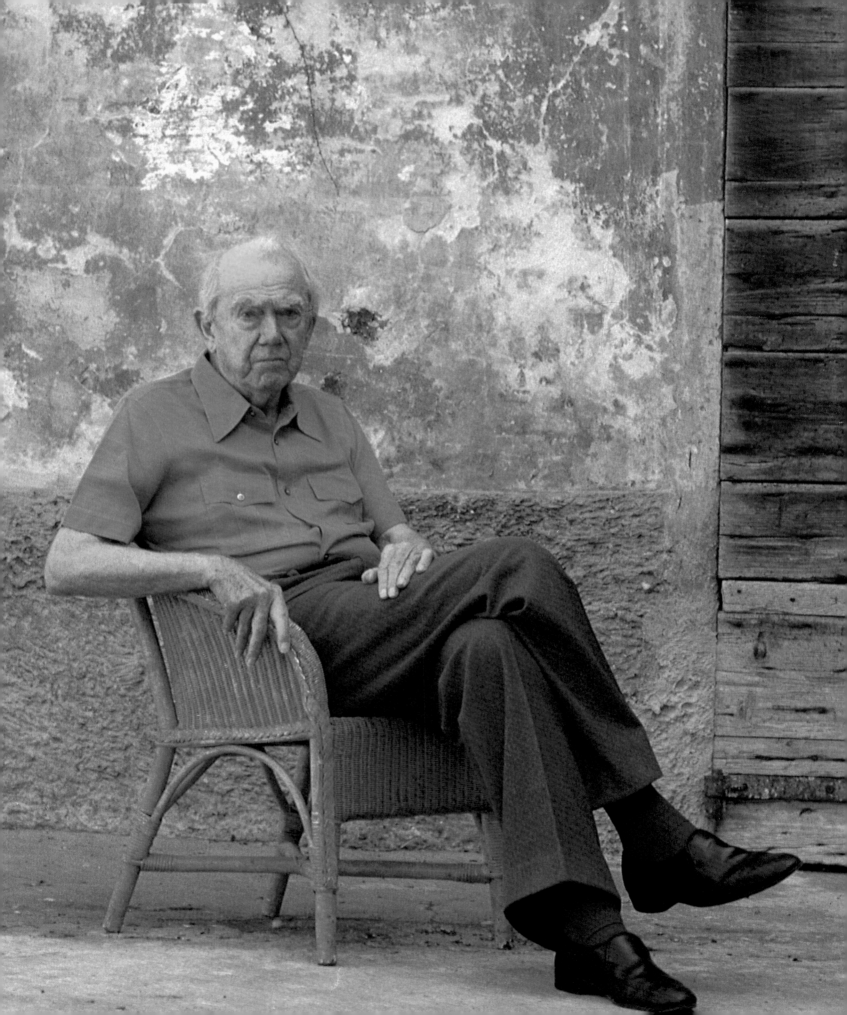

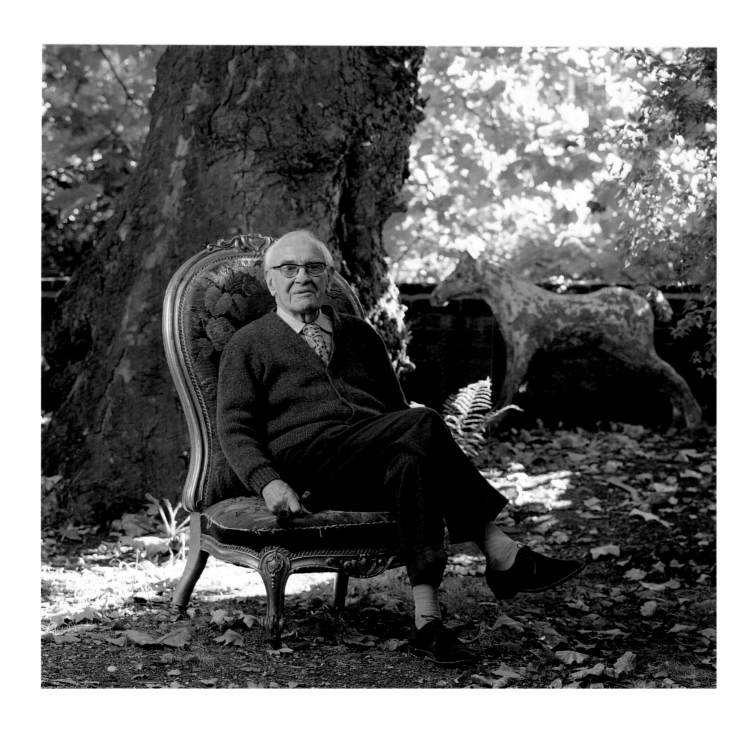

V. S. Pritchett, aged Ninety, in his Garden, 1990

Graham Greene, Cap d'Antibes, 1988

Sybille Bedford, Author, 1989

Harold Pinter, Playwright, 1990

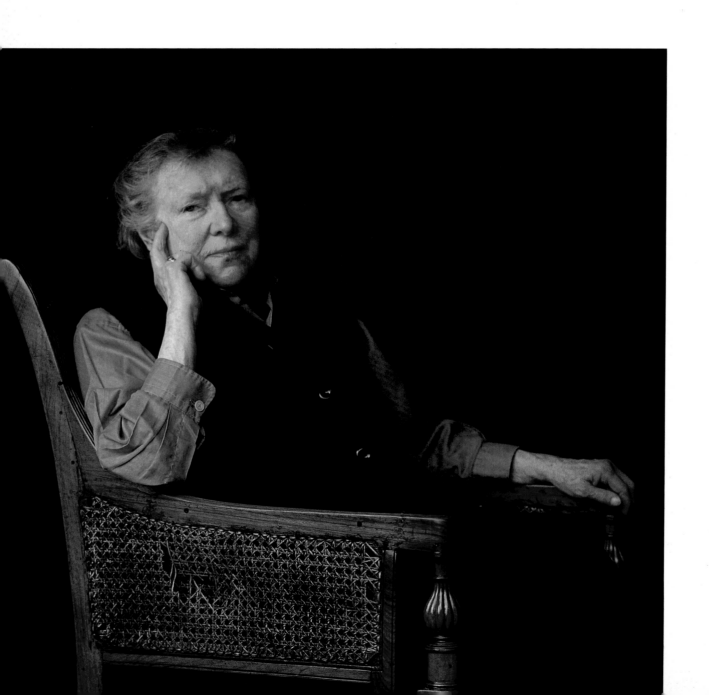

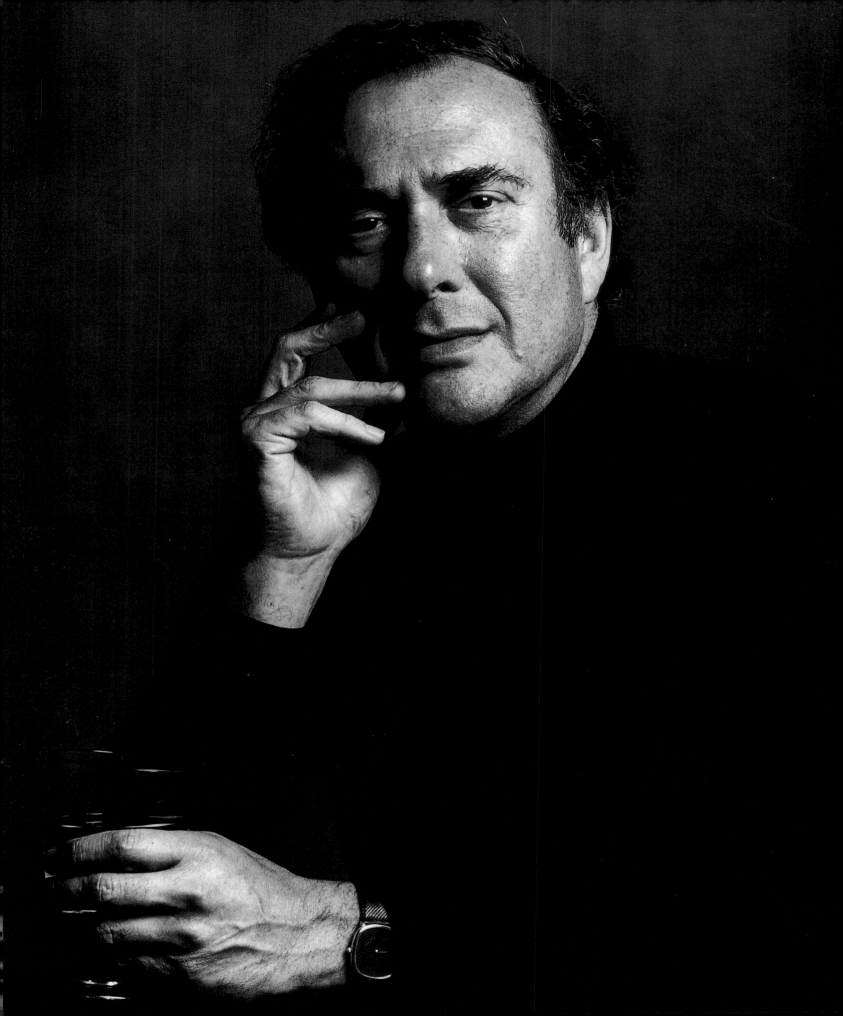

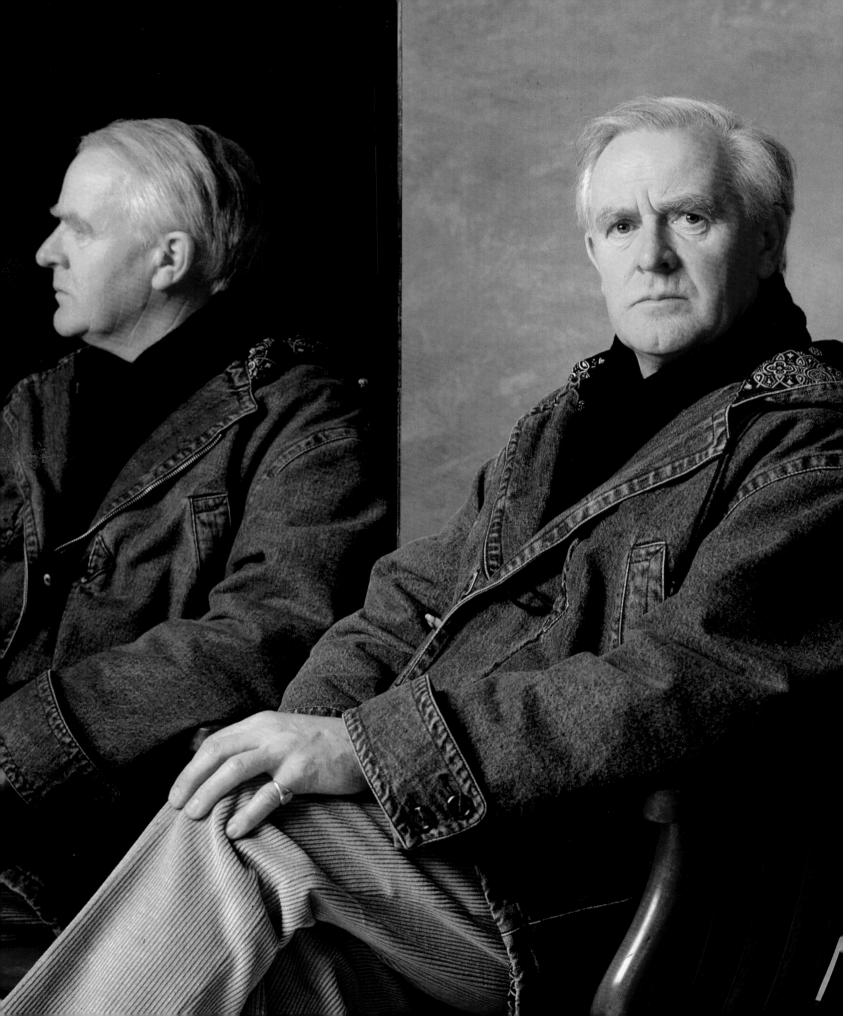

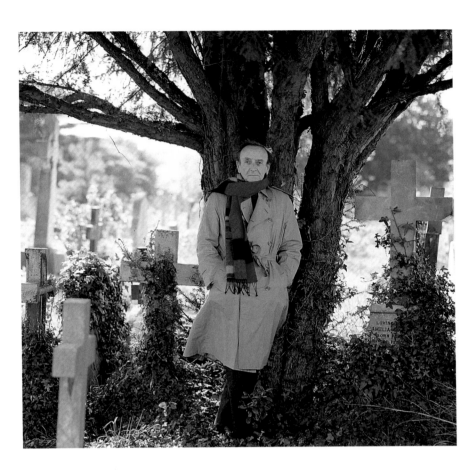

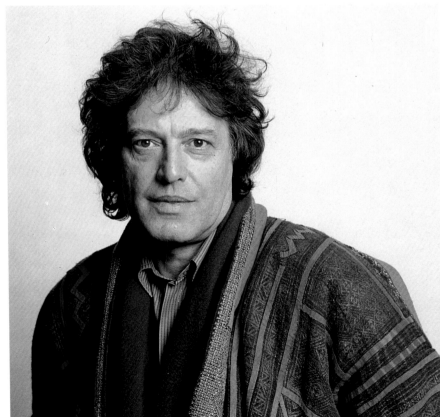

David Cornwell, alias John le Carré,
Spy Novelist, 1989

Brian Moore, Irish Novelist, 1990

Tom Stoppard, Playwright, 1990

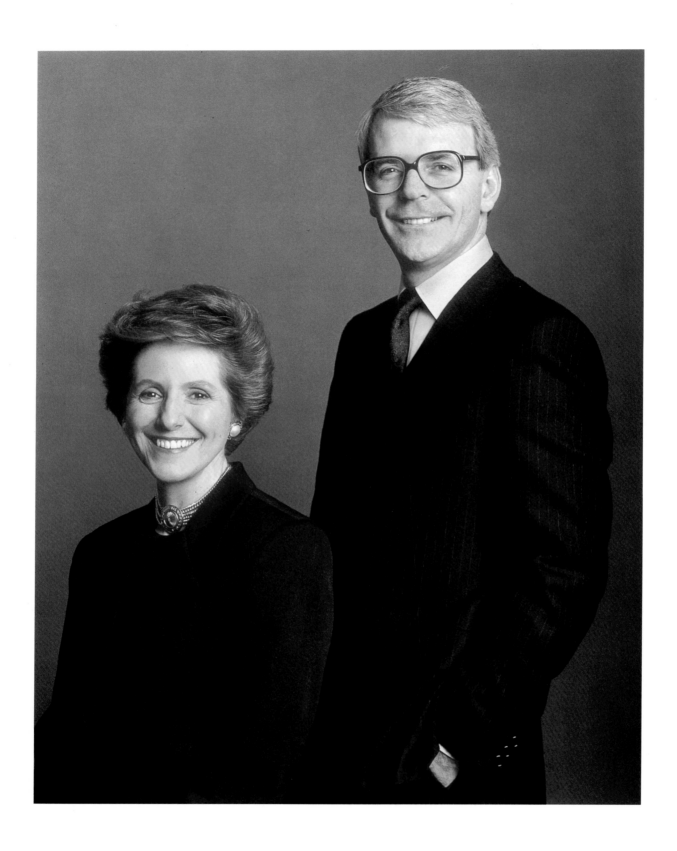

The Rt. Hon John Major, MP, The Prime Minister, and **Mrs John Major**, Biographer of Joan Sutherland, 1991

Vaclav Havel in Prague Castle; Poet, Playwright and President of Czechoslovakia, 1991

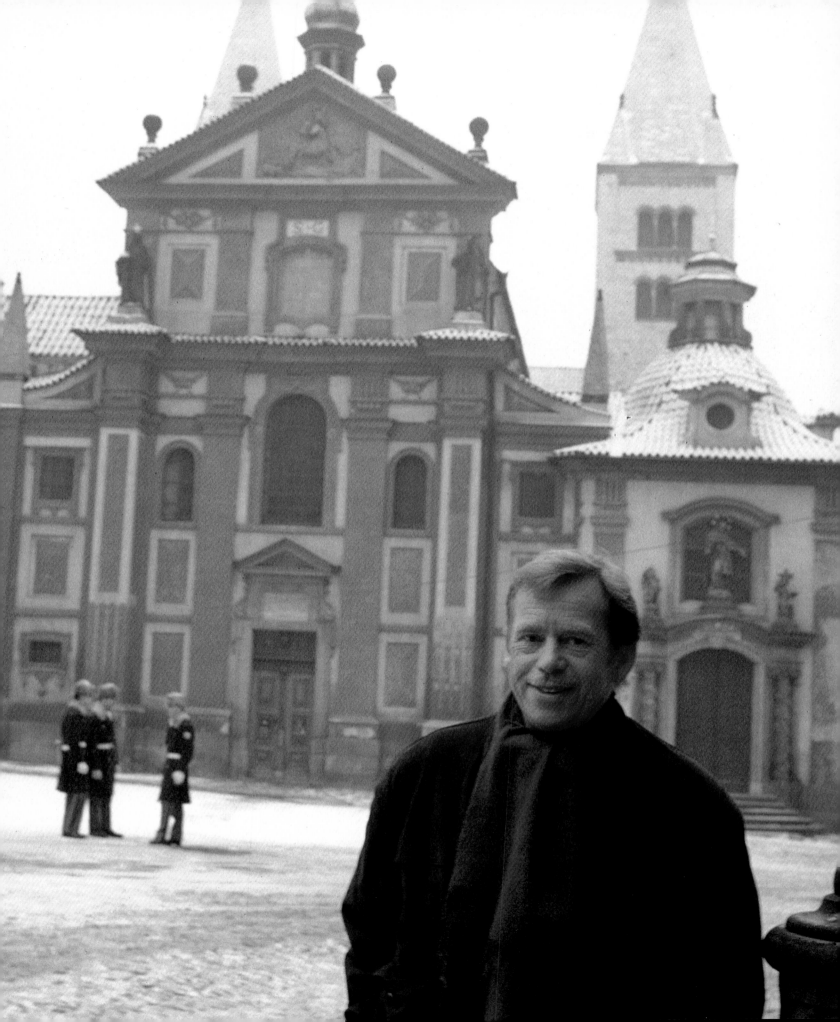

John Osborne, Playwright, 1991

Dame Barbara Cartland,
Author of 540 Romantic Novels, 1988

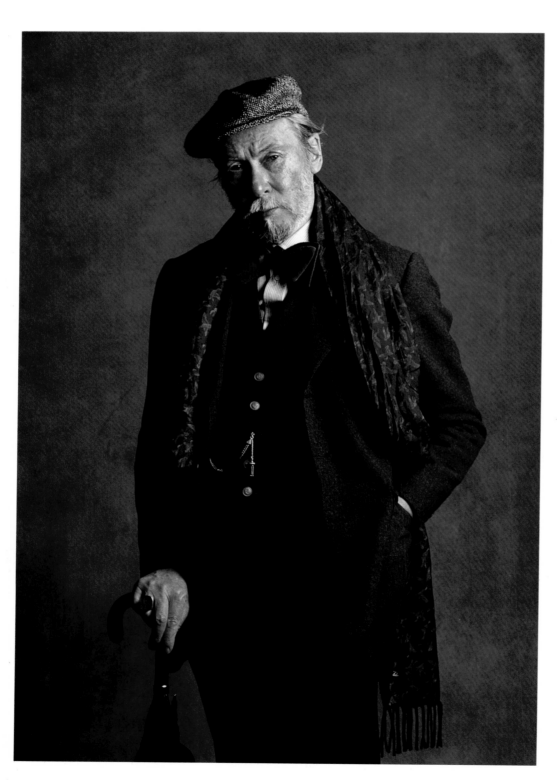

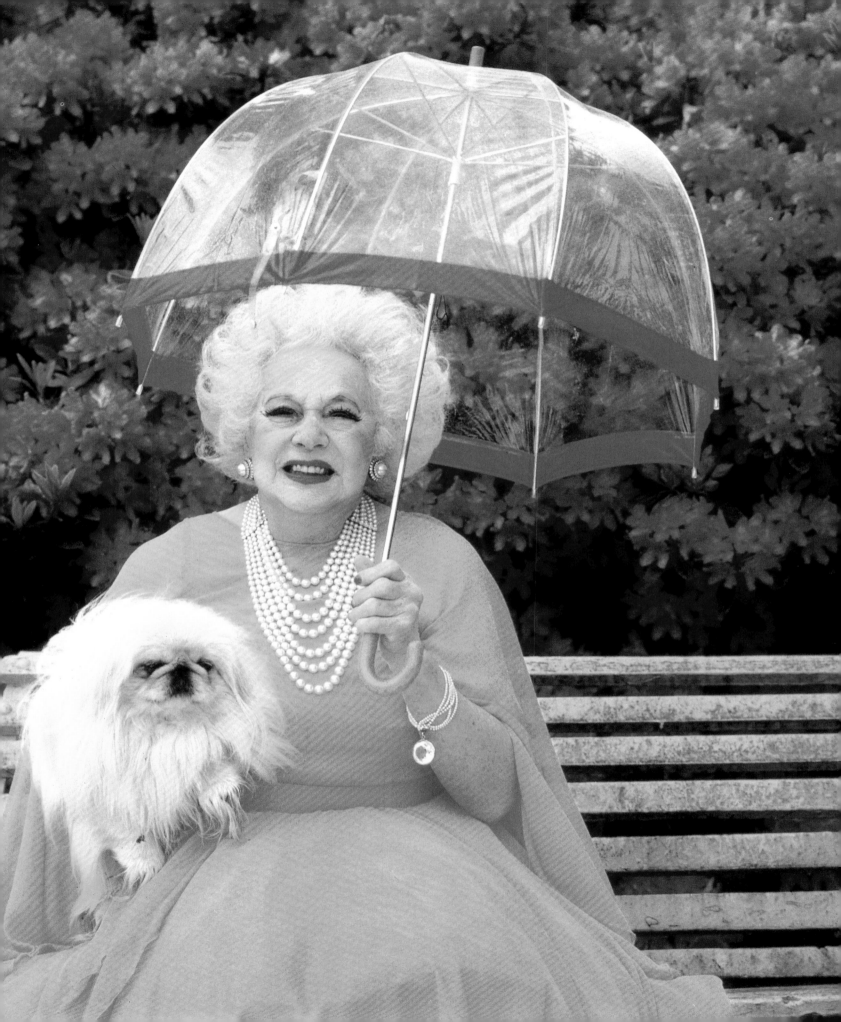

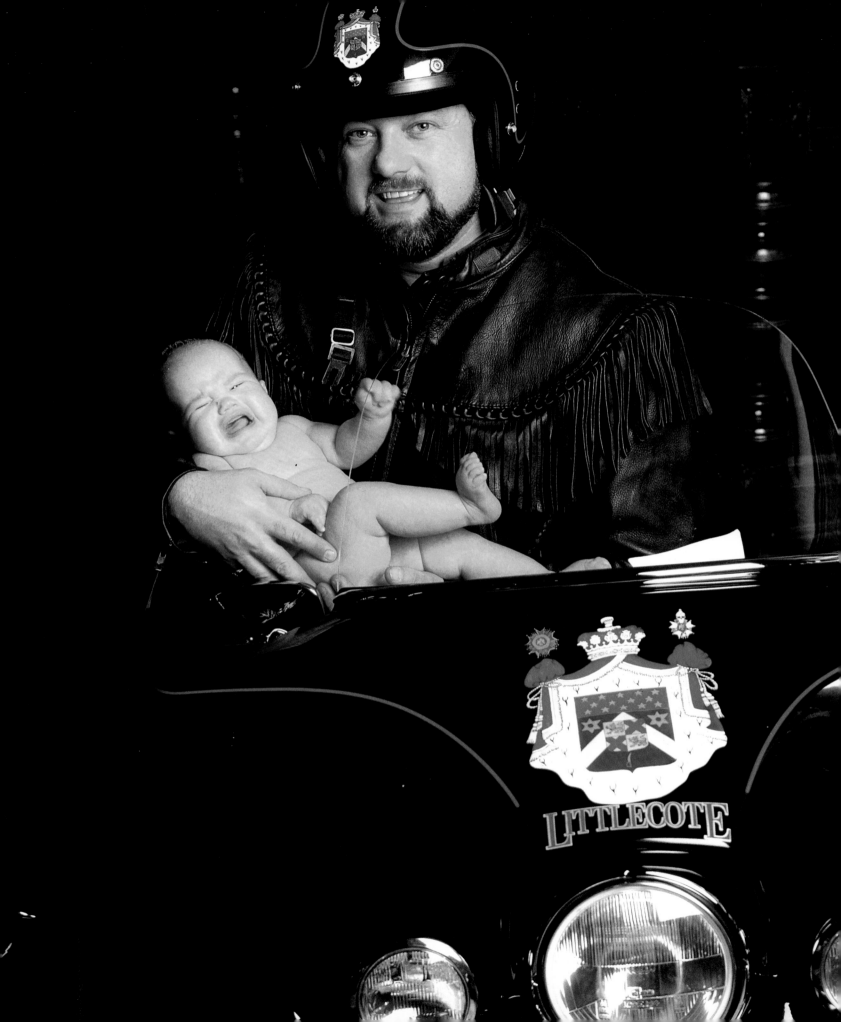

LITTLECOTE

Peter de Savary, Property Developer,
with his Daughter **Amber**, 1988

Germaine Greer and **Placido Domingo**, 1987

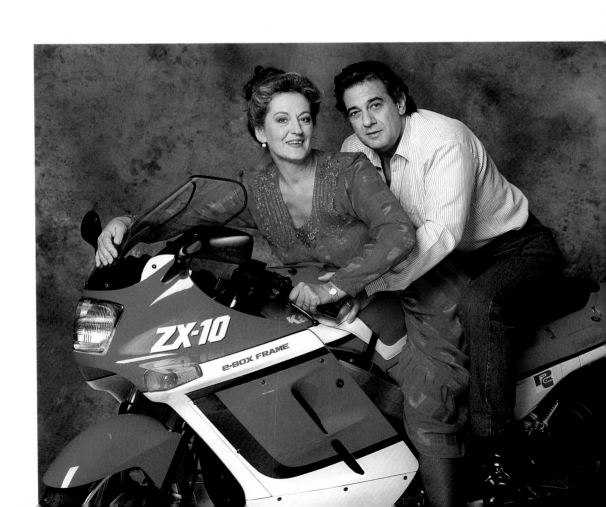

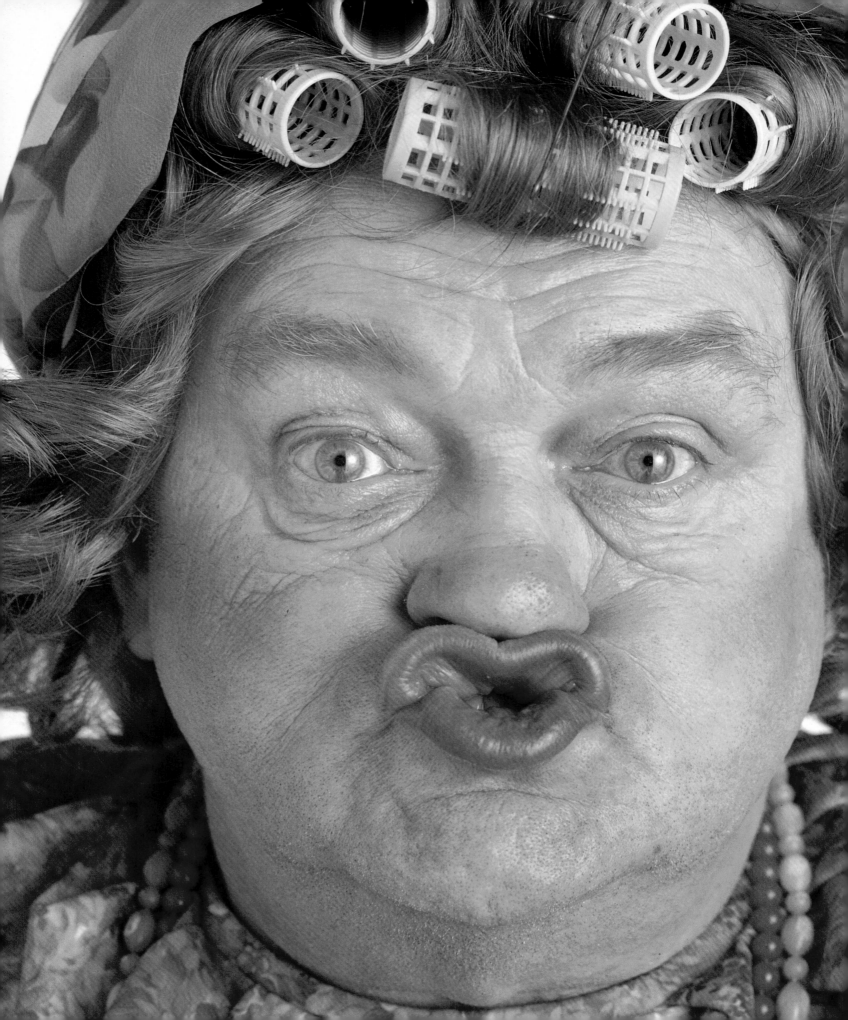

Les Dawson, Comedian, 1991

Elton John, 1989

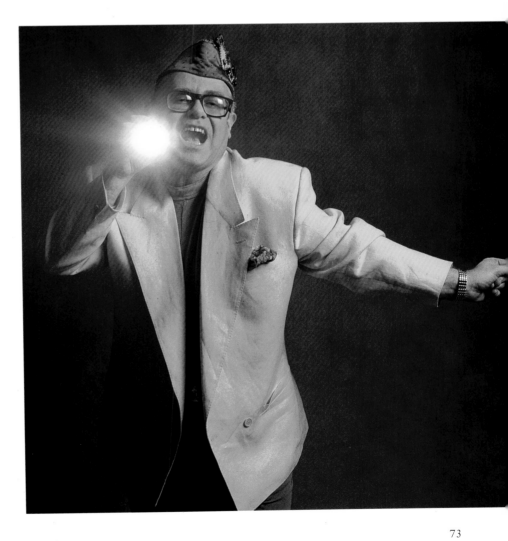

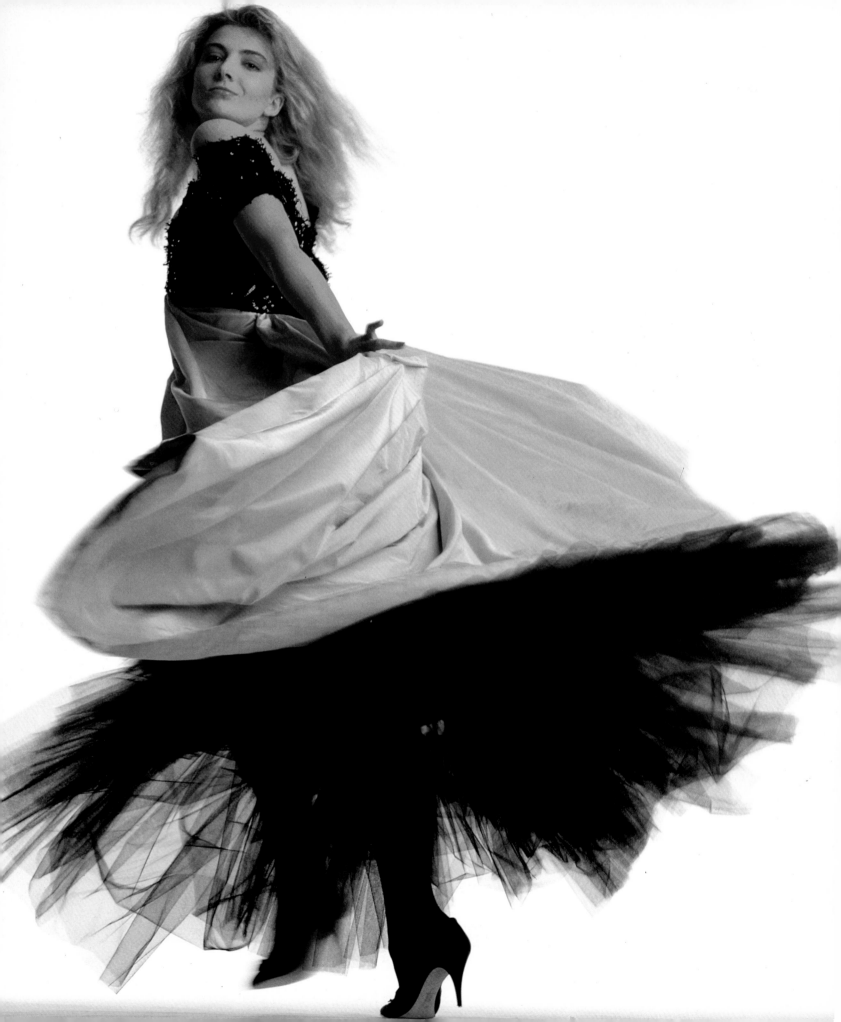

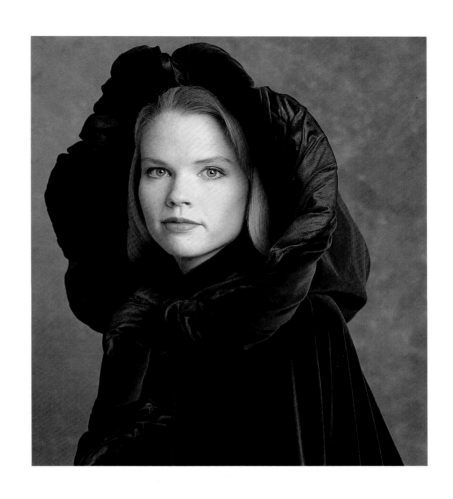

Natasha Richardson, 1987

Sara Crowe played Sybil in Noel Coward's *Private Lives*,
Directed by Tim Luscombe, 1990

Eartha Kitt, Cover for *I'm Still Here*, 1988

The Pet Shop Boys, Musicians, 1988

Griff Rhys Jones as Toad of Toad Hall
in *The Wind in the Willows*. Directed by Nicholas Hytner,
The National Theatre, 1991

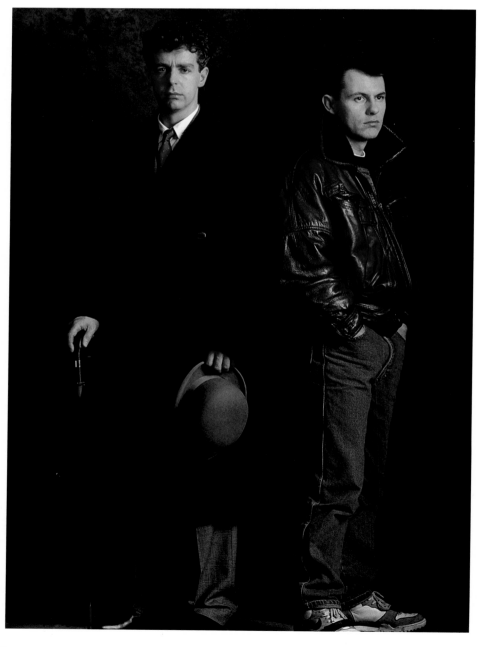

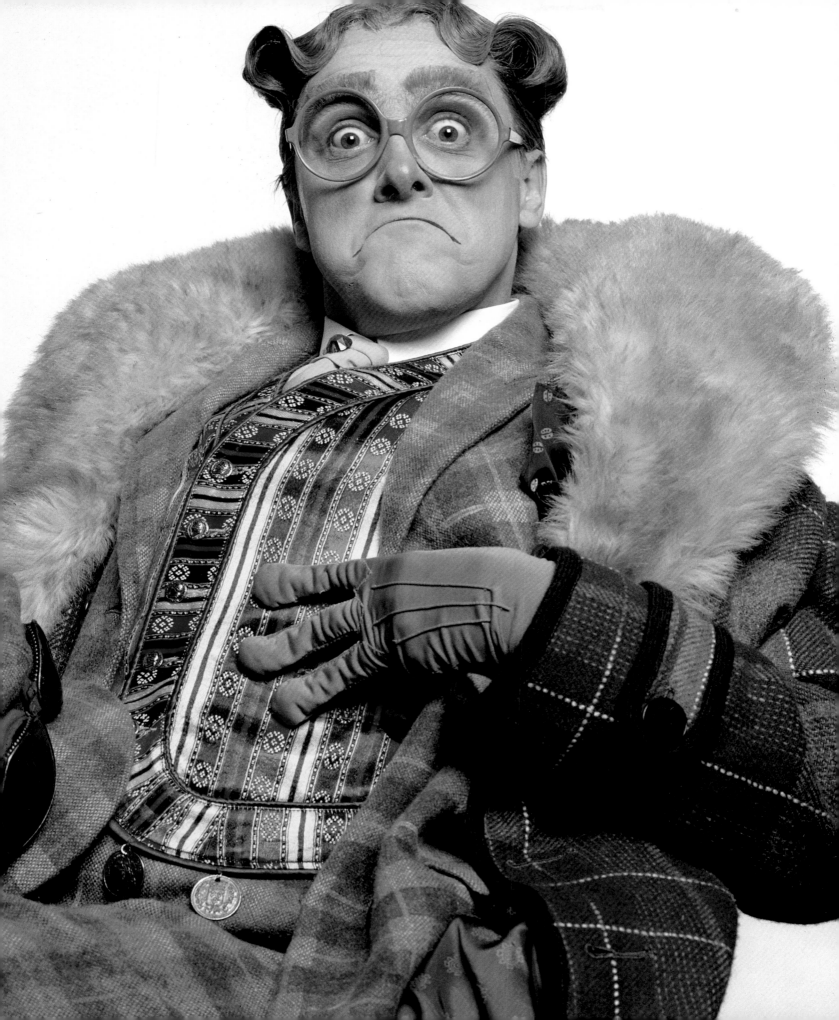

Rare Breeds, Christmas *Vogue*, 1990
Dexter Calf, Lincoln Longwool Ewe
Following pages, Hebridean Ram, White Park Cow, Tamworth Pig

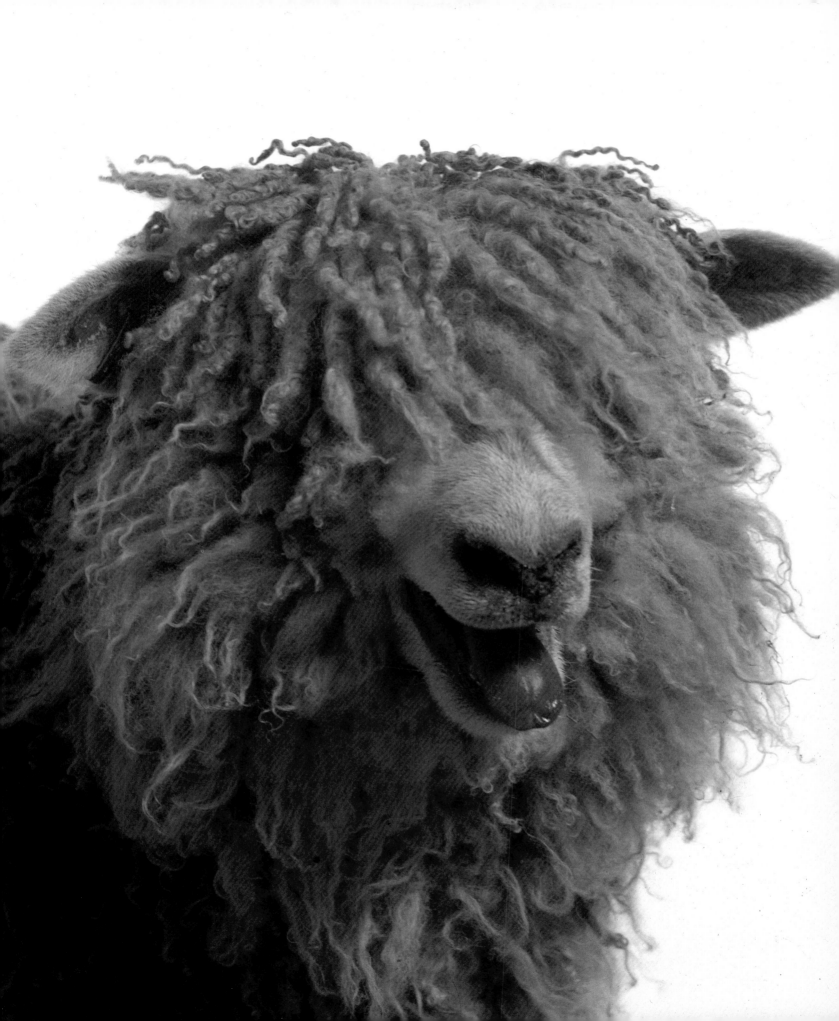

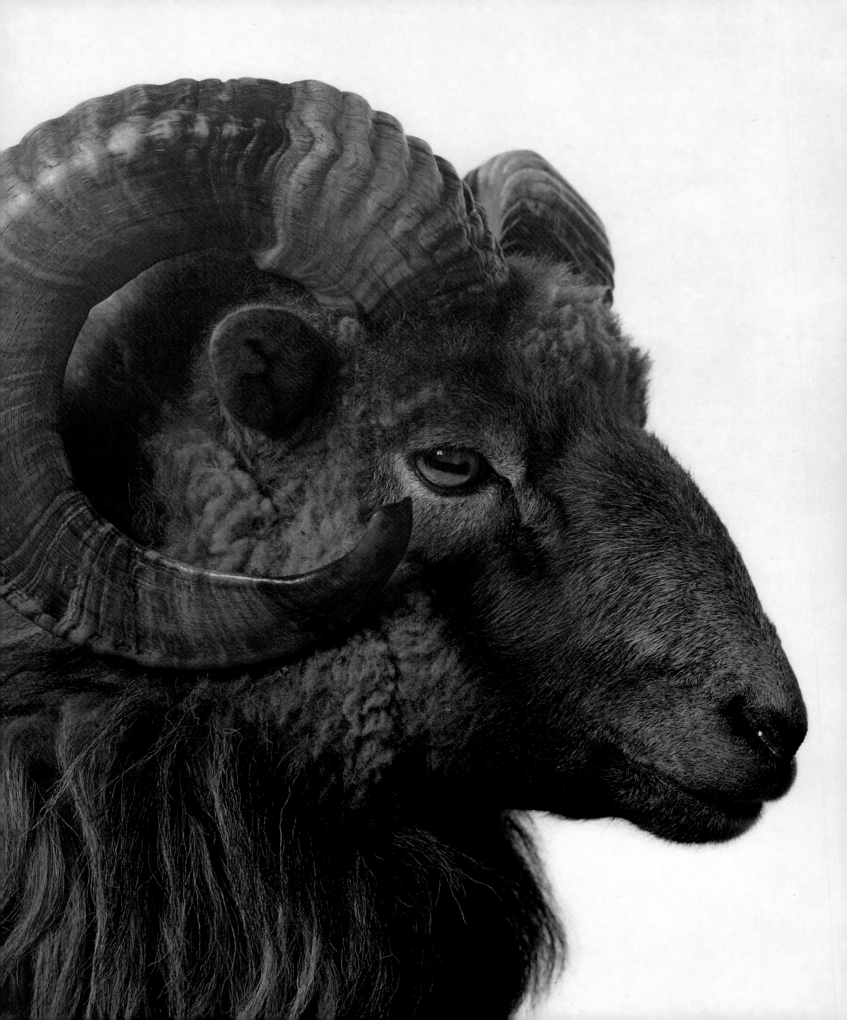

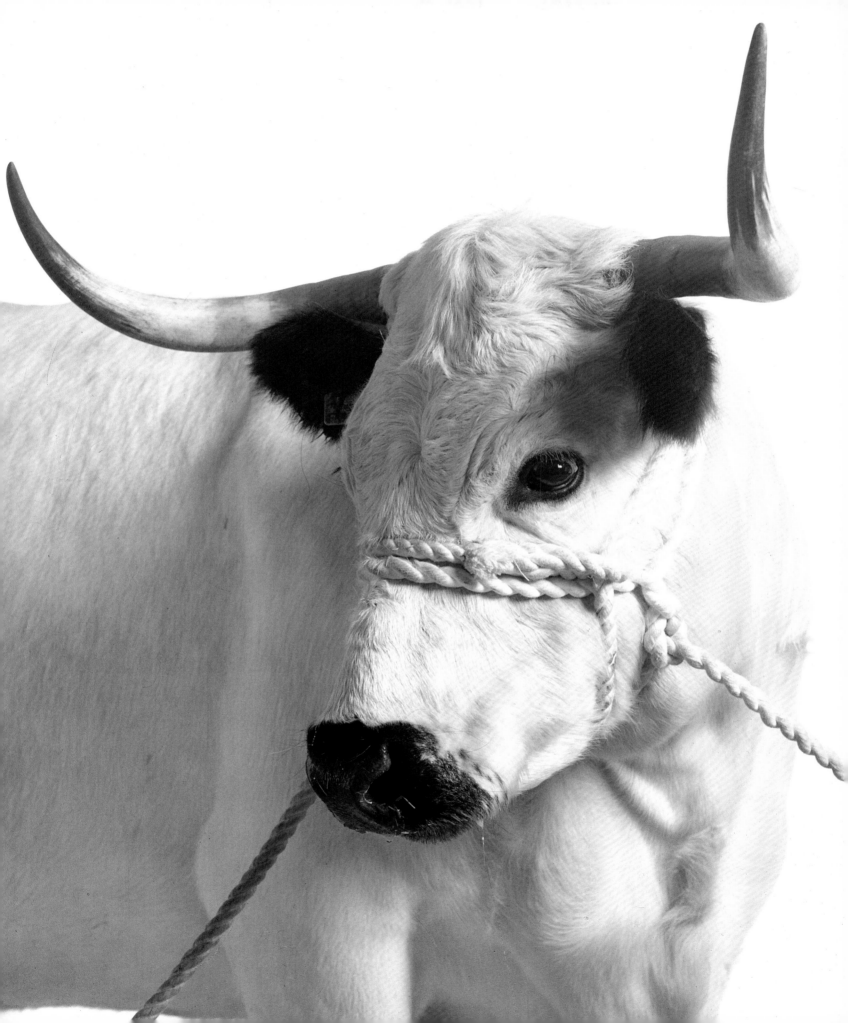

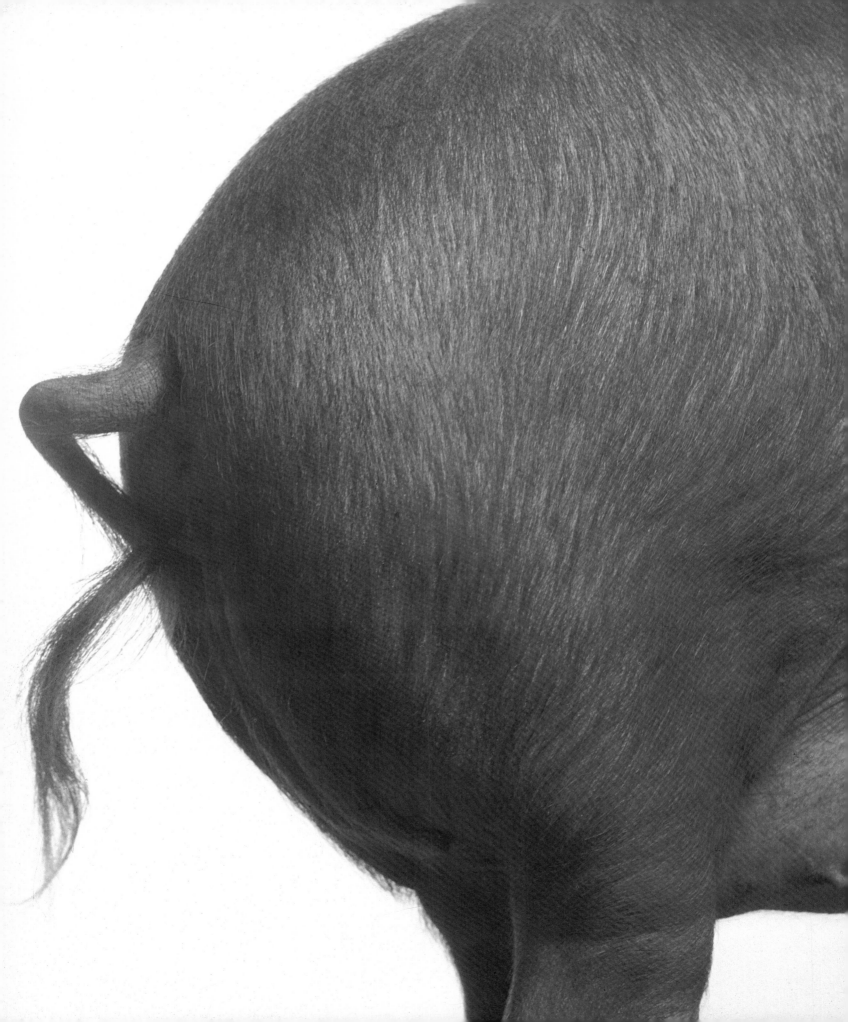

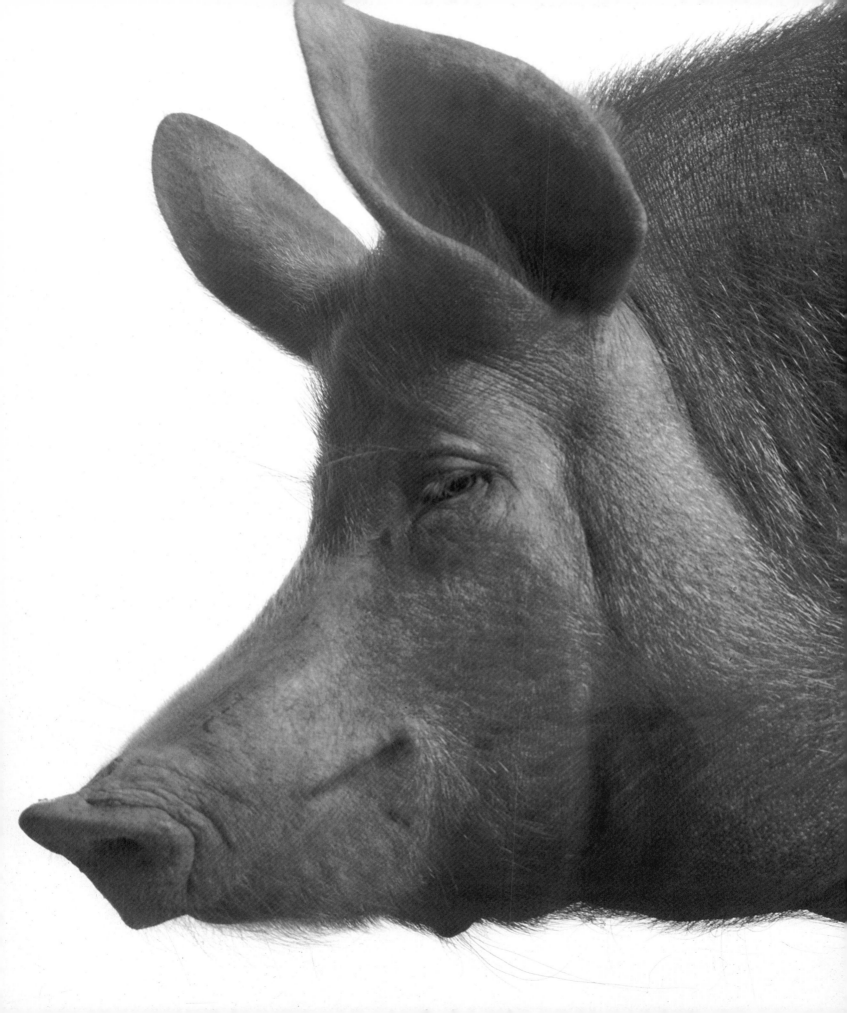

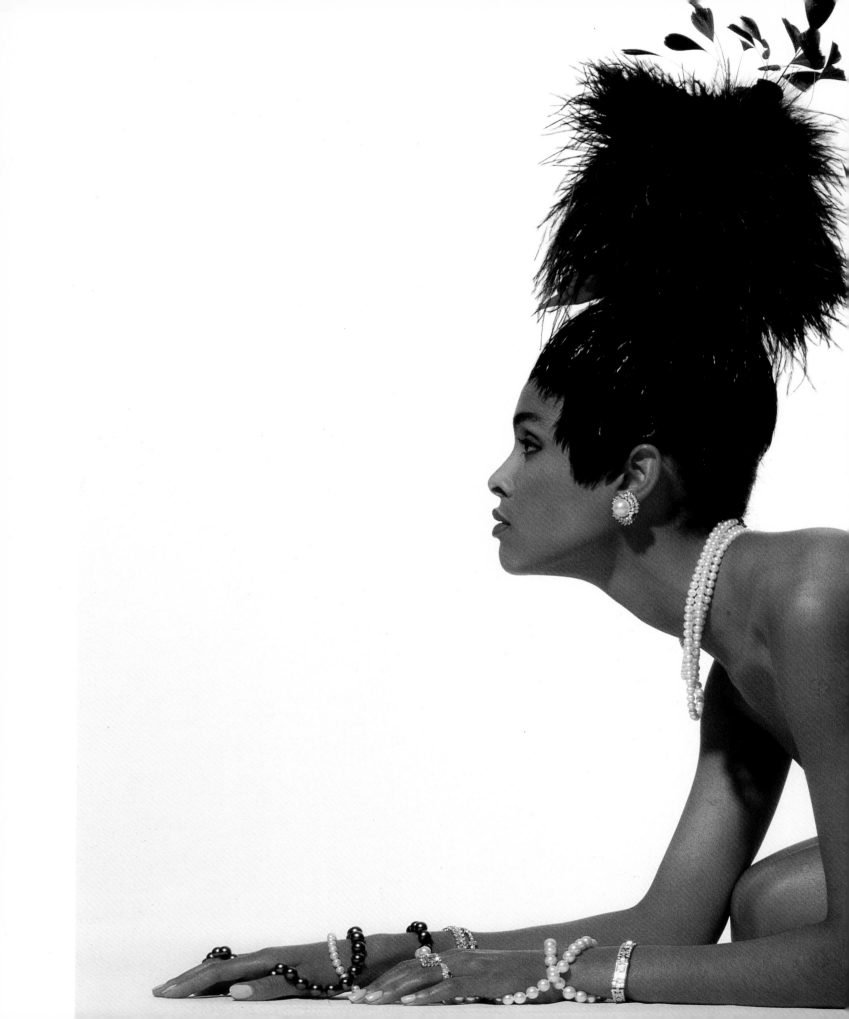

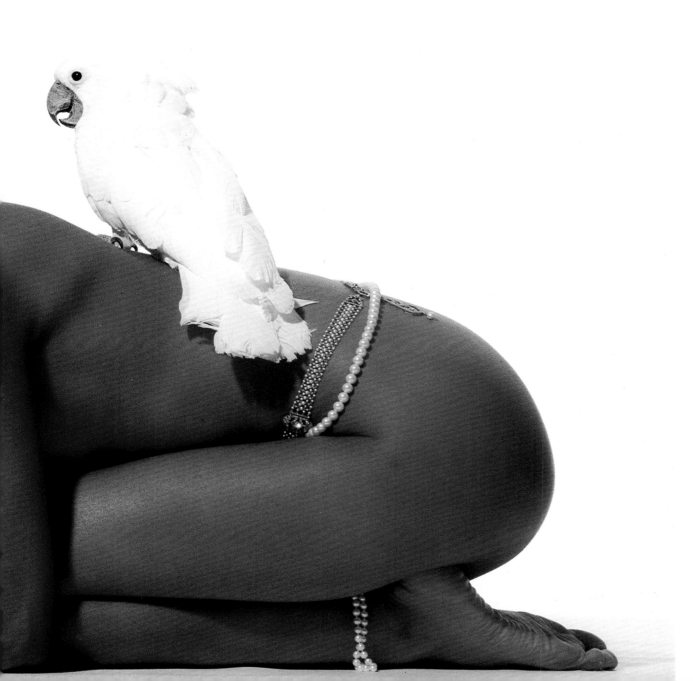

Fashion for
Vogue, 1989
This page and
overleaf right,
Lana Ogilvy
with Jewellery
and Cockatoo
Overleaf left,
Lana Ogilvy,
wearing Shoes
designed by
Jimmy Choo,
with Macaw

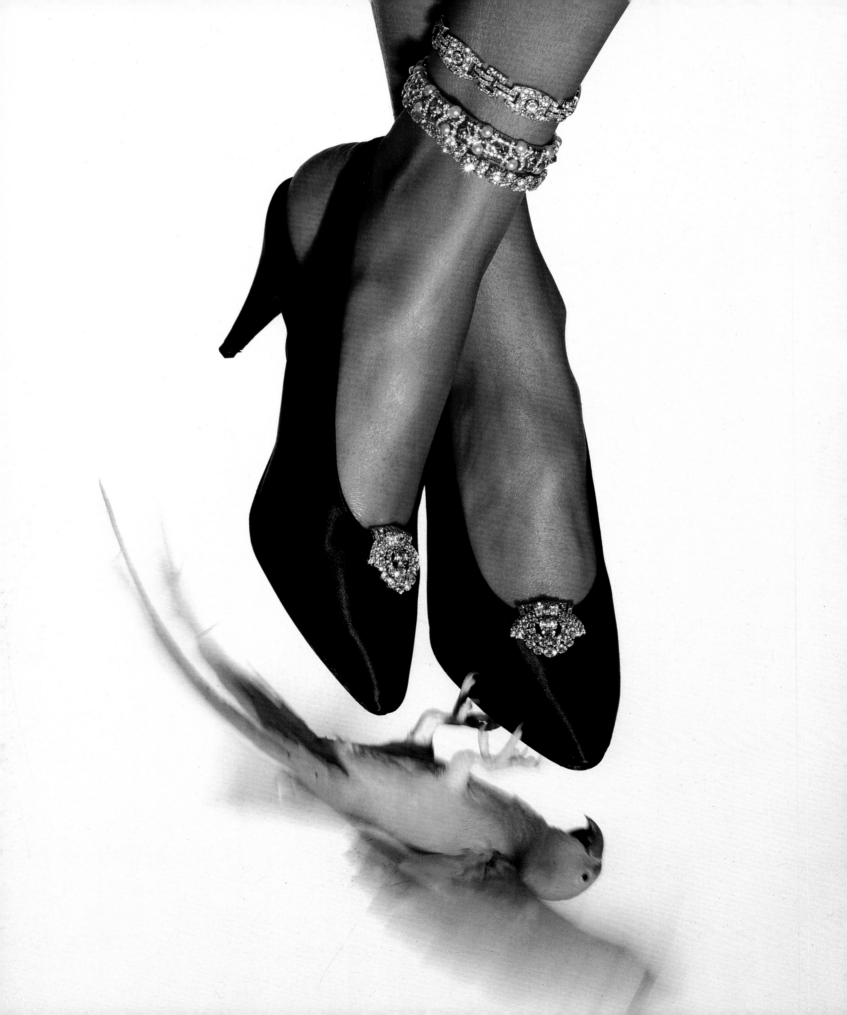

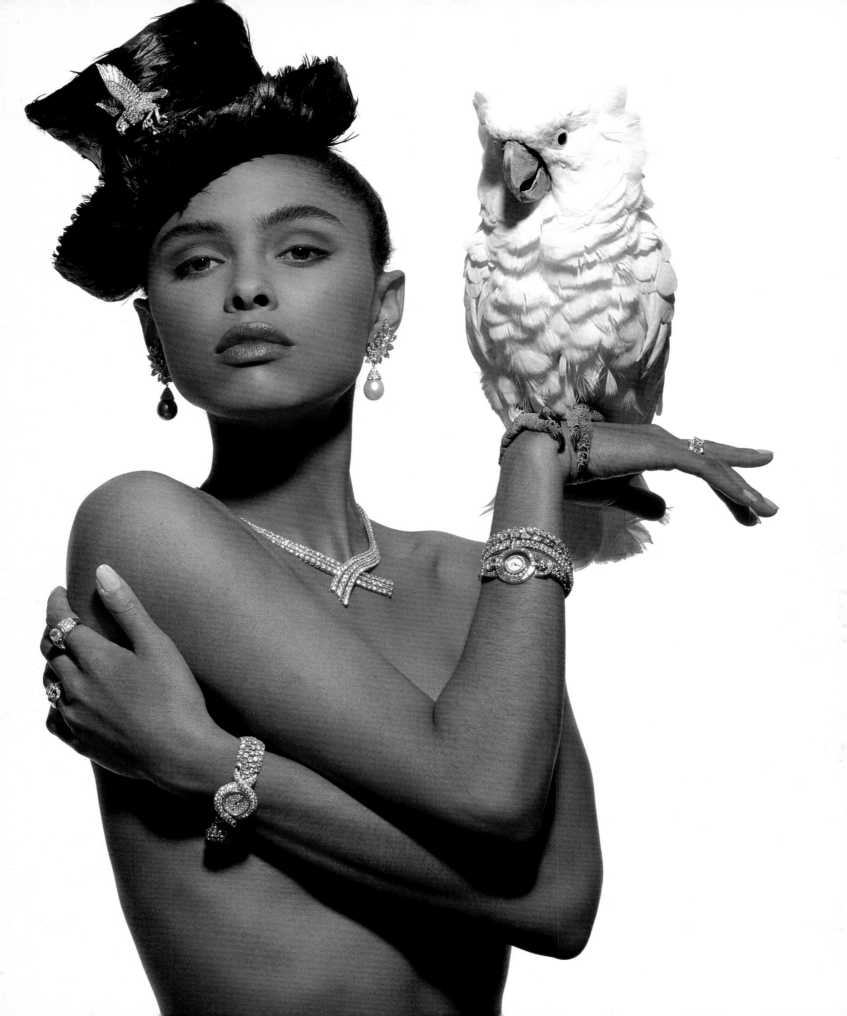

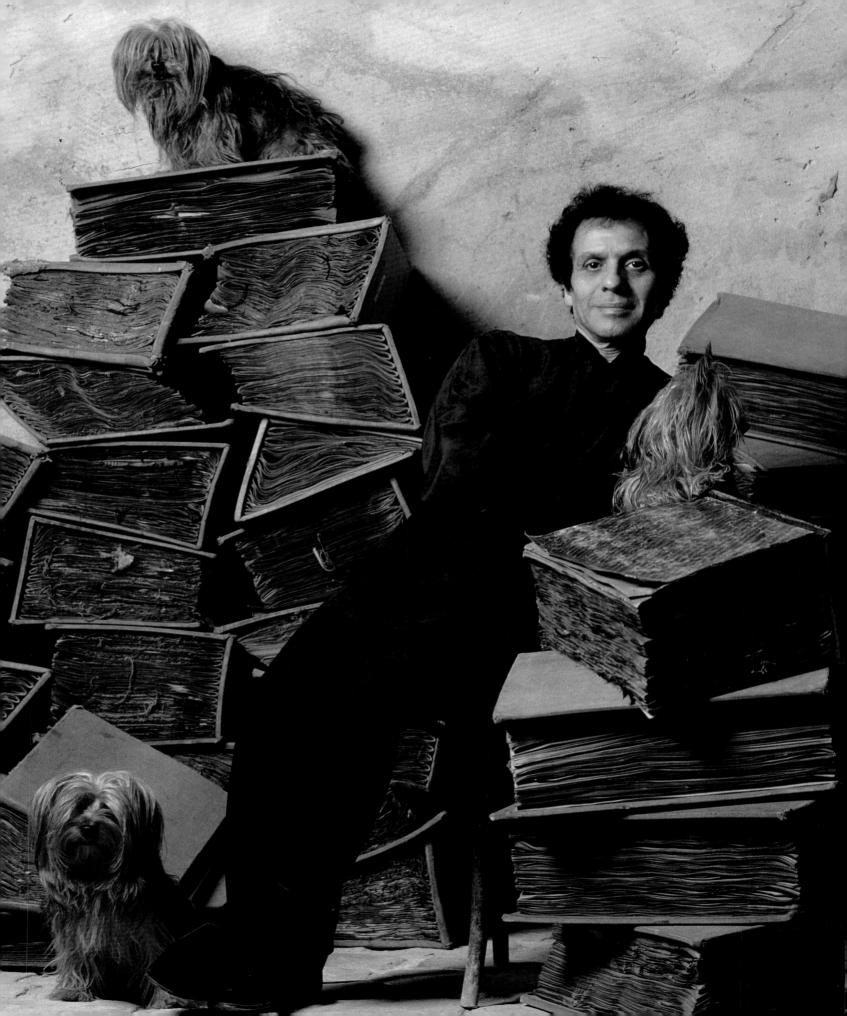

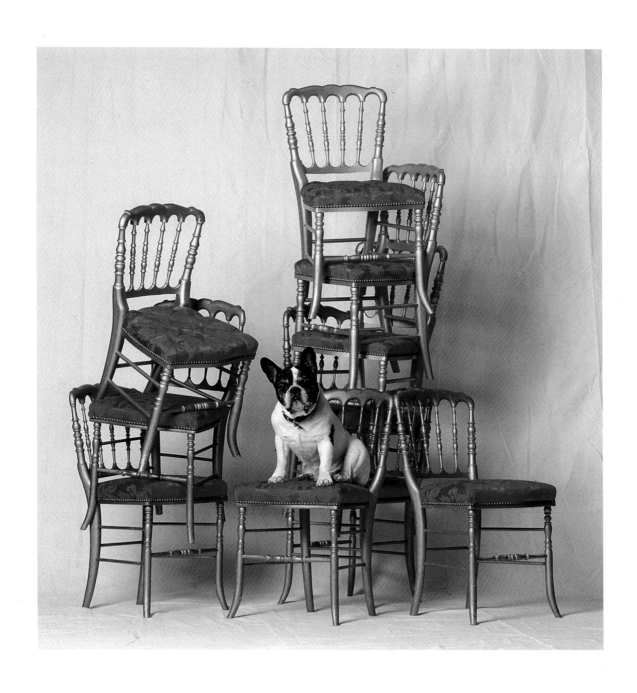

Azzedine Alaia with Patapouf, Barouf and Wabo, Paris, 1990

Moujick at Yves Saint Laurent, Paris, 1989

Giorgio Armani, Milan, 1987

Gianni Versace, Milan, 1990

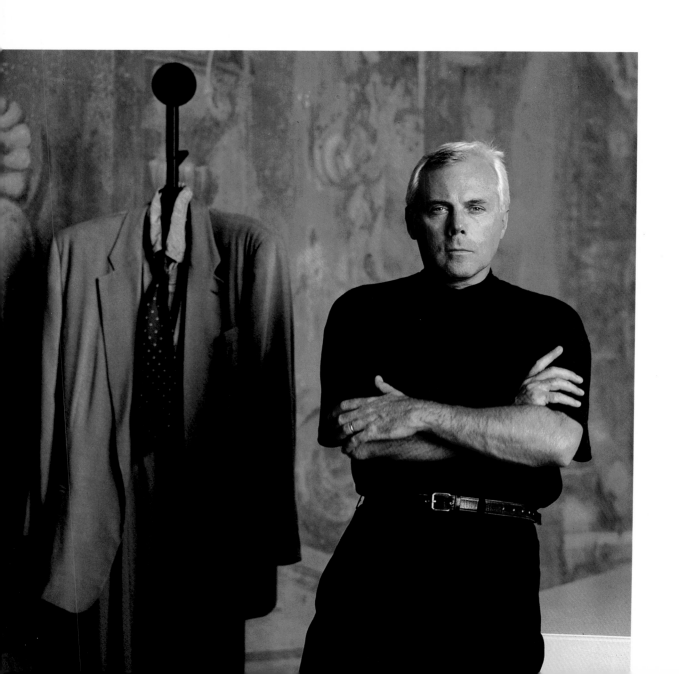

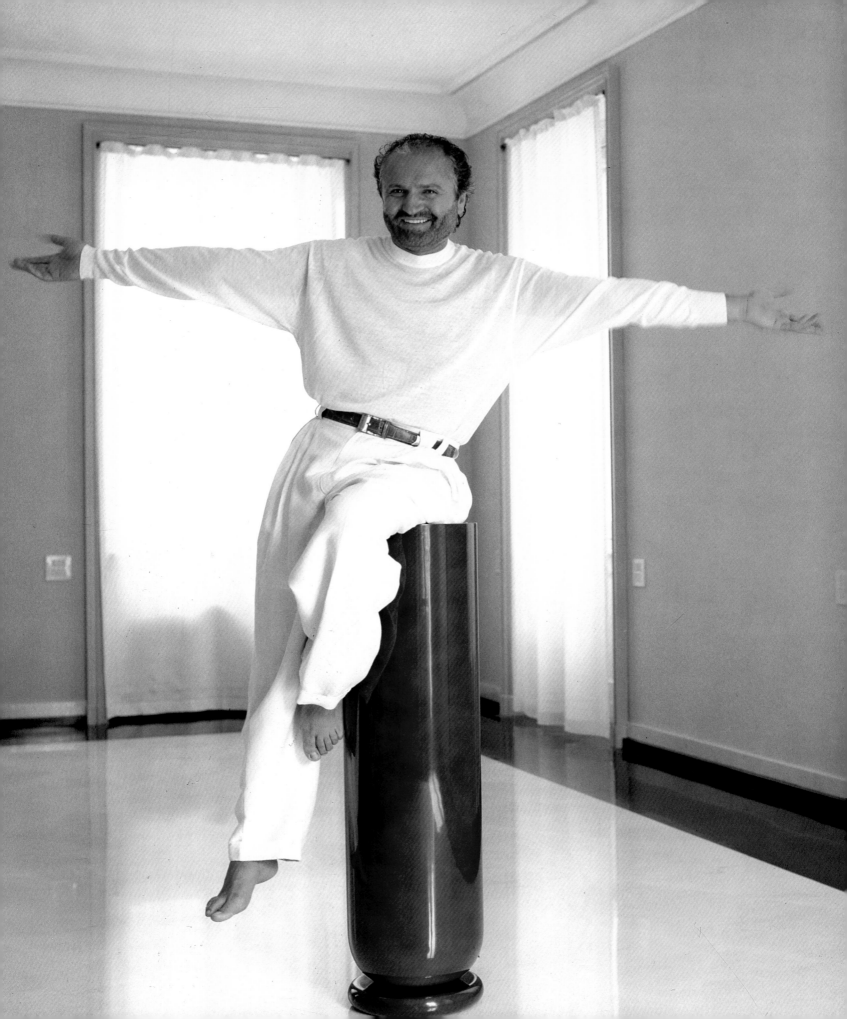

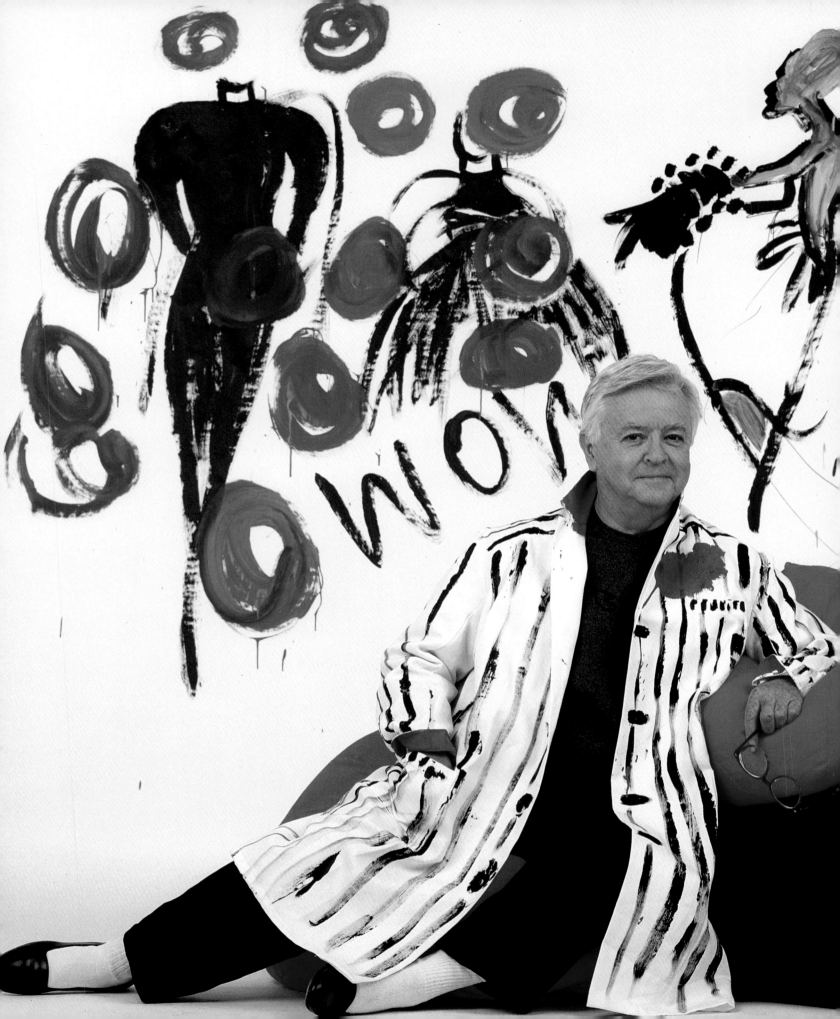

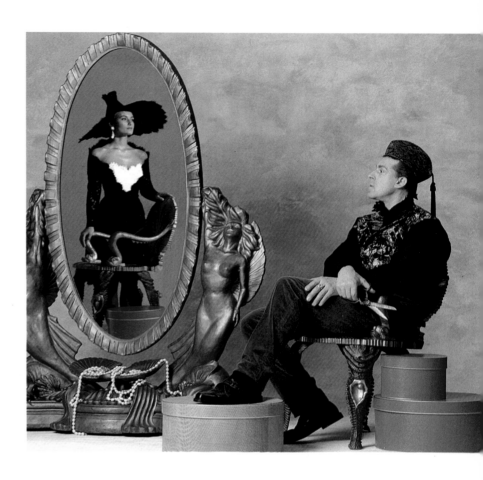

Geoffrey Beene,
New York, 1989

Antony Price, London, 1989

Pierre Cardin,
The Ritz Hotel, London, 1990

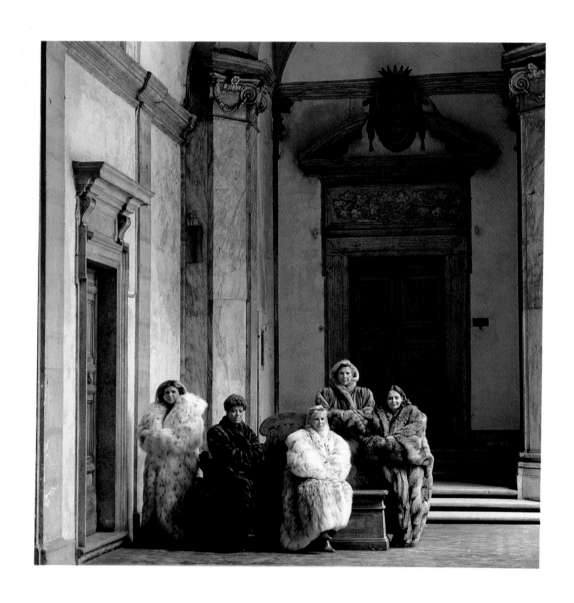

The Fendi Sisters, Rome, 1987

Valentino on his Yacht, 1990

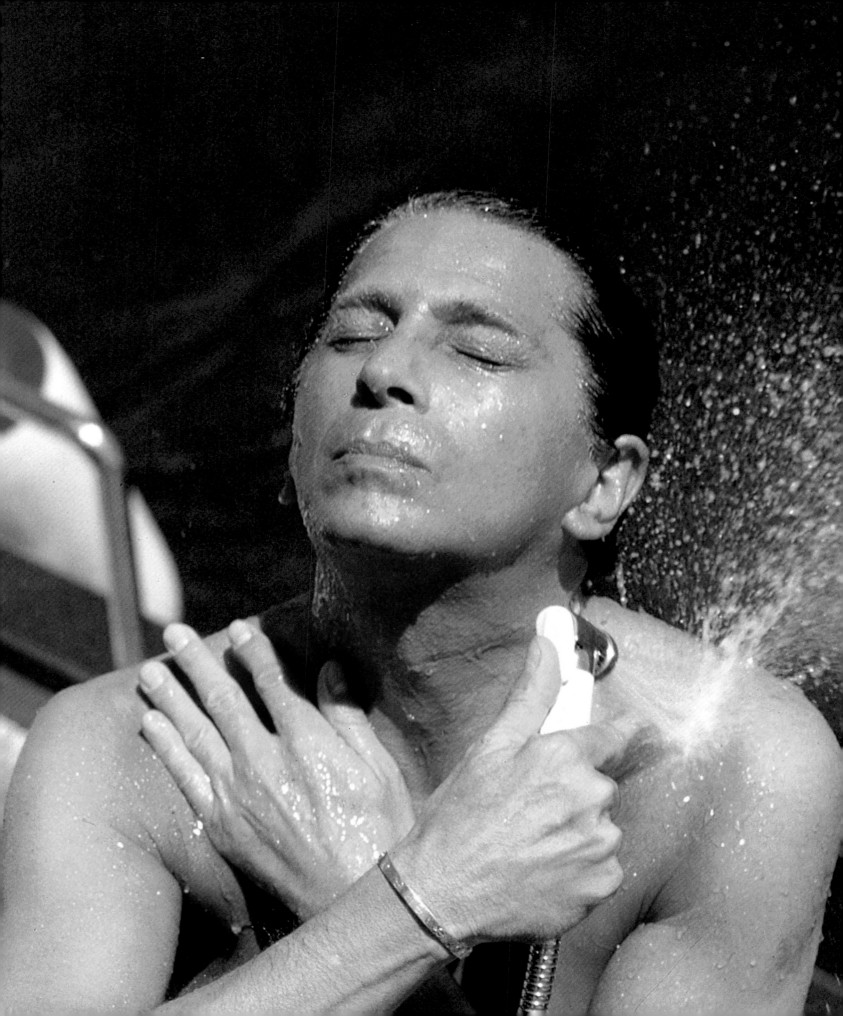

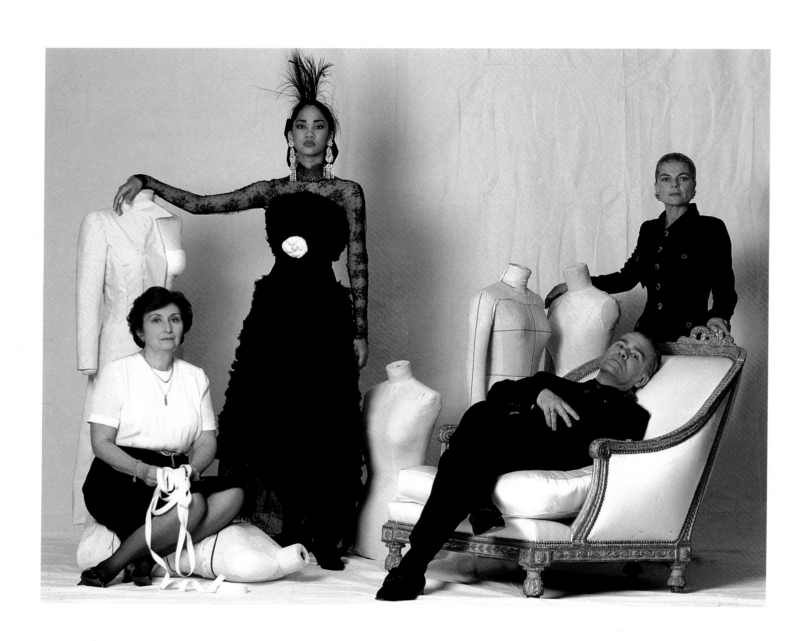

Karl Lagerfeld at Chanel, Paris, 1989

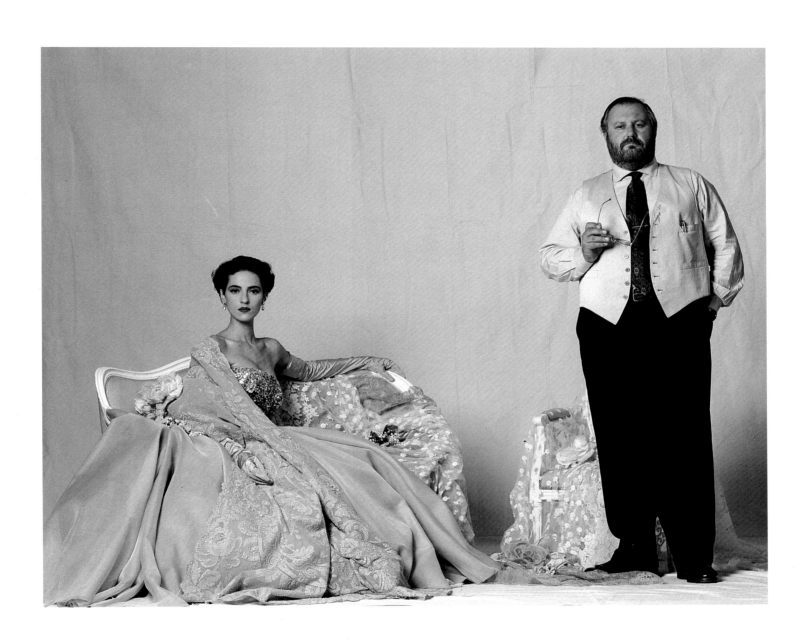

Gianfranco Ferre at Dior, Paris, 1989

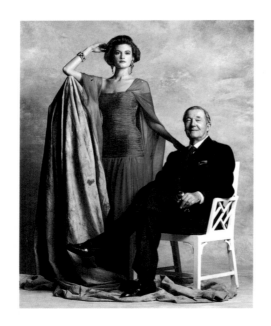

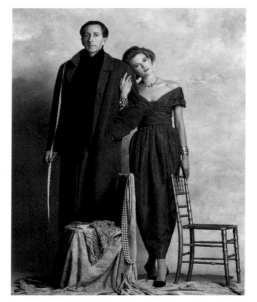

Sir Hardy Amies, London, 1990

Victor Edelstein, London, 1990

Anouska Hempel, London, 1990

Christian Lacroix, Paris, 1989

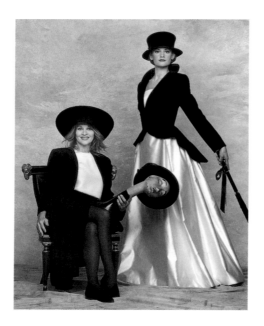

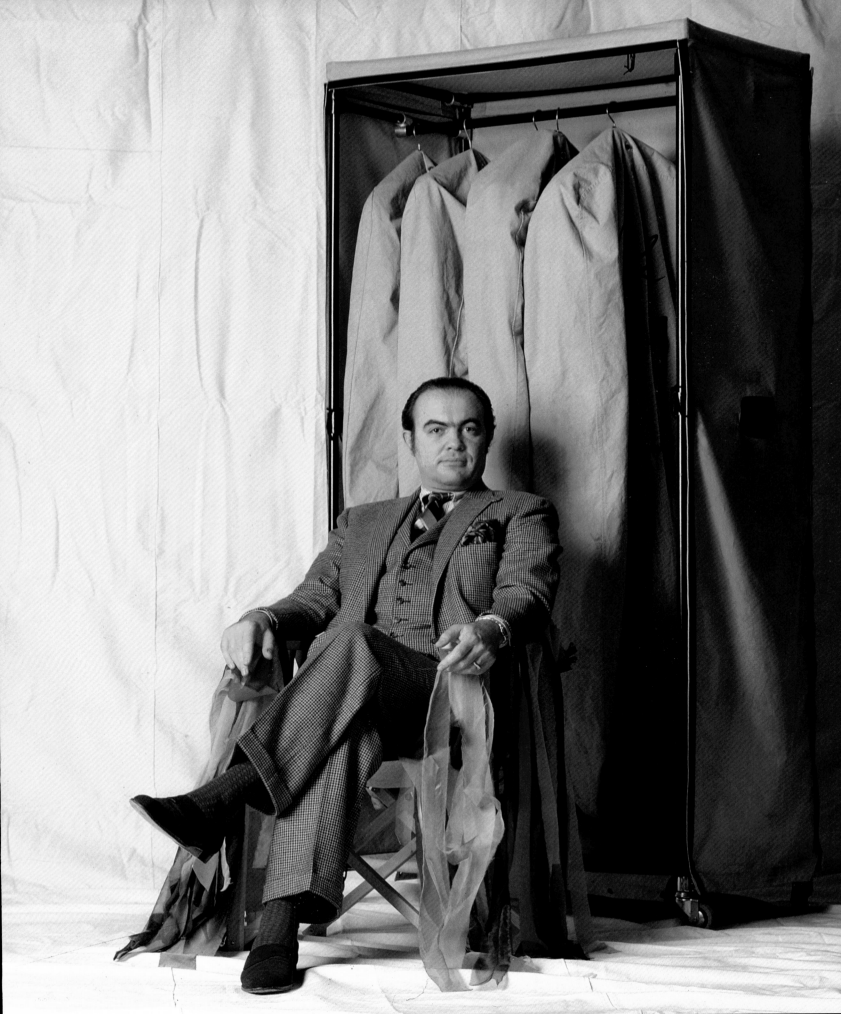

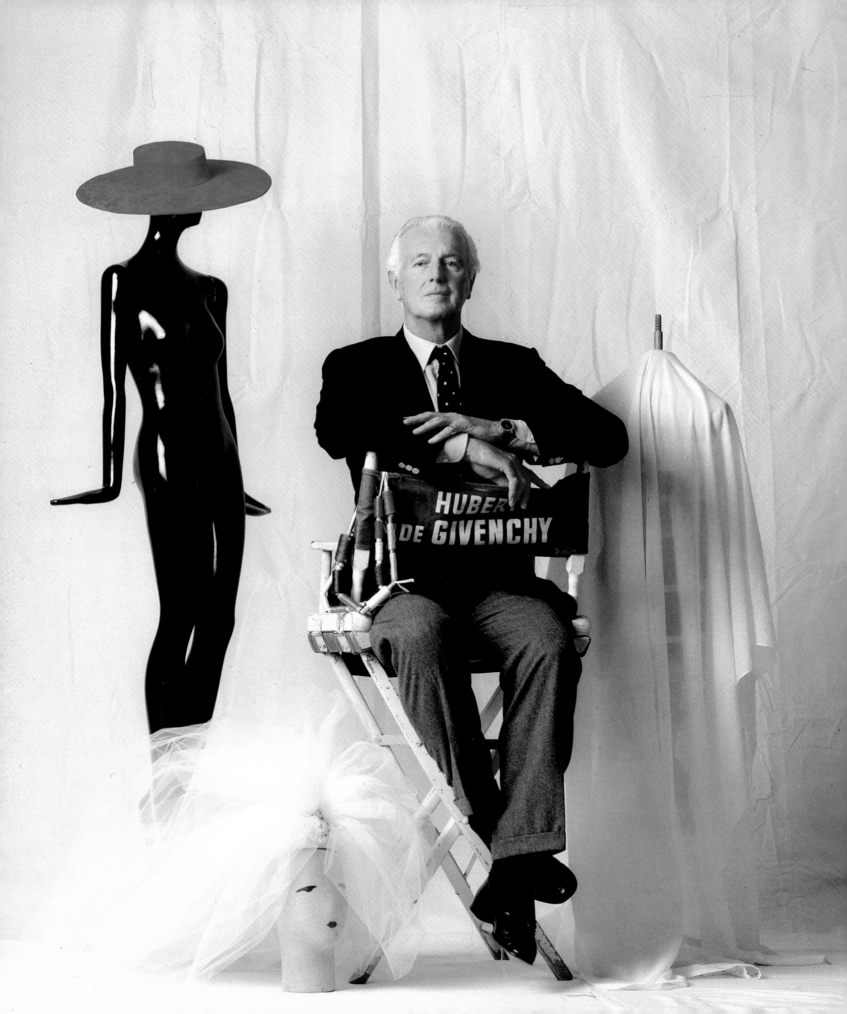

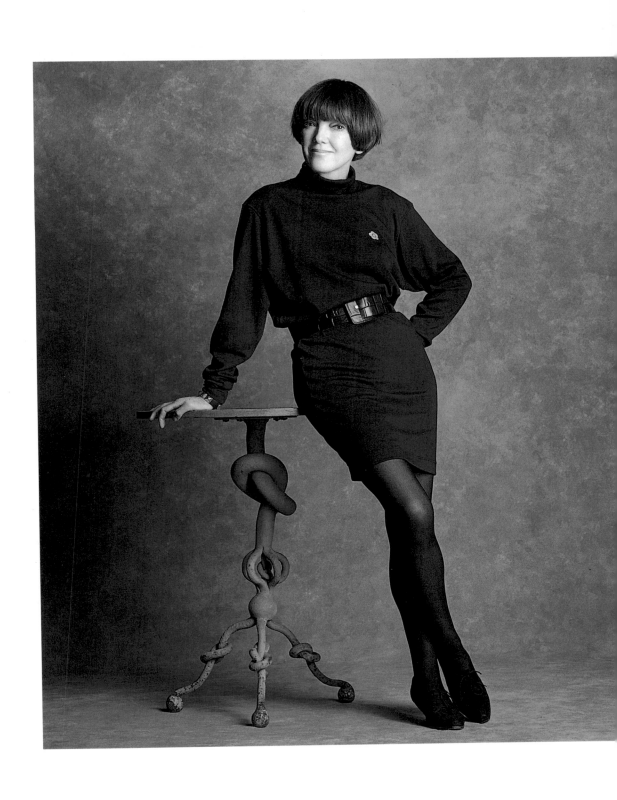

Hubert de Givenchy, Paris, 1989

Mary Quant, London, 1988

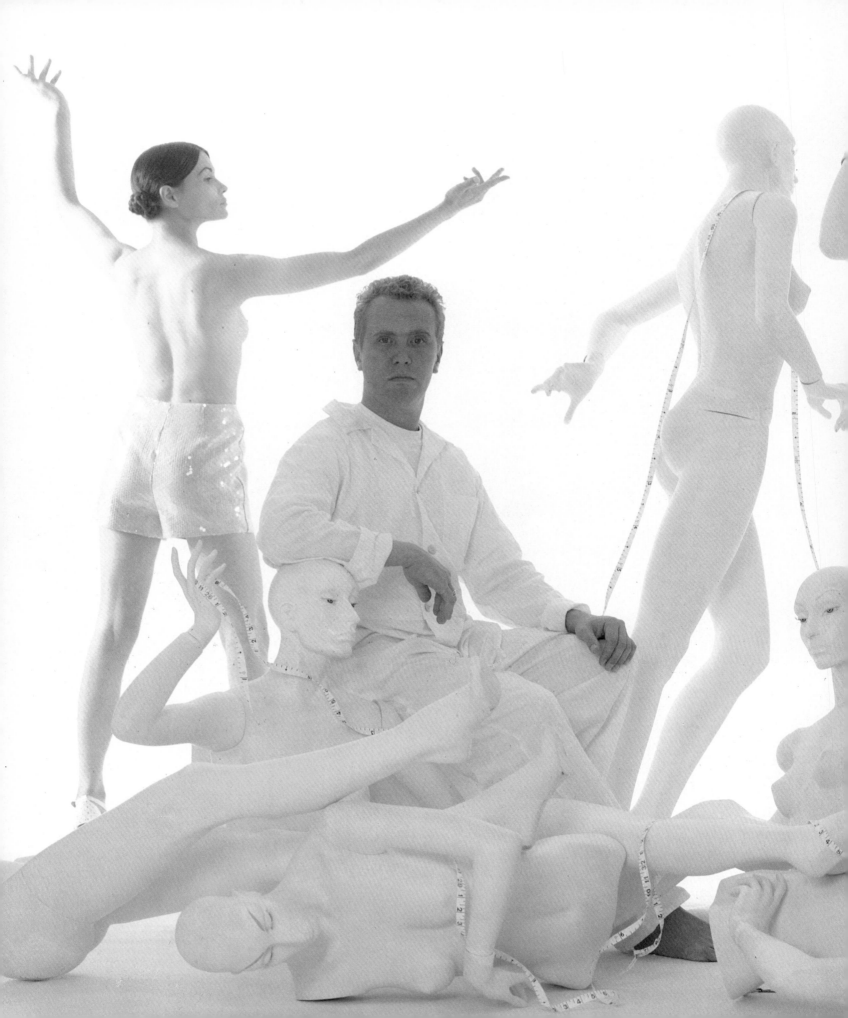

Michael Kors, New York, 1988
Donna Karan, New York, 1990

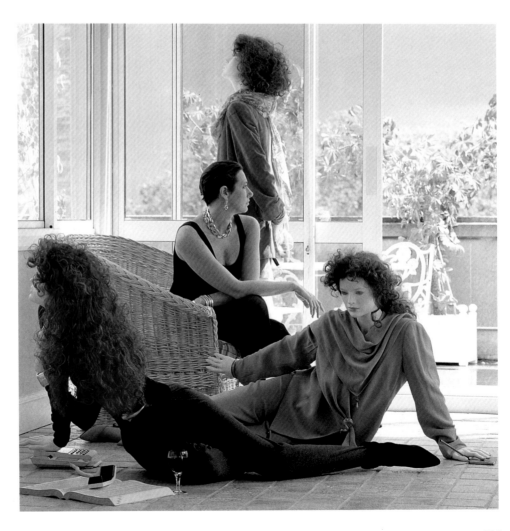

Anita Roddick, Founder of The Body Shop, 1989

Paloma Picasso, 1989

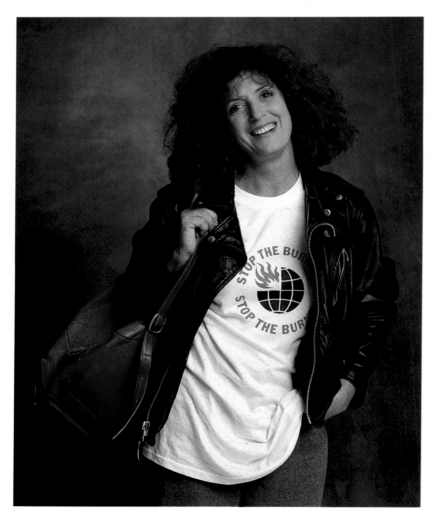

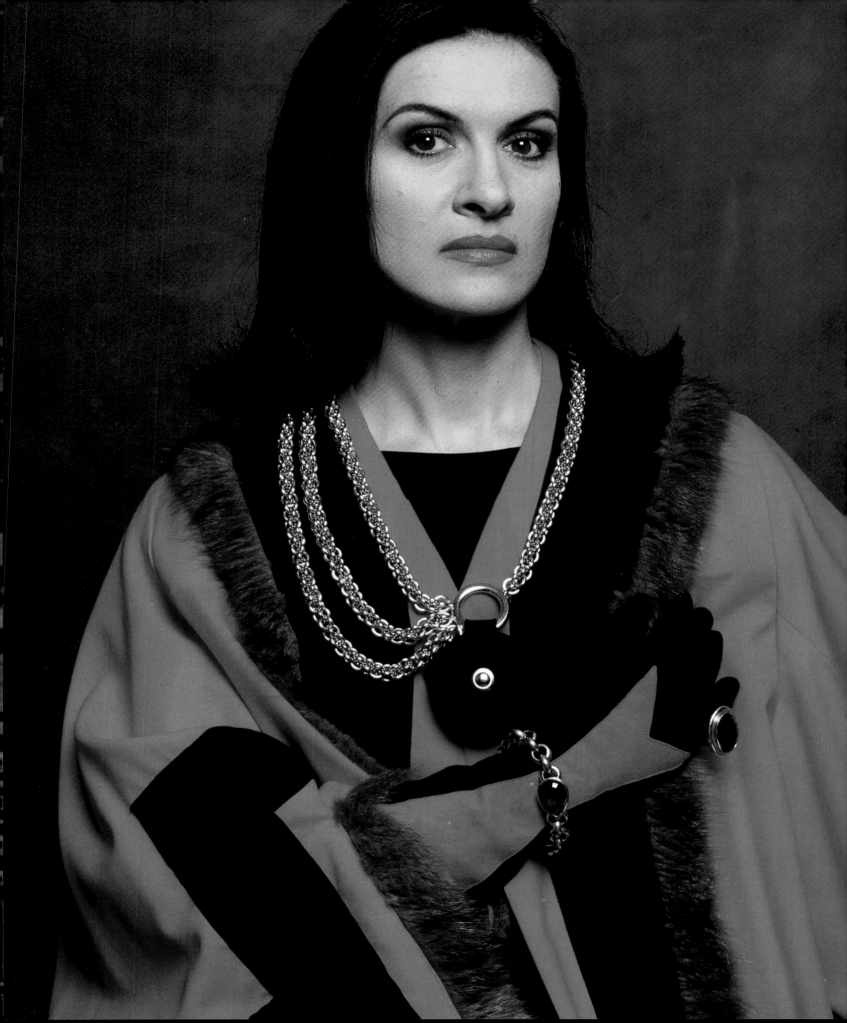

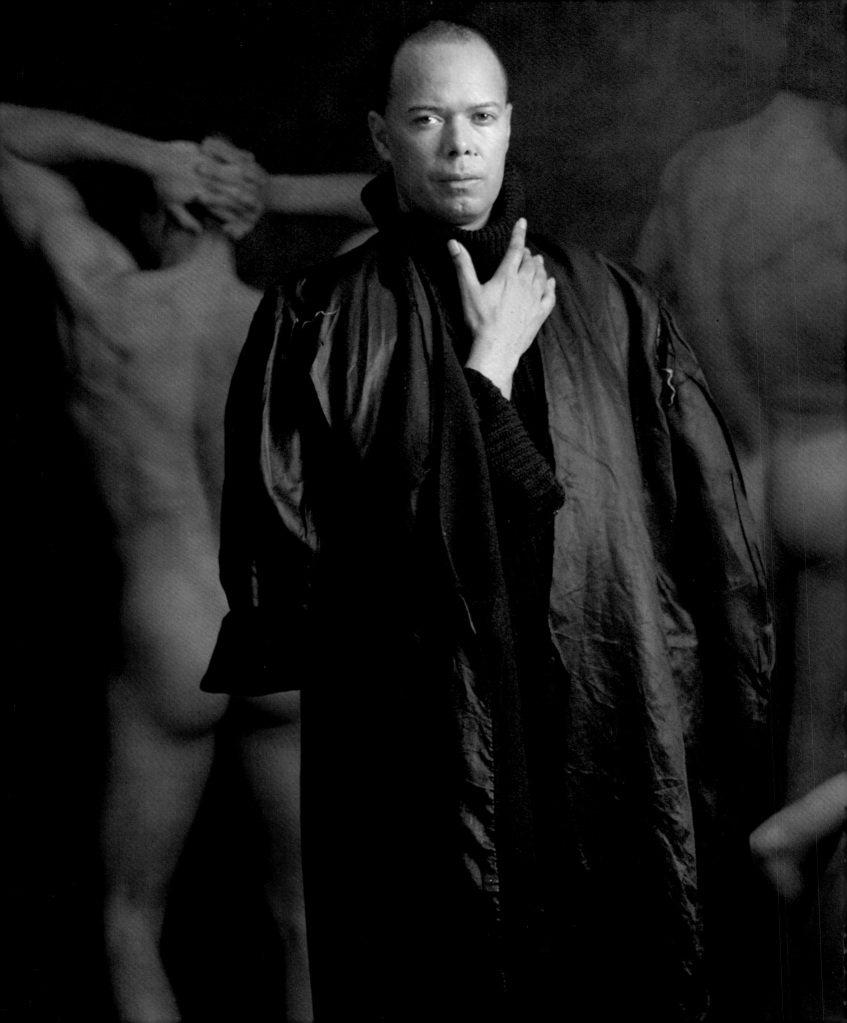

Michael Roberts, Fashion Journalist, 1988

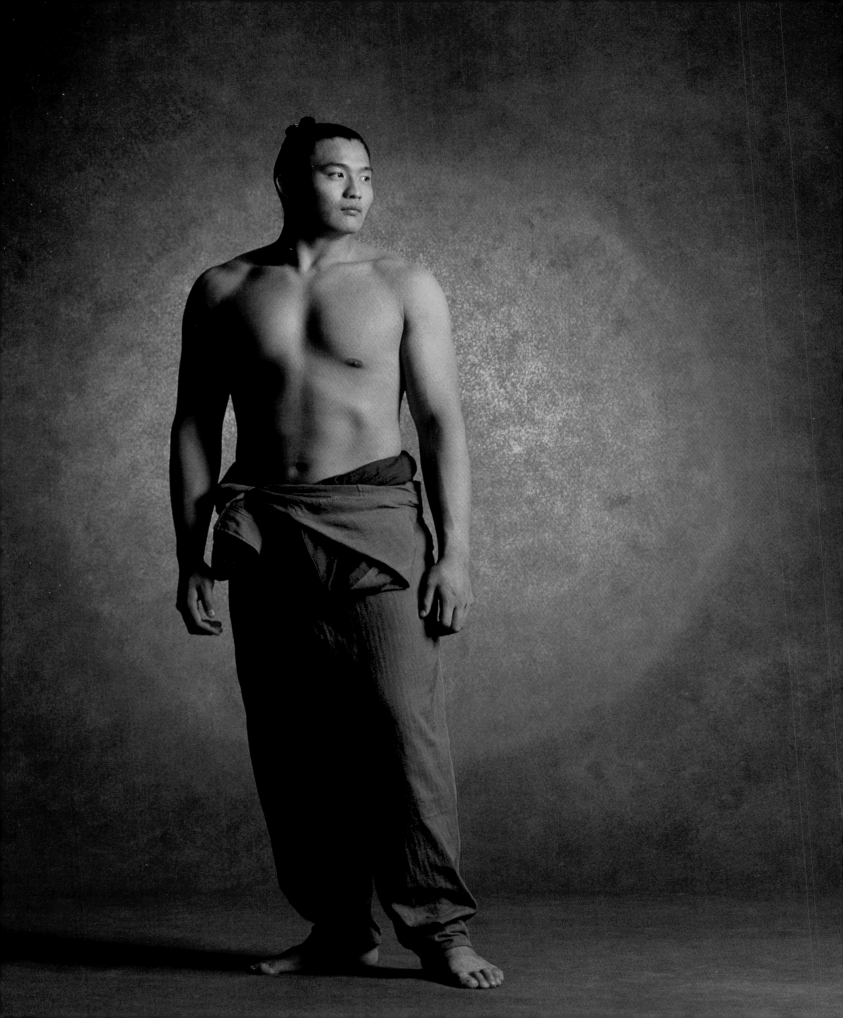

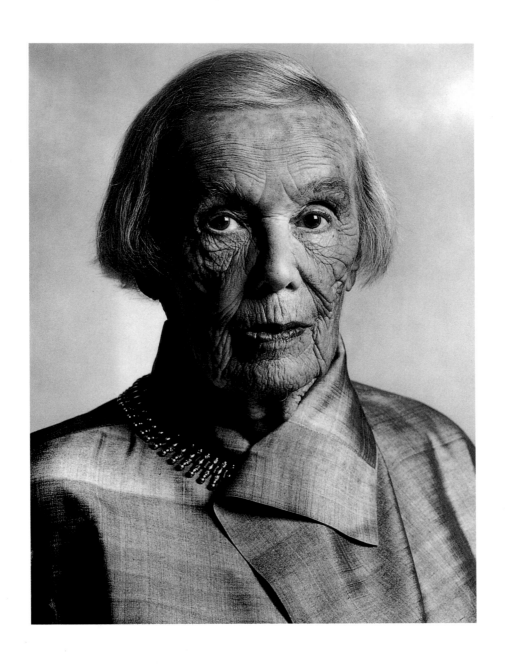

Clothes designed by **Issey Miyake** , worn by:

Koji Takahanada, Sumo Wrestler, 1989

Frances Partridge, Bloomsbury Writer, 1989

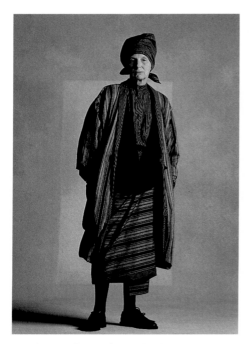

Jocelyn Herbert, Theatre Designer, 1987

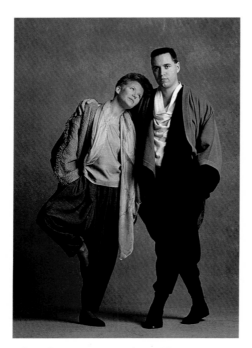

Jake Tilson, Painter, and **Jennifer Lee**, Potter, 1989

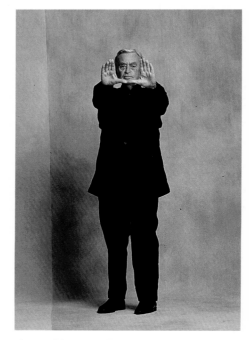

Sir David Lean, Film Director, 1988

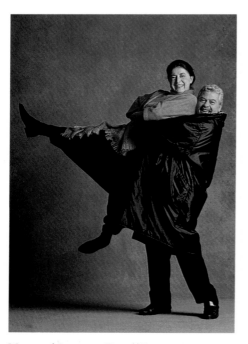

Mara and **Lorenzo Berni**, Restaurateurs, San Lorenzo, 1989

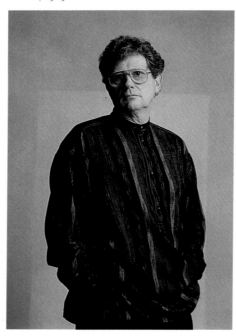

Jeremy Fry, Inventor and Engineer, 1987

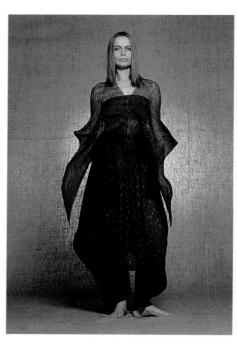

Verushka (Vera Lehndorff), Model and Artist, 1989

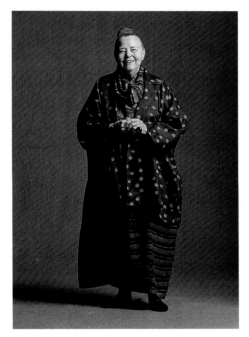

Charlotte Perriand, Designer, 1989

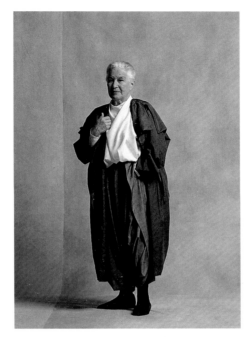

Dame Veronica Wedgewood,
Historian, 1988

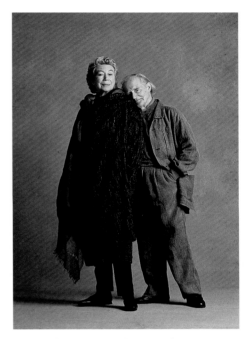

Sir Hugh Casson, Architect, and
Lady Casson, Interior Designer, 1989

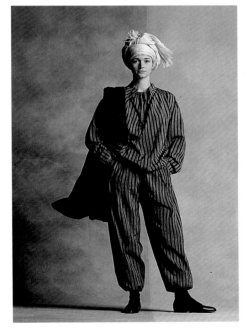

Marina Warner, Author, 1987

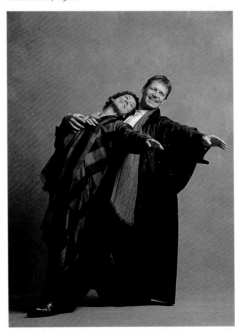

Nicholas Serota, Director of the Tate
Gallery, and, **Angela Serota**, a Governor
of the Royal Ballet School, 1989

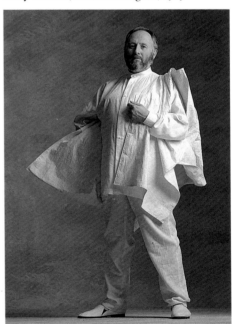

Anthony Powell, Costume Designer, 1988

III

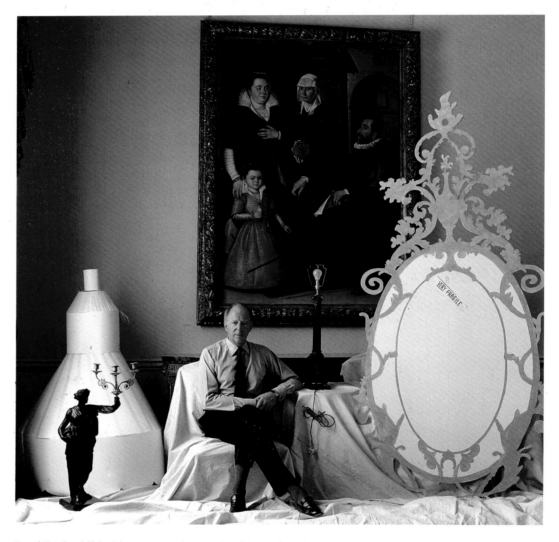

Lord Rothschild with Paper Mock-Up Chandelier and Looking Glass,
during the Redecoration of Spencer House, London, 1990

American *House & Garden*,
Interior Designers,
New York, 1988
Sister Parrish

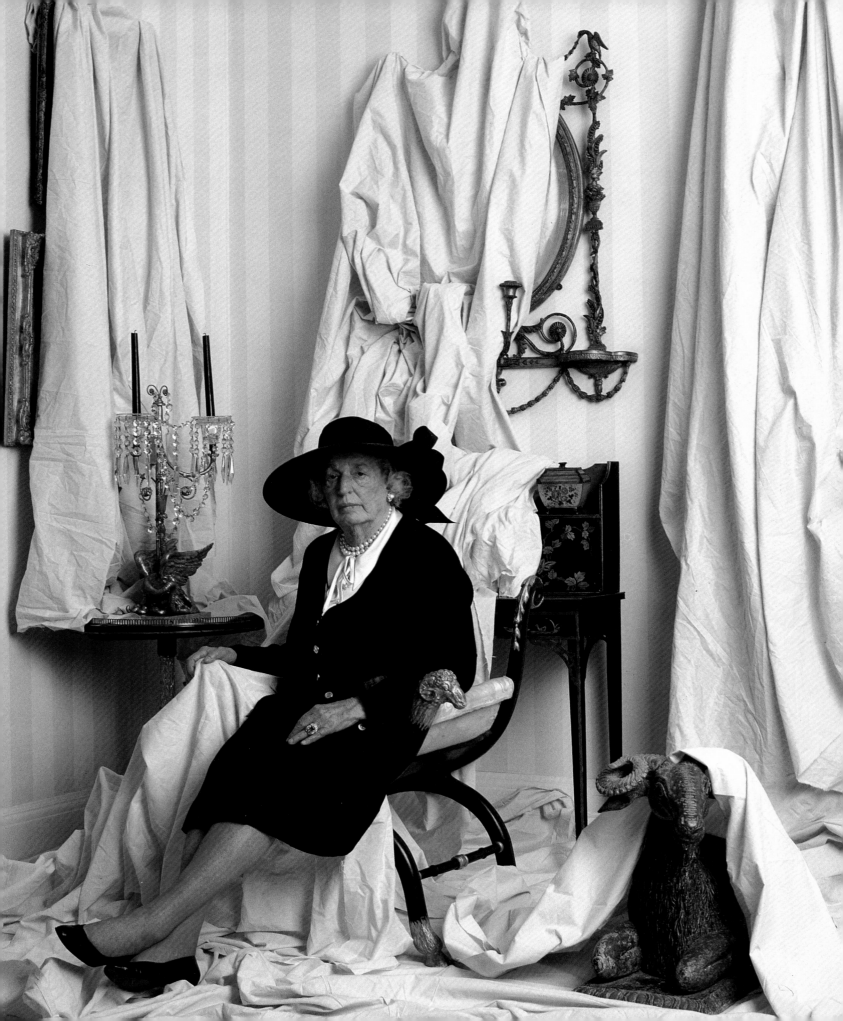

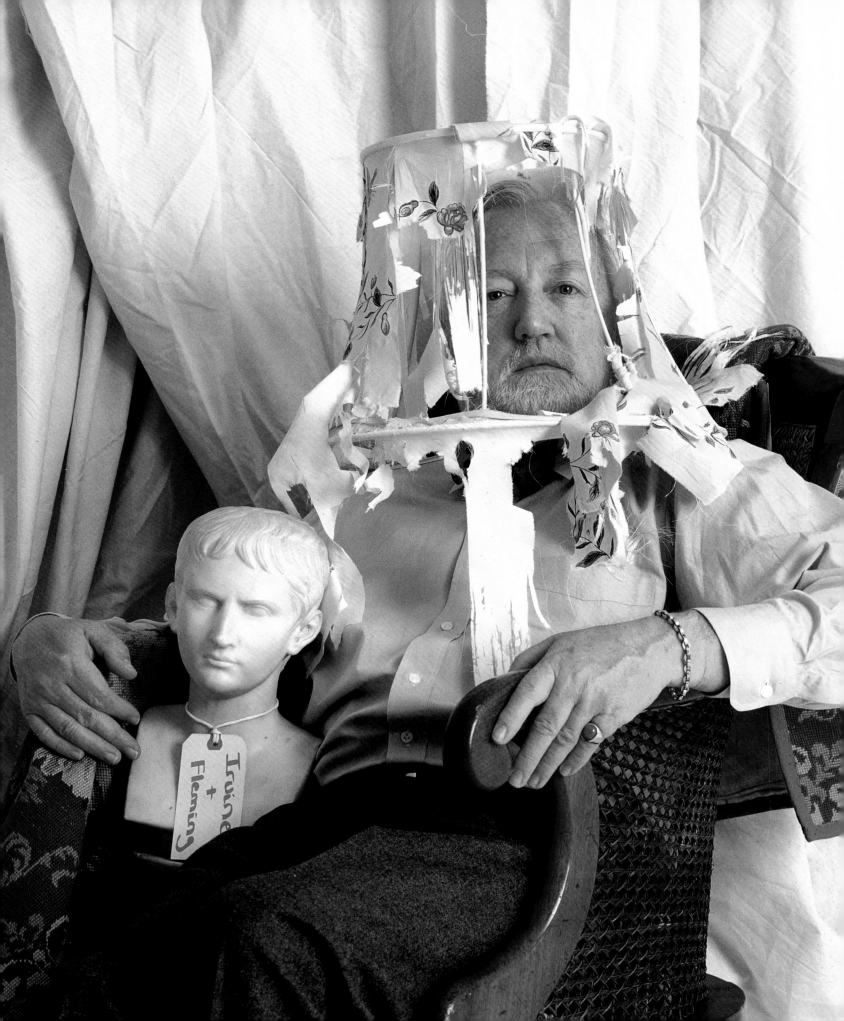

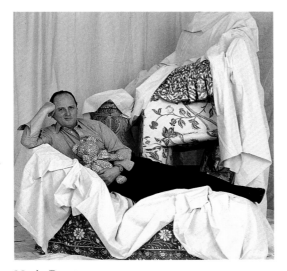

Mario Buatta

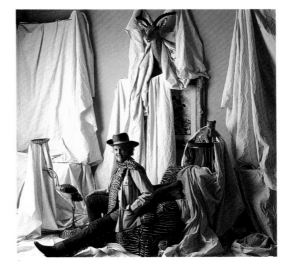

Mrs Virgil Sherrill

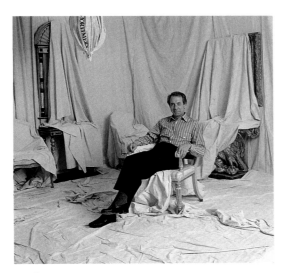

Mark Hampton

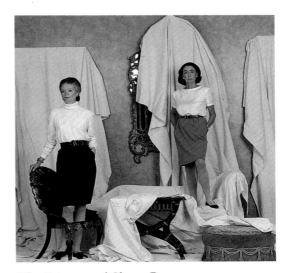

Mica Ertegun and **Chessy Rayner**

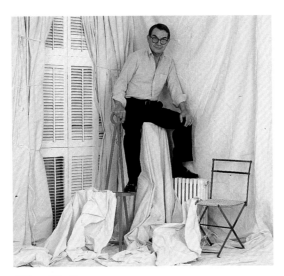

Albert Hadley

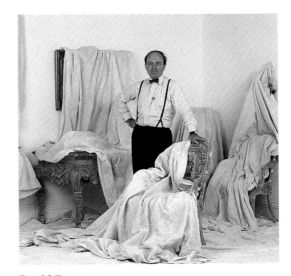

David Easton

Keith Irvine and **Tom Fleming**

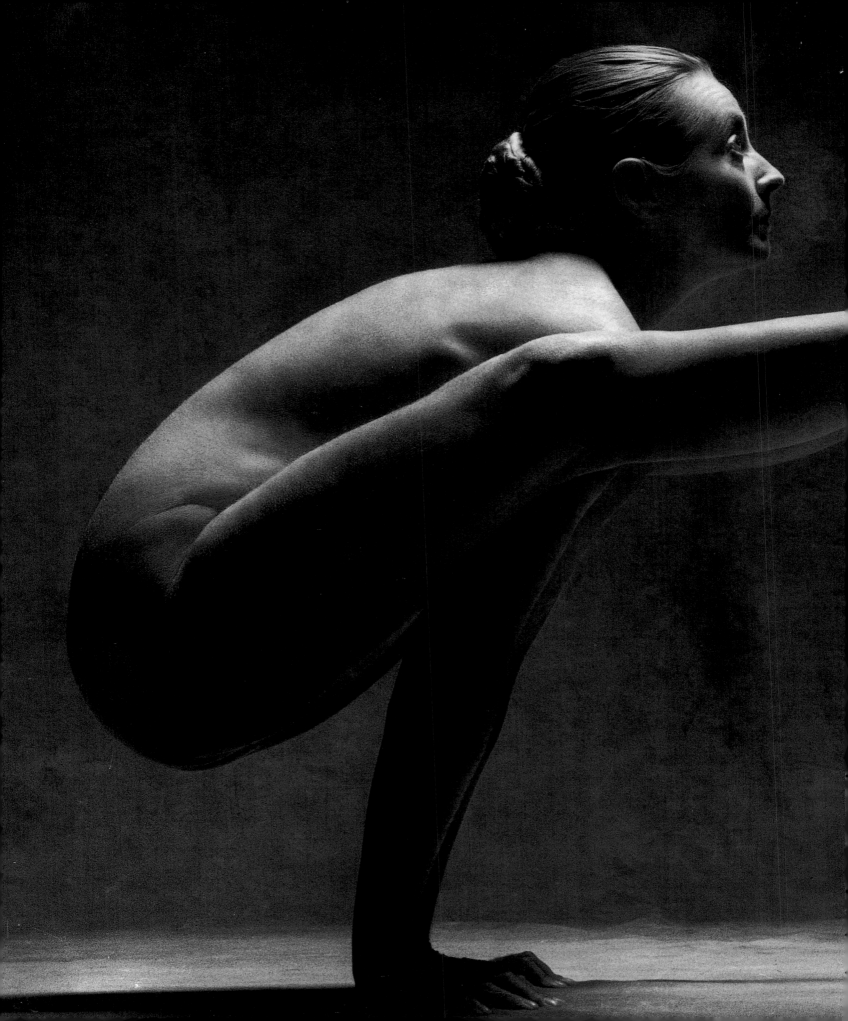

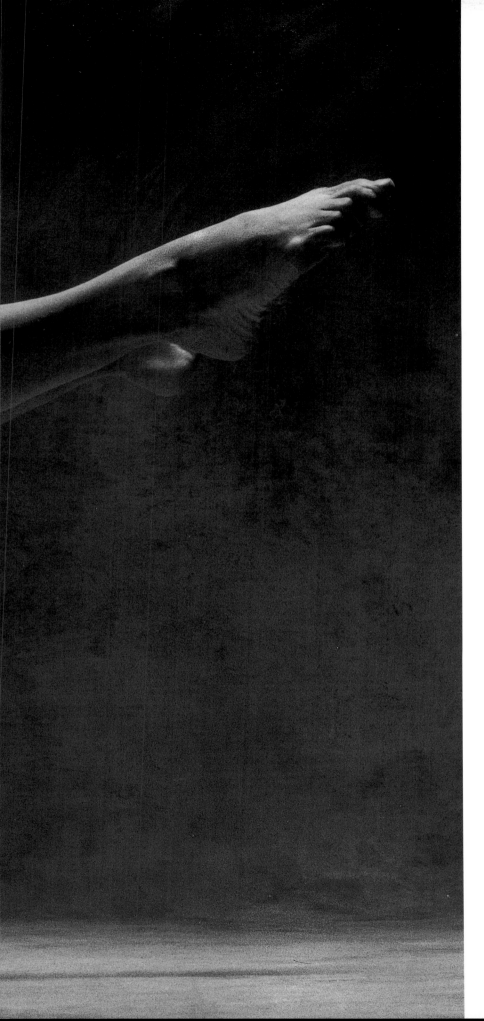

Radha Warrell, Yoga Teacher, 1990

Gary Lineker, Captain of the English Football Team, 1991

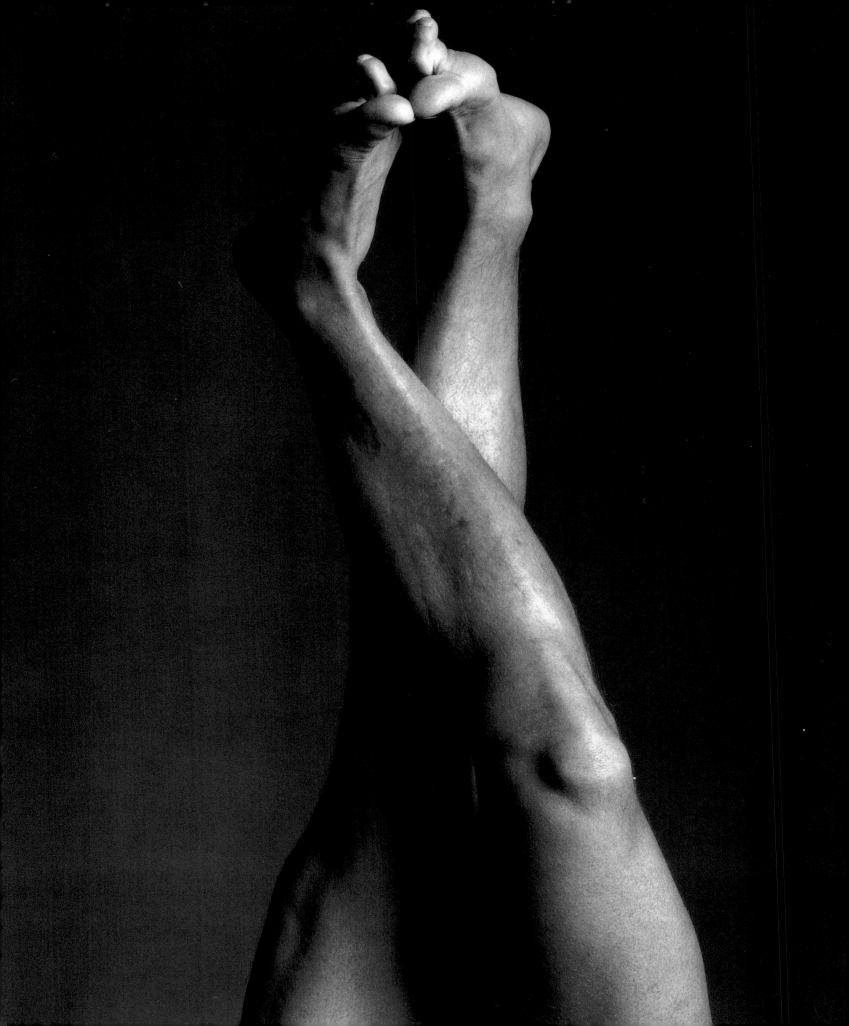

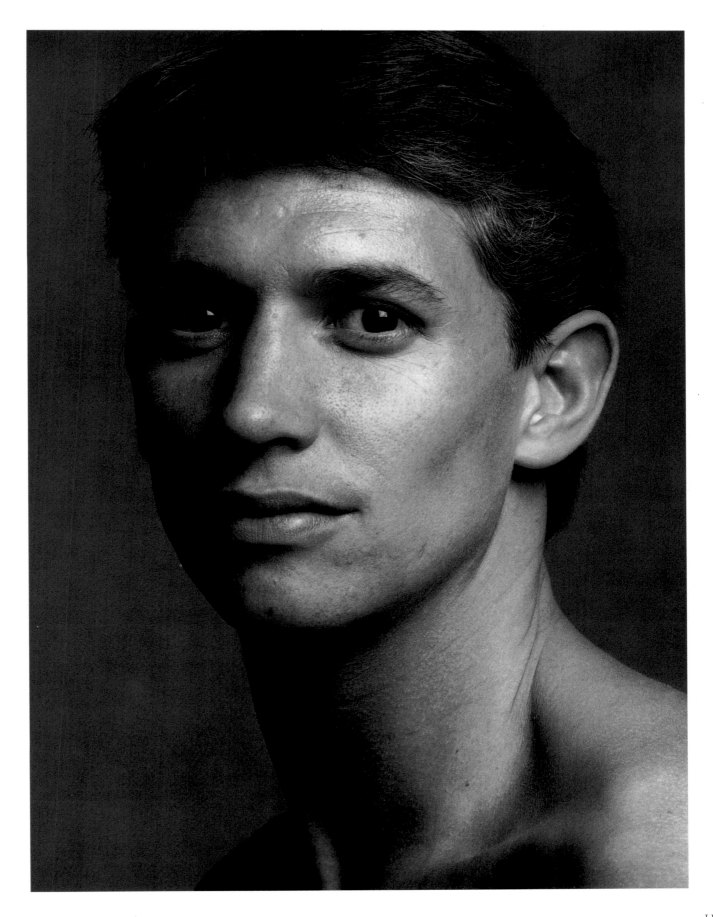

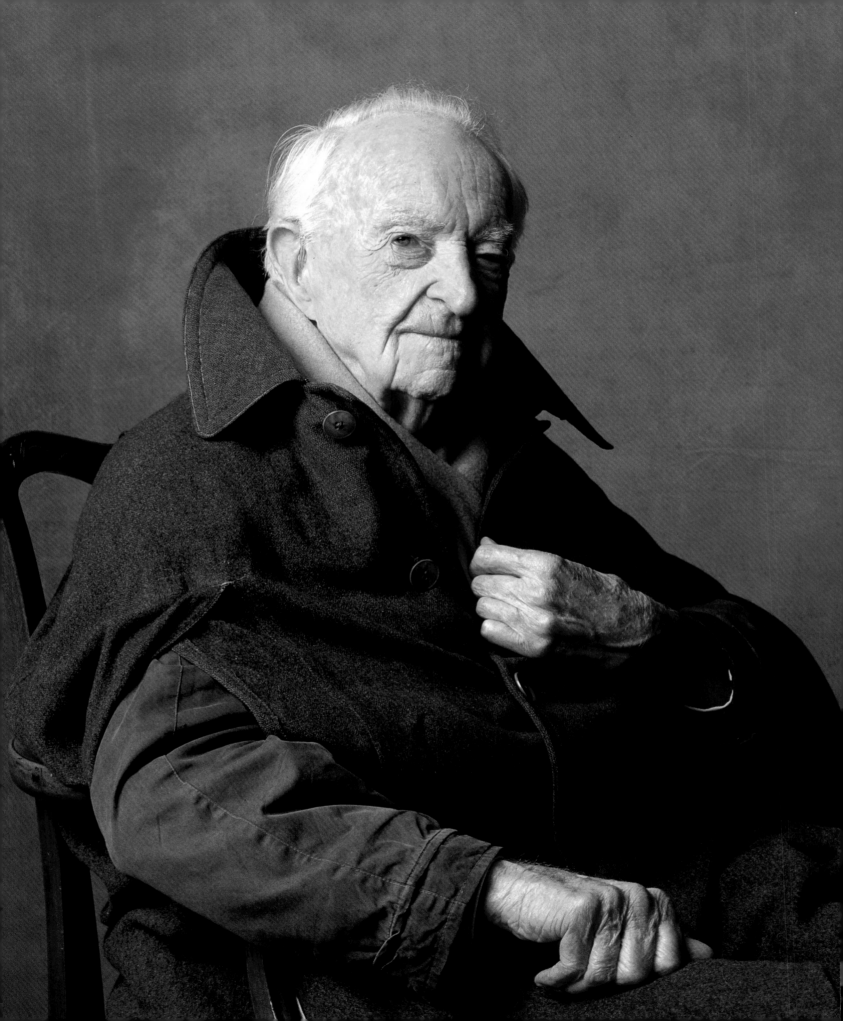

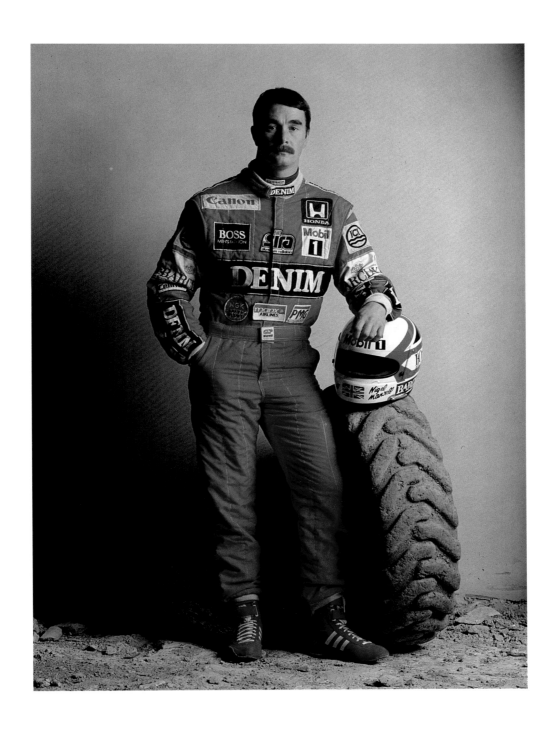

Sir Thomas Sopwith, Aviator, Inventor and Designer of The Sopwith 'Camel' and 'Pup', aged One Hundred, 1988

Nigel Mansell, Formula One Racing Driver, 1987

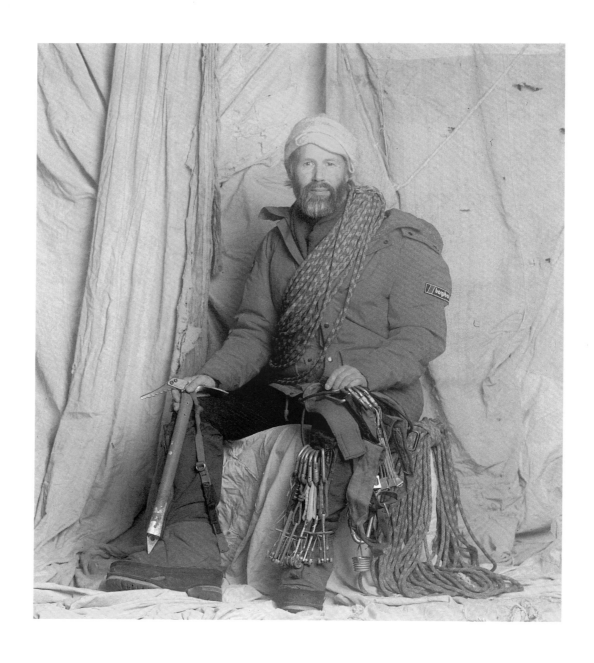

Chris Bonnington, Mountaineer, 1987

Simon Weston, ex-Welsh Guardsman and Falklands Veteran. Cover for *Walking Tall*, 1988

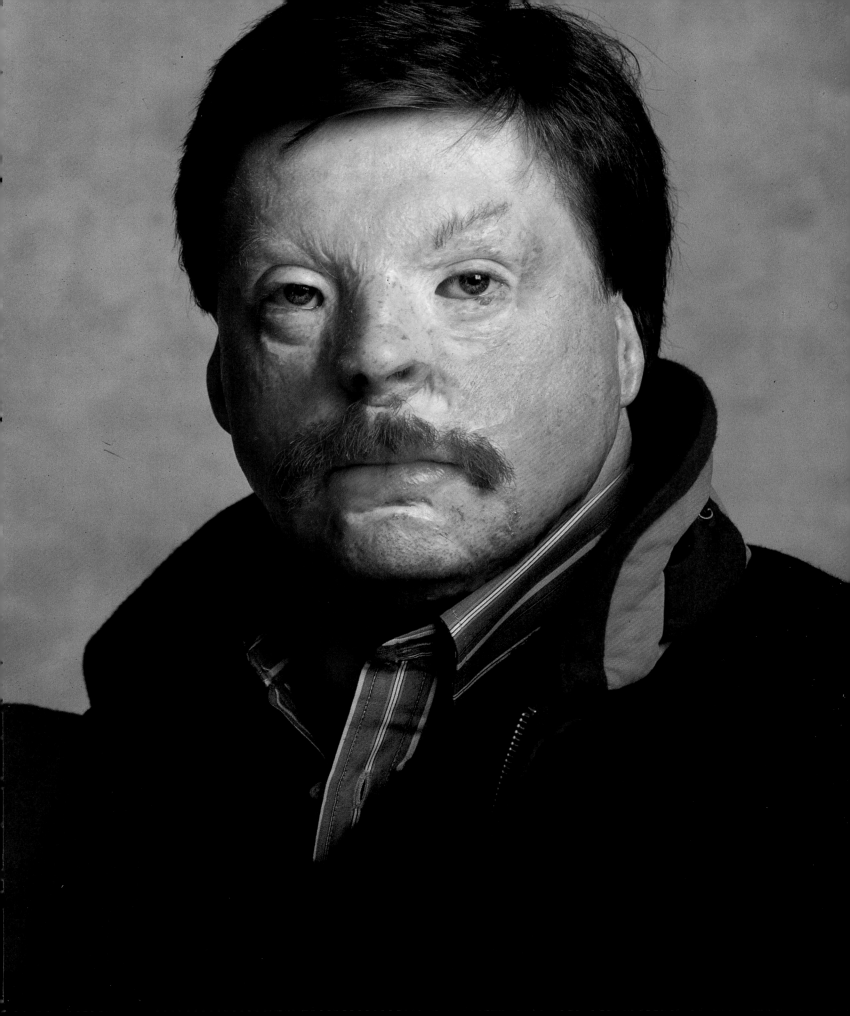

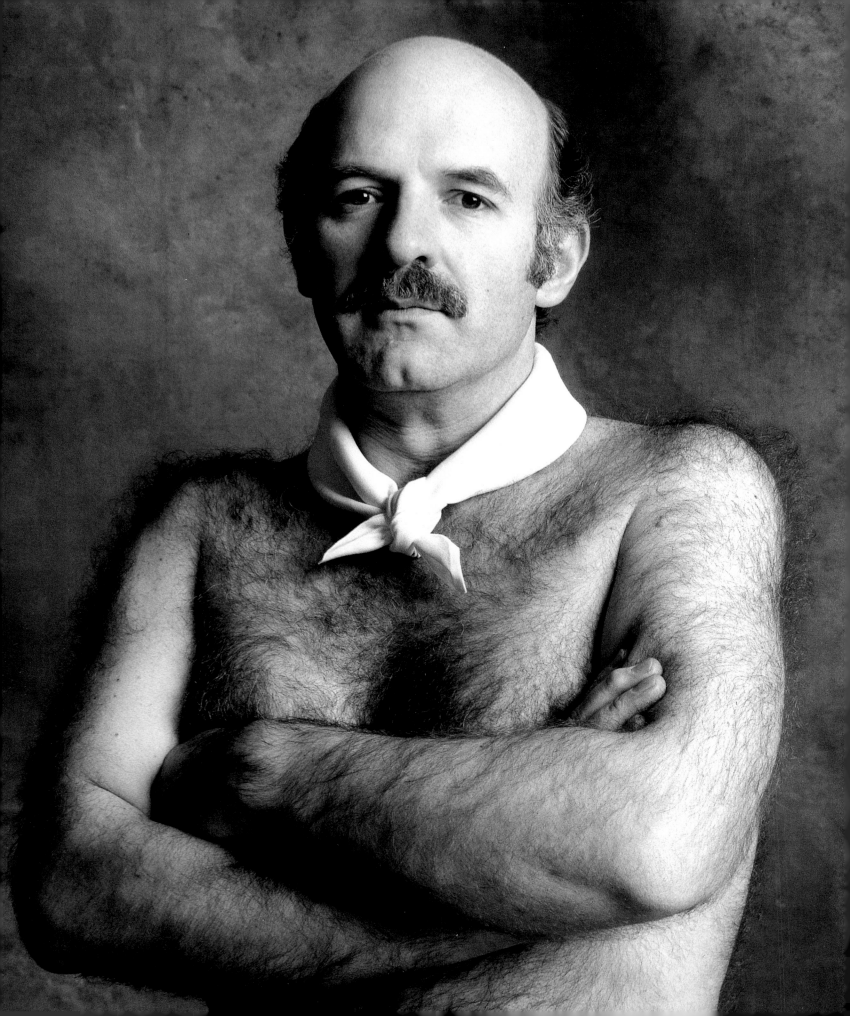

Anton Mosimann, Chef de Cuisine, 1988

Frances Armstrong-Jones in
Costume for a School Parade, 1988

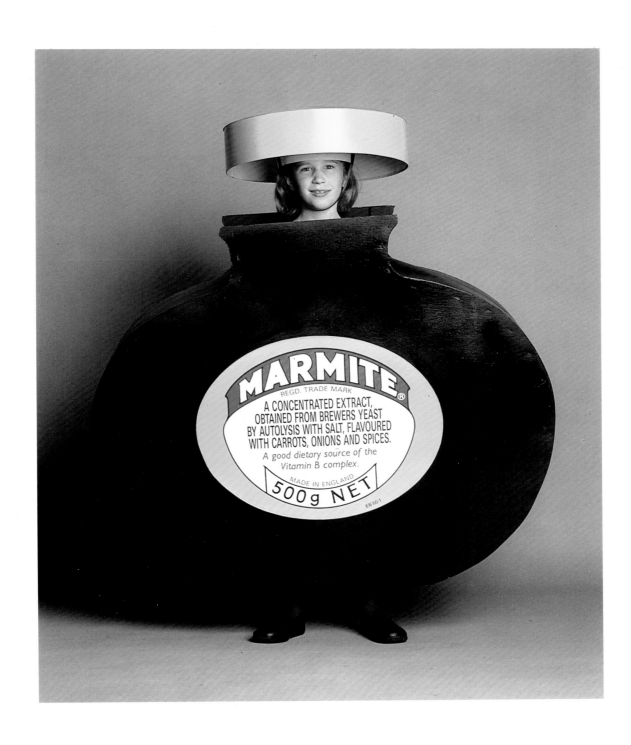

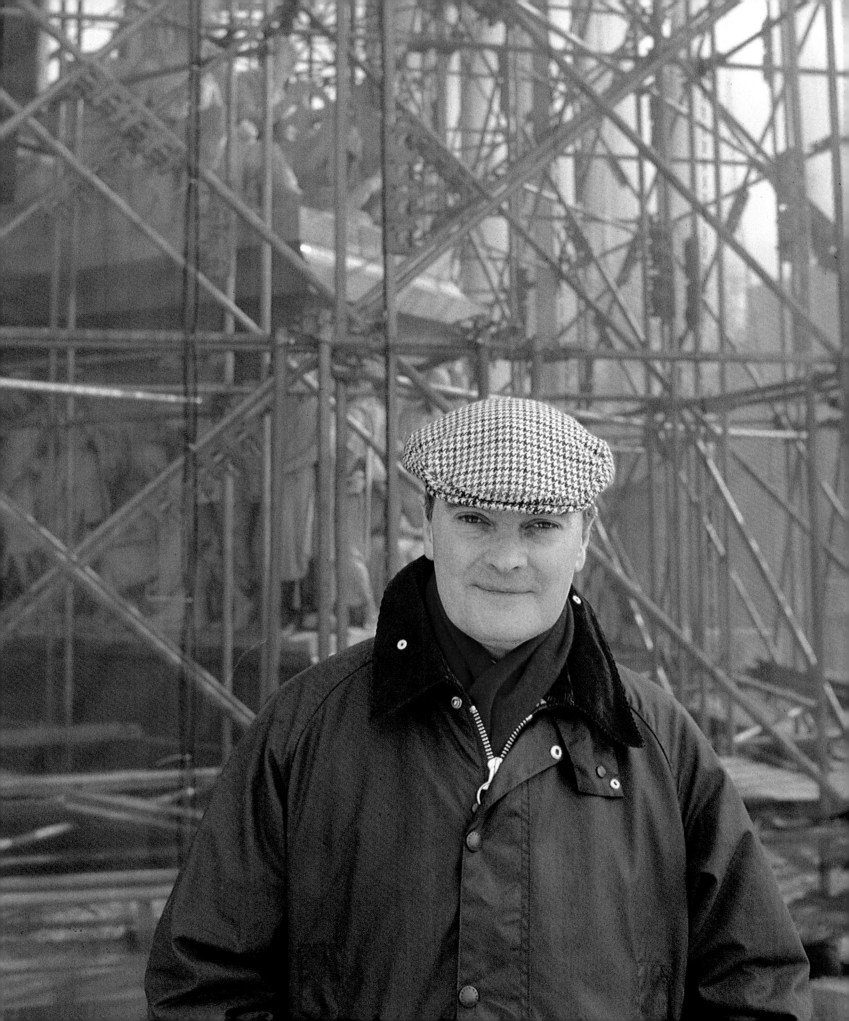

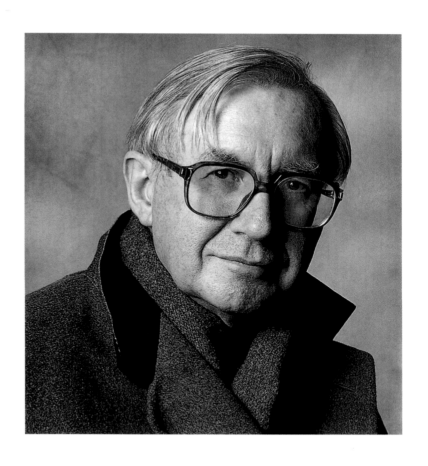

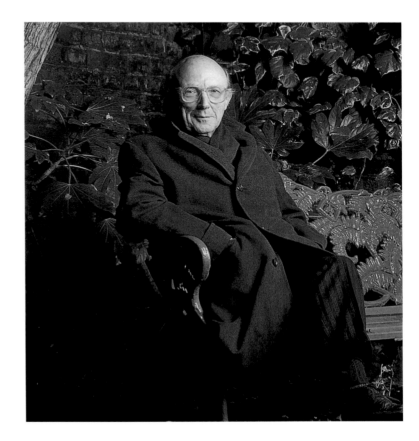

Lord Palumbo, Chairman of the
Arts Council, 1991

Lord Rees-Mogg, Chairman of the
Arts Council (1982–9), 1989

Lord Gibson, Chairman of the
Arts Council (1972–77), 1988

John Bellany, Scottish Painter, with Halibut, 1990

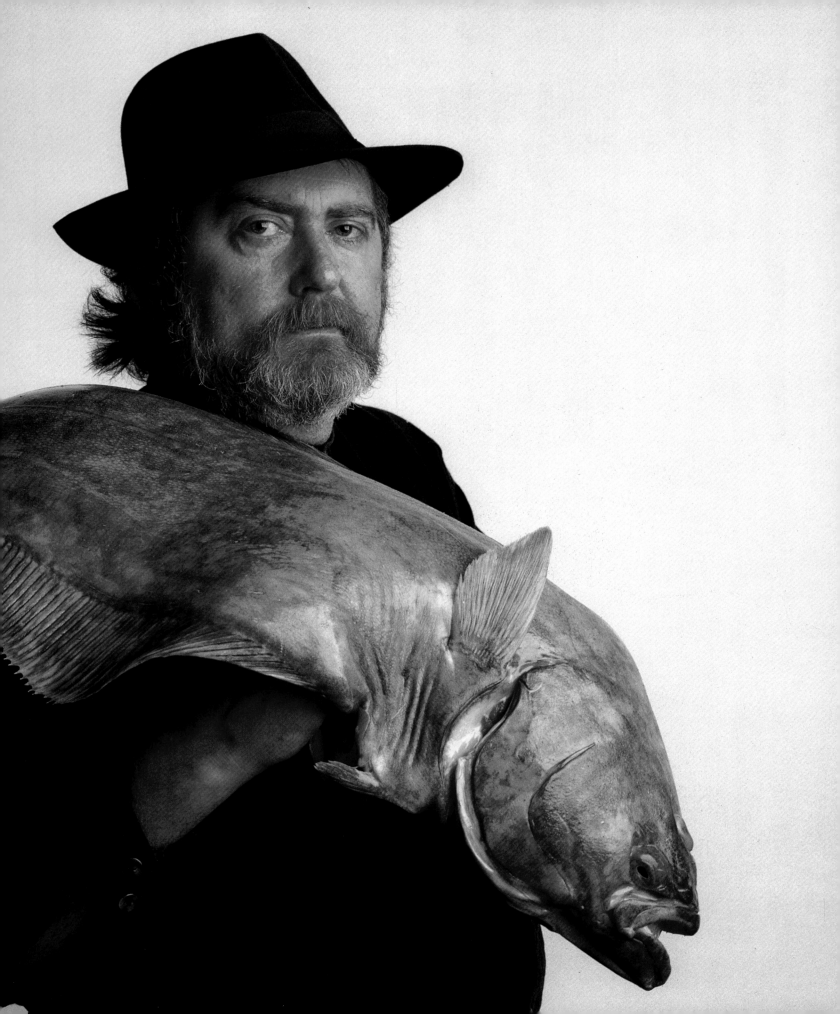

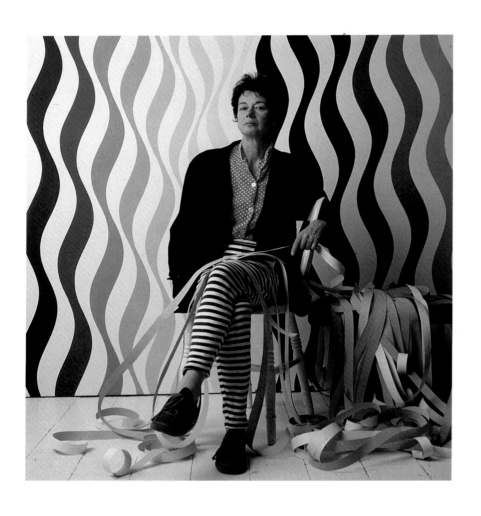

Bridget Riley, Artist, 1987

Adrian Berg, Painter, 1987

130

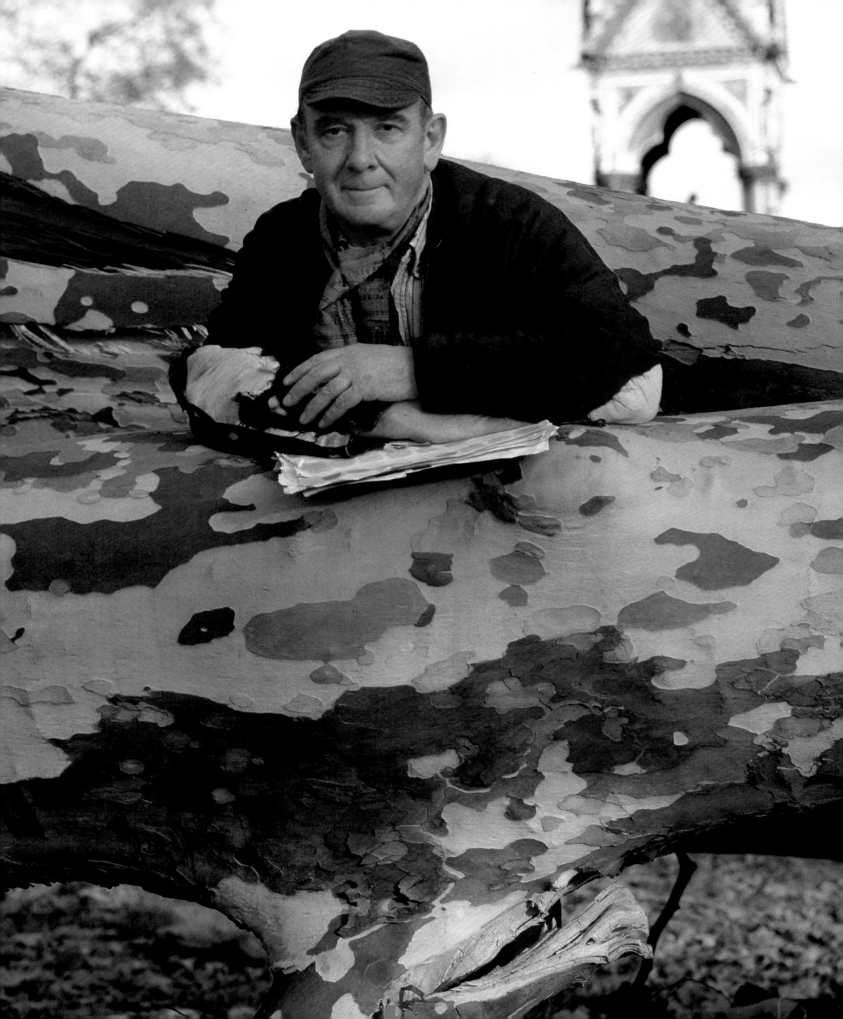

John Richardson, Art Historian, New York, 1988

Ruskin Spear, Artist, 1987

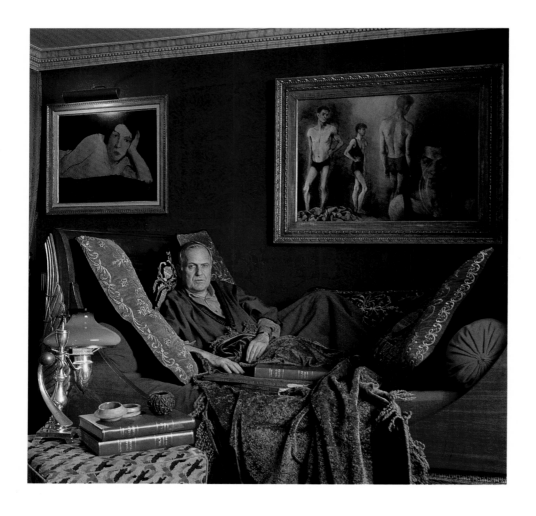

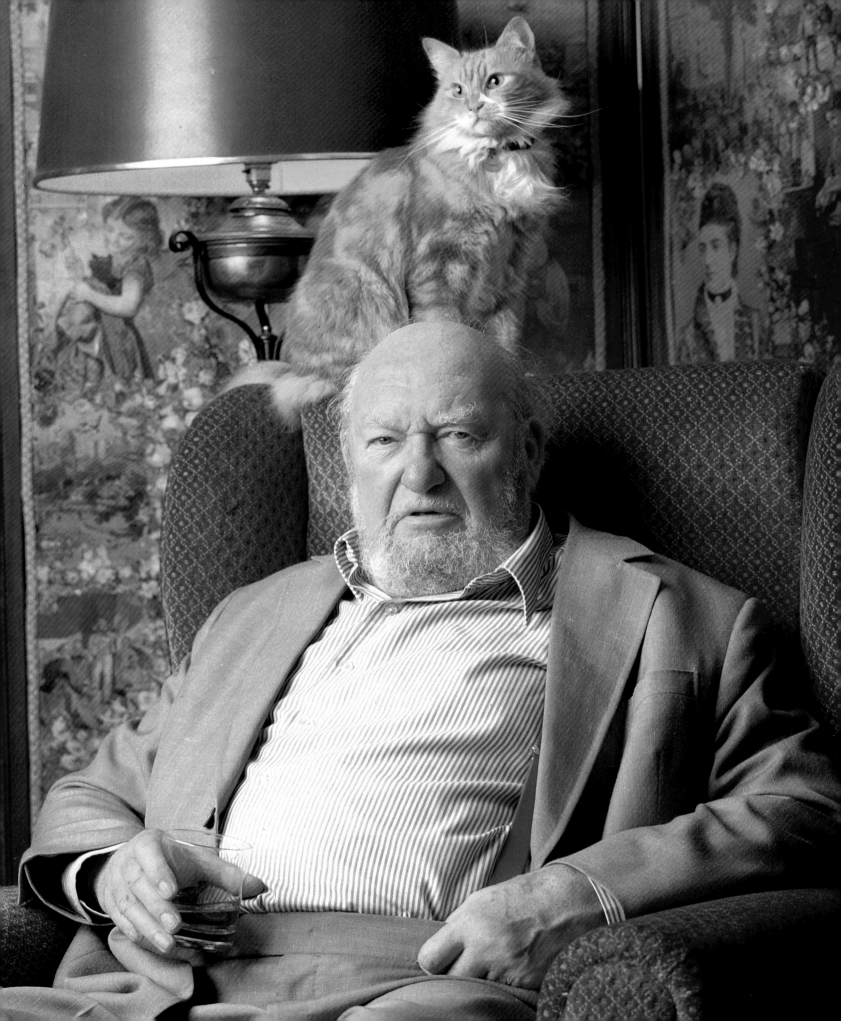

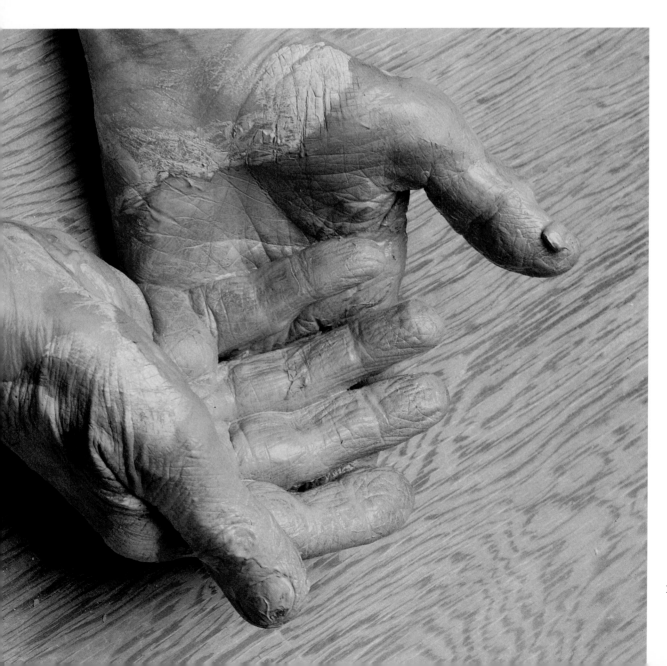

Lucie Rie, Potter, 1988

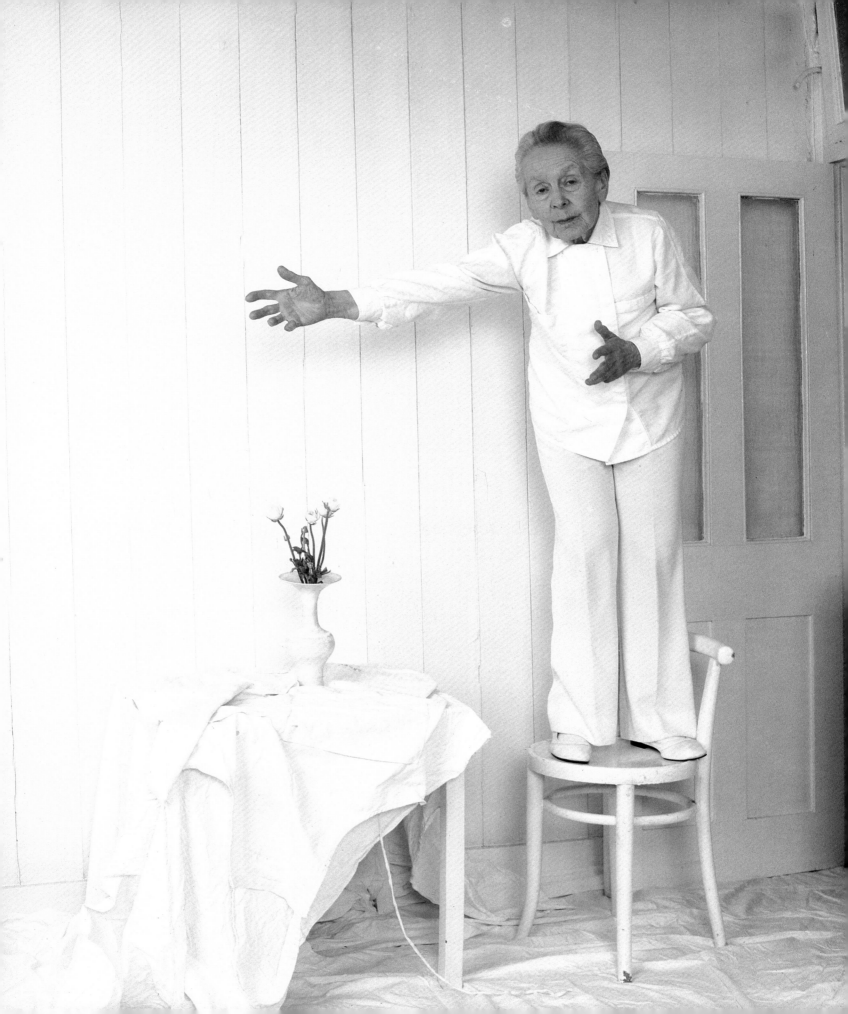

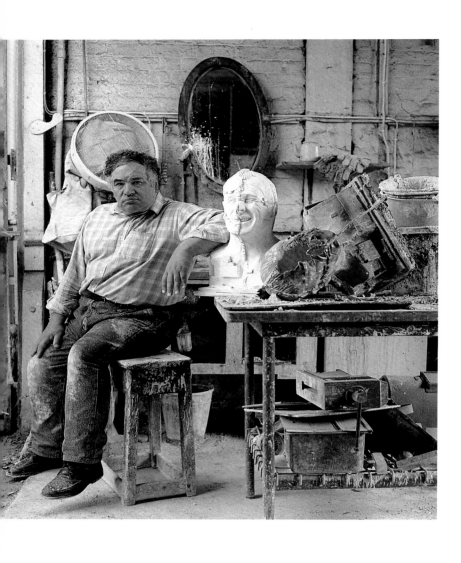

Sir Eduardo Paolozzi, Sculptor, 1988

Jack Smith, Artist, 1987

Craigie Aitchison, Painter, and his Bedlington Terrier, **Candy**,
in front of **Naa Otwa Swayne** and her Portrait, 1988

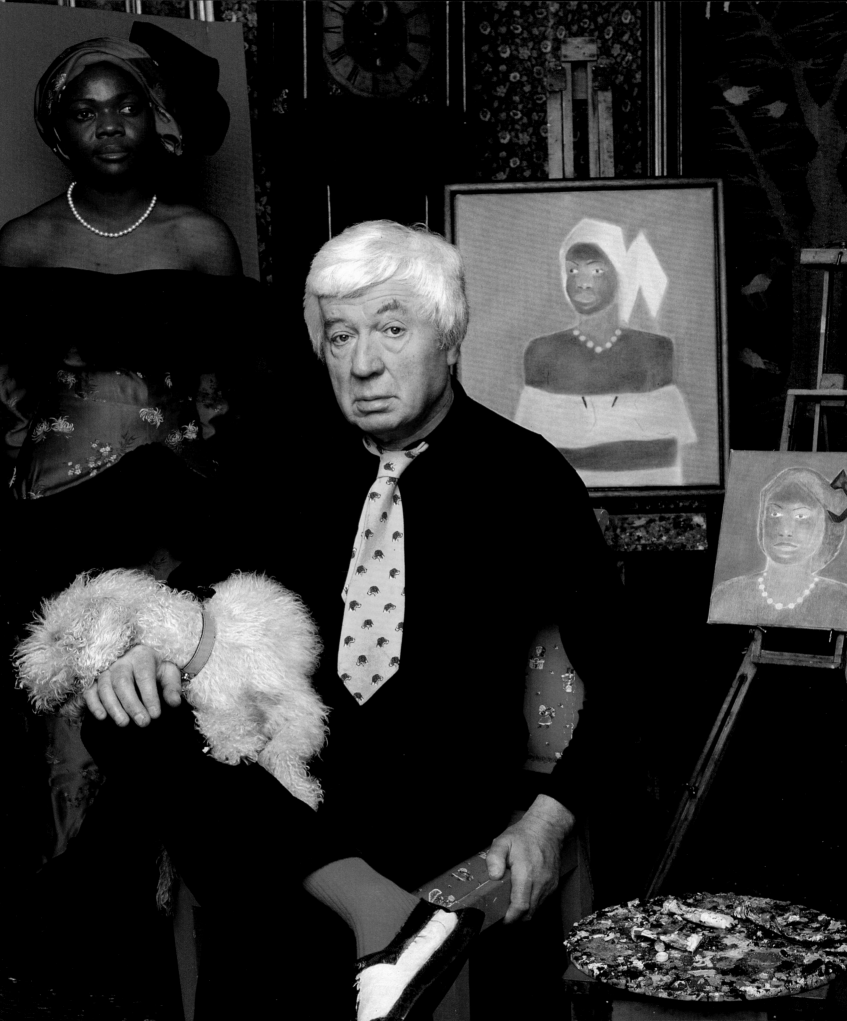

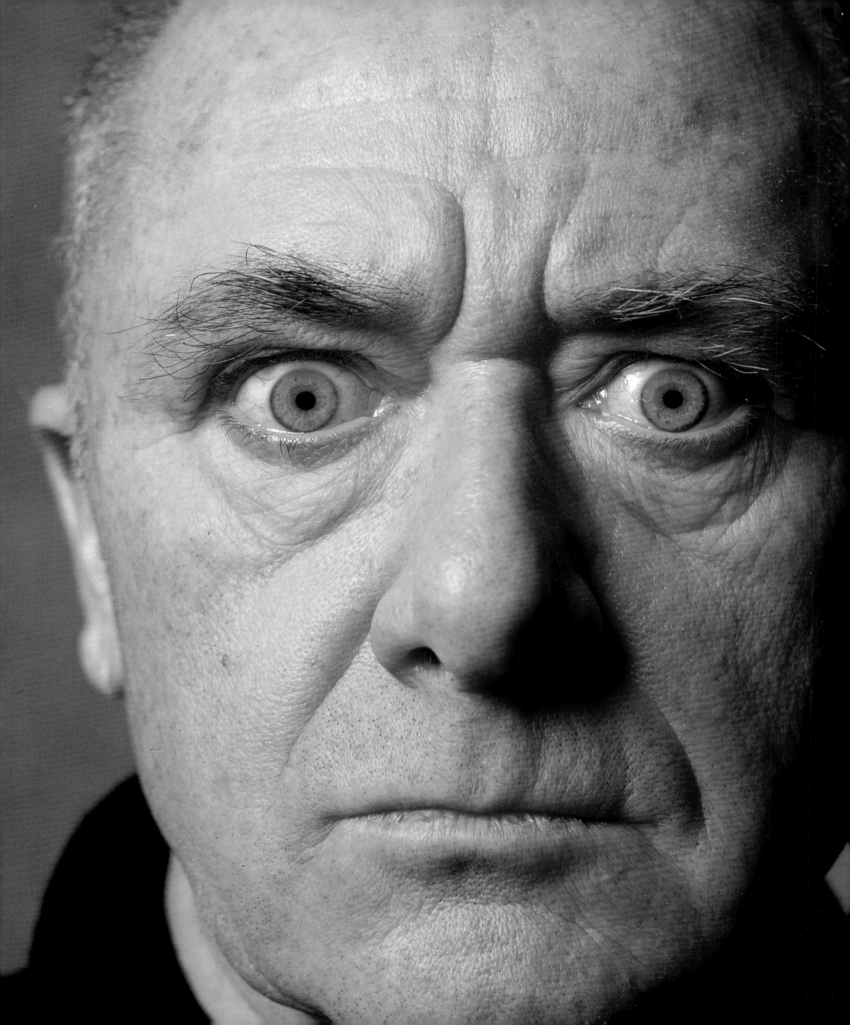

Gerhard Richter, Painter, 1991

Sean Scully, Painter, 1987

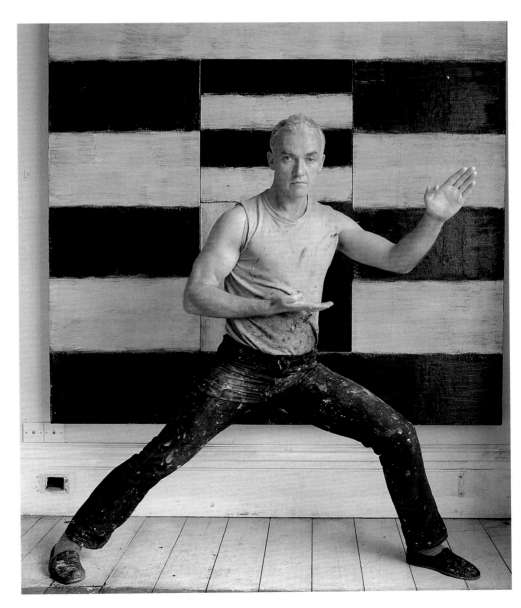

David Tremlett, Painter, 1988

Anthony Gormley, Sculptor, 1988

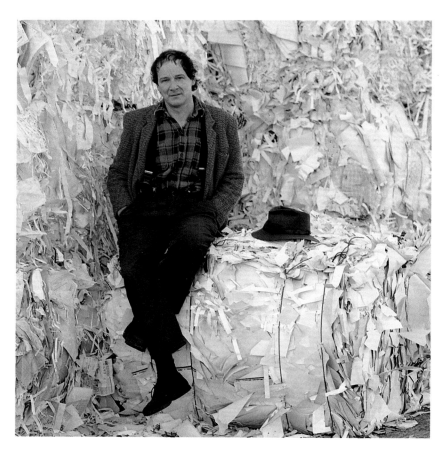

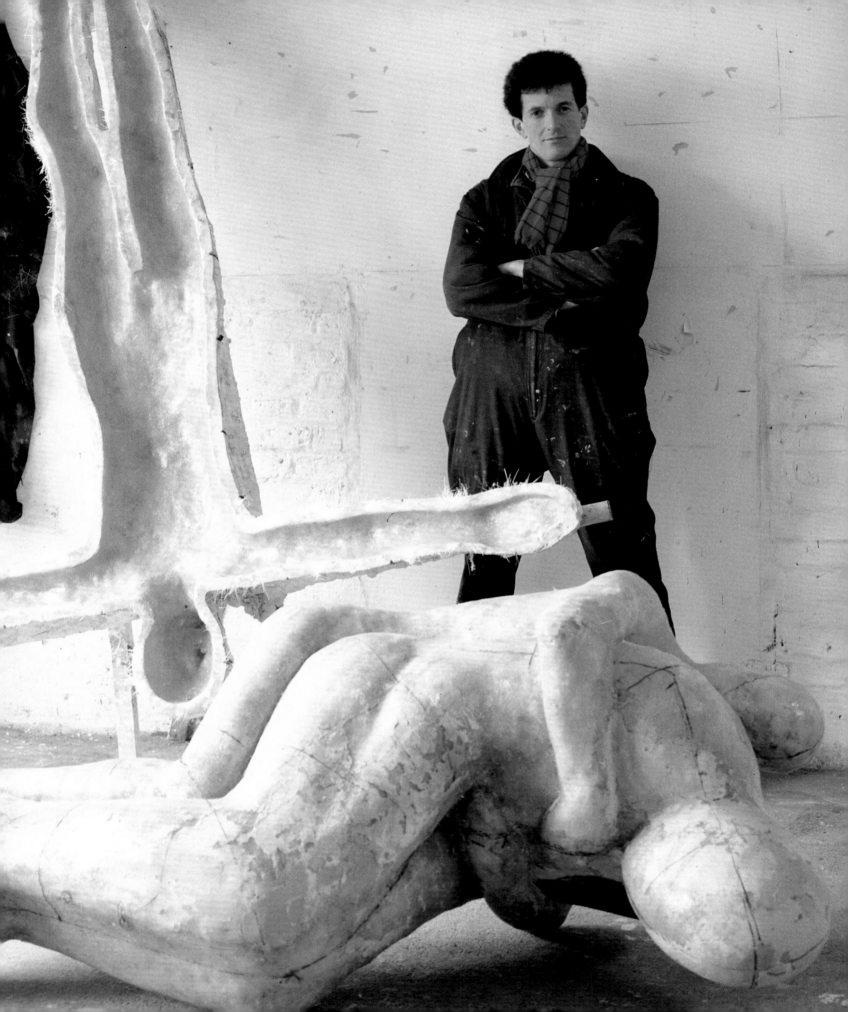

Michael Craig–Martin, Sculptor, 1988

144

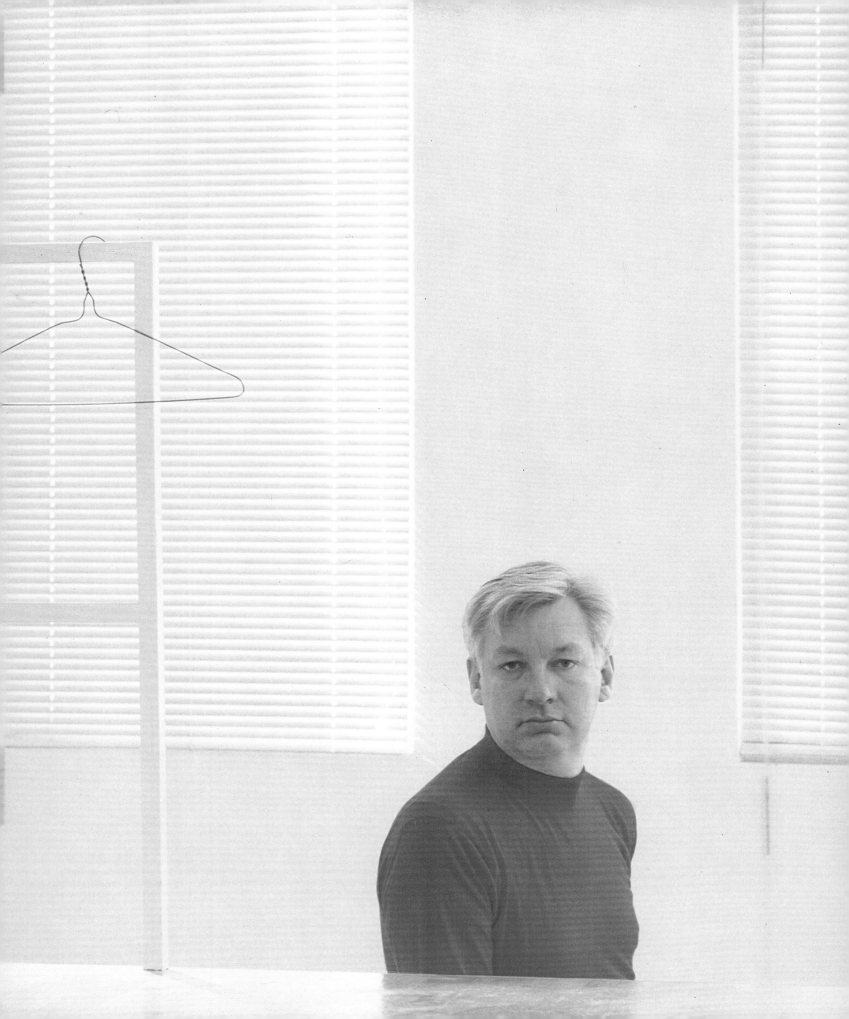

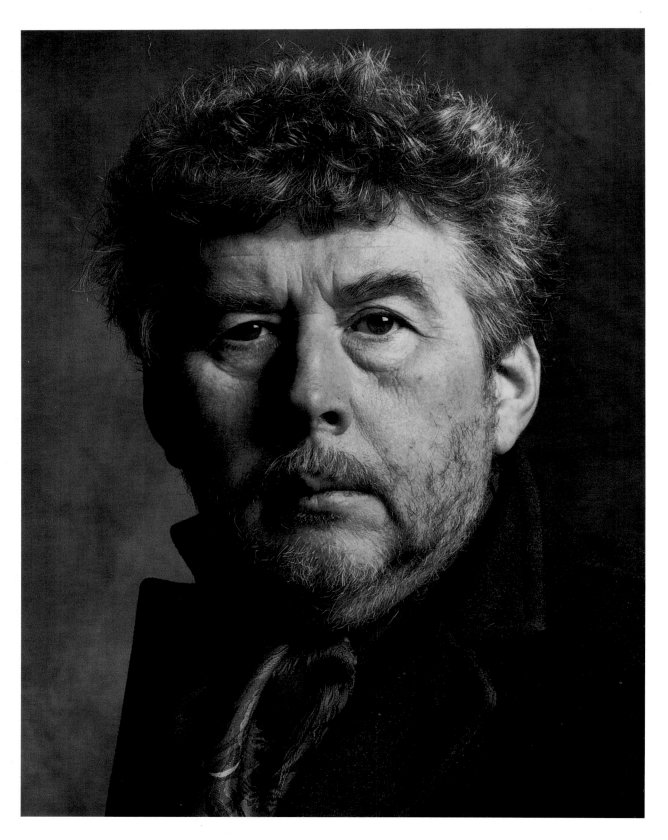

Sir Harrison Birtwistle, Composer, 1991

Sir Georg Solti, Conductor, 1987

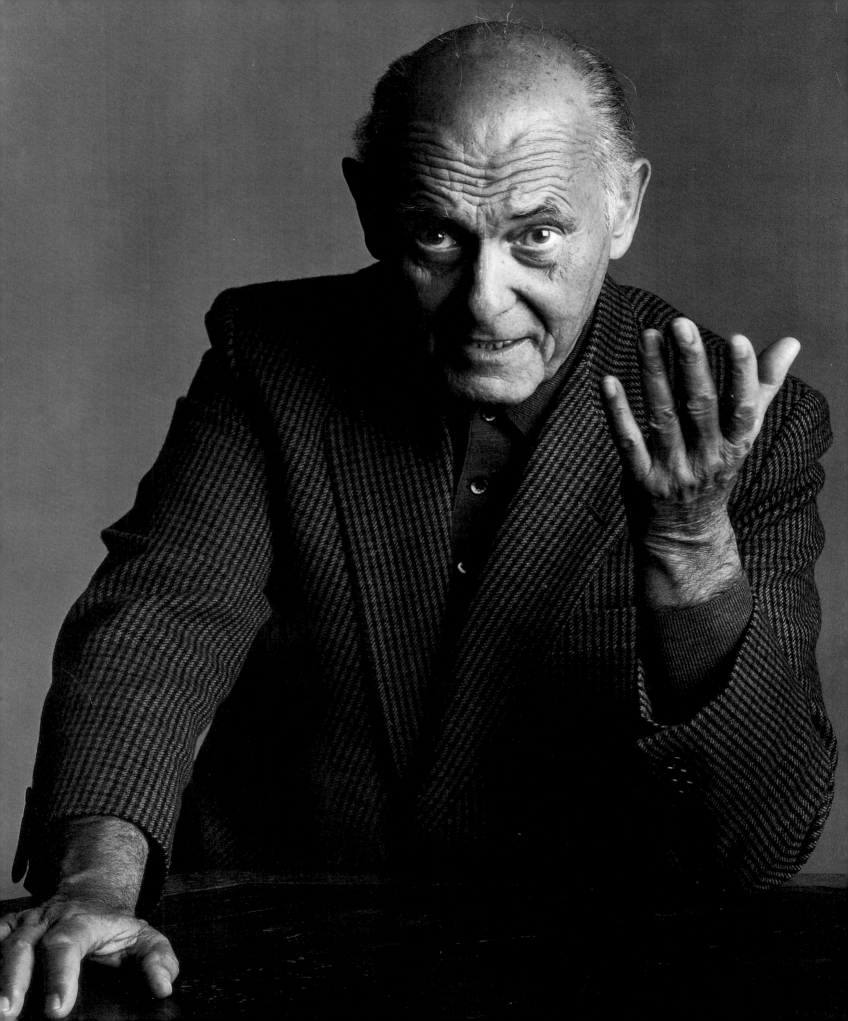

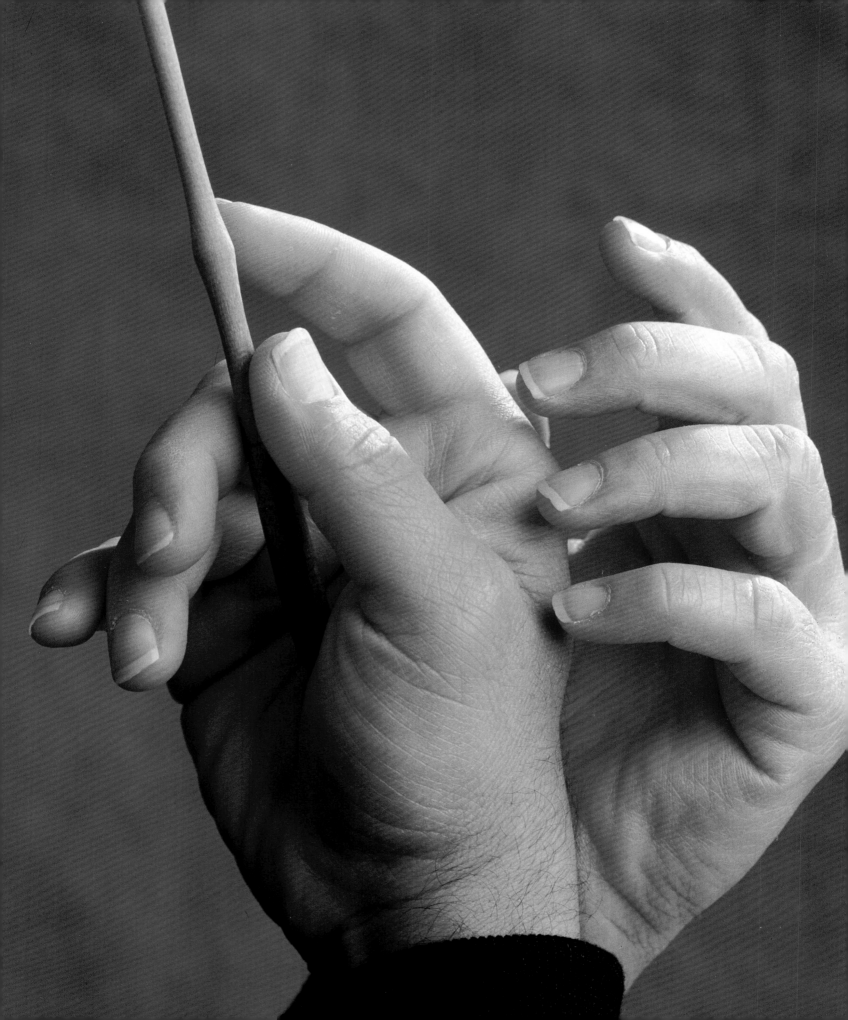

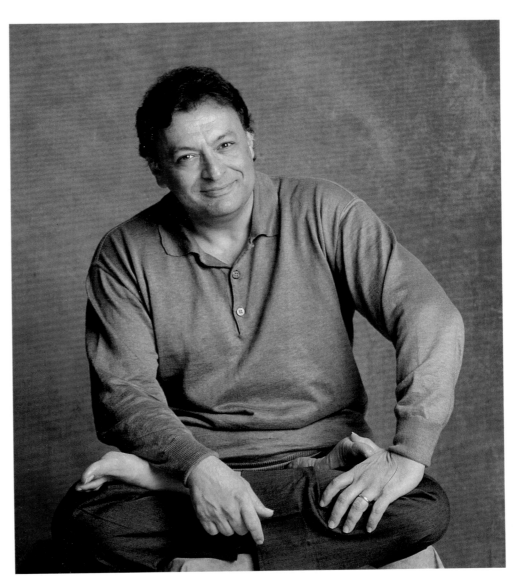

Zubin Mehta, Conductor, 1990

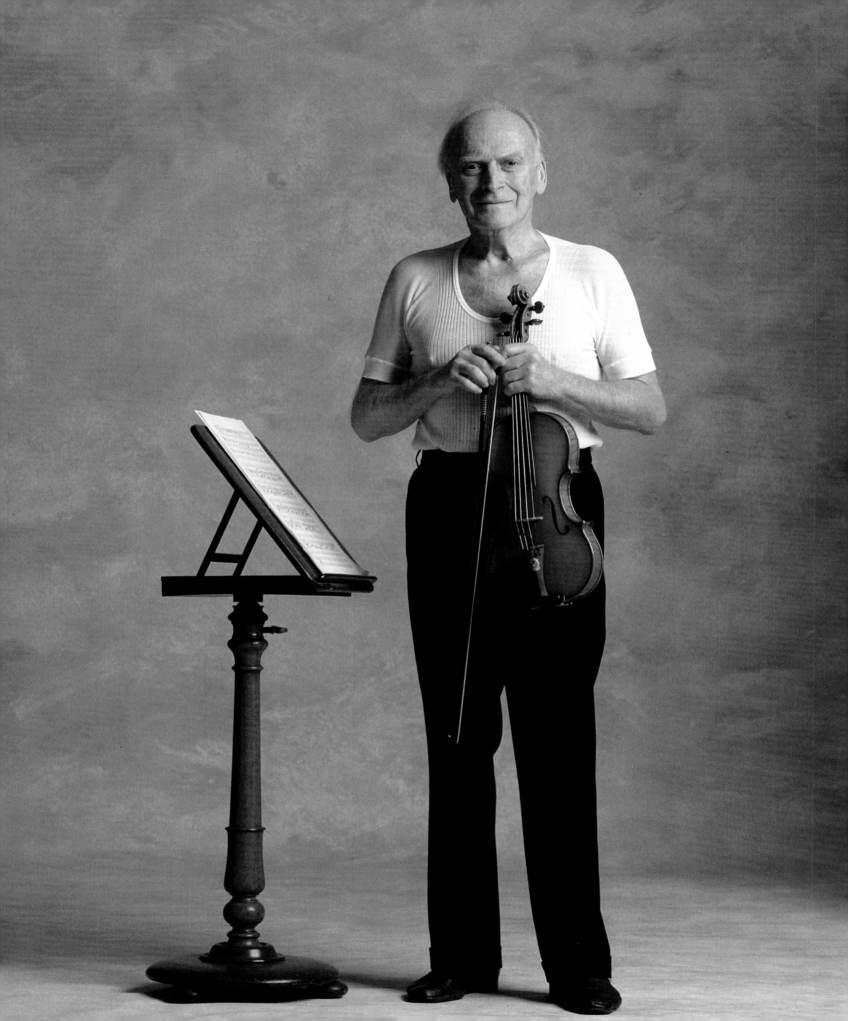

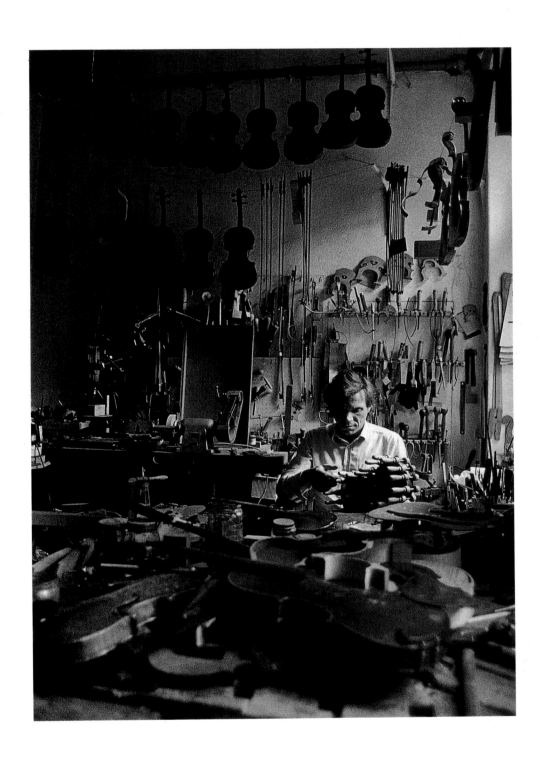

Sir Yehudi Menuhin, 1990

Violin Maker, Berlin, 1988

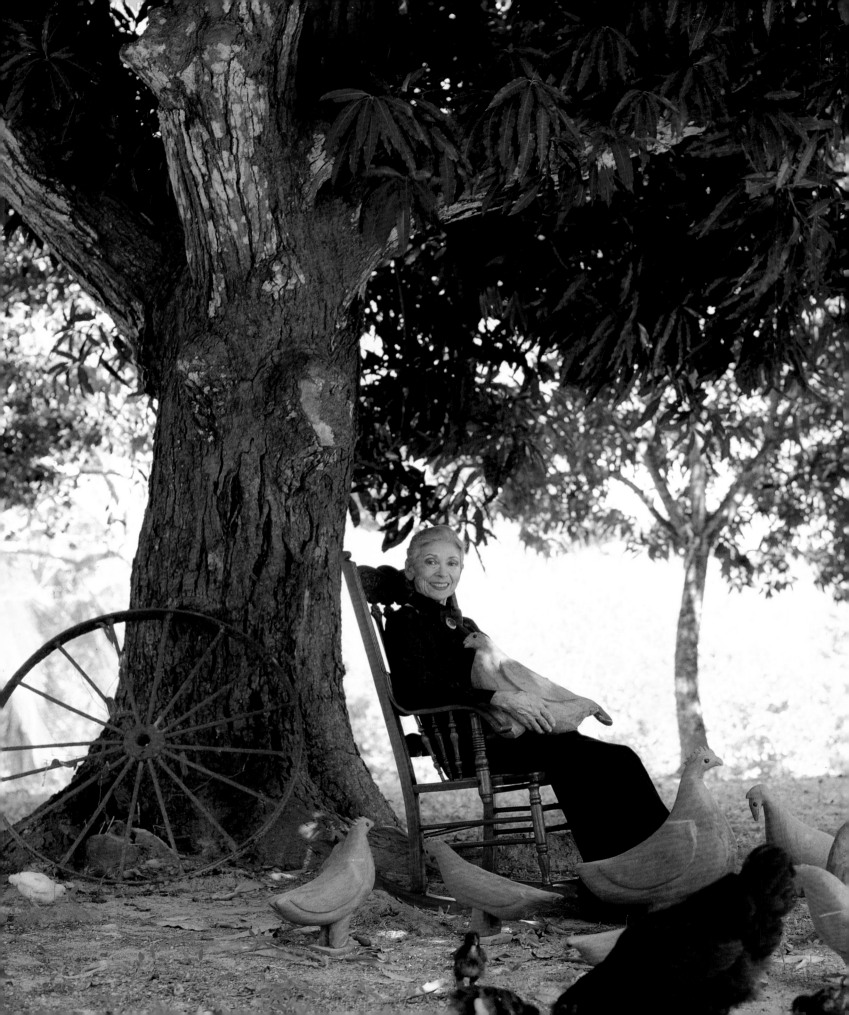

Dame Margot Fonteyn on her Ranch in Panama, 1990

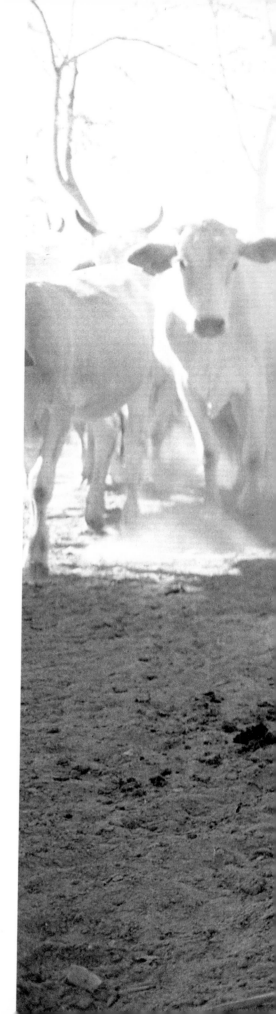

INDEX OF NAMES

Page references in *italic* type refer to photographs